About the Author

JAKE MORRISSEY has studied and written about architecture for twenty years. His work has appeared in the *Washington Post, Chicago Tribune, San Francisco Chronicle,* and dozens of other publications and books. He is the author of the novel *A Weekend at Blenheim* and lives near New York City.

ALSO BY JAKE MORRISSEY

A Weekend at Blenheim

THE
GENIUS
IN THE
DESIGN

BERNINI, BORROMINI,
and the Rivalry
THAT TRANSFORMED ROME

JAKE MORRISSEY

HARPER PERENNIAL

NEW YORK • LONDON • TORONTO • SYDNEY

HARPER ● PERENNIAL

A hardcover edition of this book was published in 2005 by William Morrow, an imprint of HarperCollins Publishers.

FIRST HARPER PERENNIAL EDITION PUBLISHED 2006.

Designed by Nicola Ferguson

The Library of Congress has catalogued the hardcover edition as follows:

Morrissey, Jake.
 The genius in the design: Bernini, Borromini, and the rivalry that transformed Rome/Jake Morrissey.— 1st ed.
 p. cm.
 Includes bibliographical references and index.
 ISBN 0-06-052533-9
 1. Borromini, Francesco, 1599–1667. 2. Bernini, Gianlorenzo, 1598–1680. 3. Architects—Italy—Rome—Biography. 4. Church architecture—Italy—Rome. 5. Architects and patrons—Italy—Rome—History—17th century. I. Title.

NA1123.B6M67 2005
726.5'092'24563—dc22
 [B] 2004054653

ISBN-10: 0-06-052534-7 (pbk.)
ISBN-13: 978-0-06-052534-7 (pbk.)

07 08 09 10 ❖/RRD 10 9 8 7 6 5 4 3 2

For Rula. Again and always.
And for Emma and Charlotte.
For the first time.

Non est ad astra mollis e terris via
There is no easy way from the earth to the stars.

——SENECA

Nullum magnum ingenium sine mixtura dementiae fuit
There is no great genius without some touch of madness.

——SENECA

CONTENTS

ILLUSTRATIONS

✶

THE
GENIUS
IN THE
DESIGN

❦

*

ONE

The Beginning and the End

⸺⊰※⊱⸺

SUICIDE IS NEVER AN EASY DEATH. ITS DE-
tails can be simple, its execution effortless, even
graceful. But the pain that incites it in the first
place, the anguish that breeds the longing for
self-destruction, never fades. It stands out on
the soul like a welt on tender skin, aching and
raw. Even after the deed is done, the mark
remains—a last, terrible legacy of a life lived in
torment.

The sad, strange suicide of Francesco Bor-
romini was such a death, as complex and as
peculiar as the man himself. At once abrupt
and protracted, impulsive and deliberate, his
death stunned his small circle of intimates by
its curious mix of recklessness and calculation,
just as the churches and palazzi he designed
over his three decades as an architect startled
Rome by the power of his demanding, idio-
syncratic genius.

His passing marked the end of an extraordinary career, one that would have made him the undisputed architect of Rome and the founder of the era known as the Baroque had it not been his fortune—or misfortune—to have lived during the lifetime of an artist whose acknowledged talent, worldwide reputation, and enormous success bedeviled Borromini to the very end: Gianlorenzo Bernini.

This is their story.

The two men could not have been more different. Unlike the subtle, gracious, diplomatic Bernini, who moved easily through the courts of popes and princes, Borromini found it difficult to sustain relationships with both his patrons and many of his peers. He lived quietly, never marrying or fathering children. Some speculate that he was gay. He never amassed a large personal fortune. He didn't have a wide circle of friends. When he died, his passing wasn't mourned by many—certainly not by Rome's elite, who found him difficult and argumentative, inflexible and quick to take offense. Even in a city used to dealing with temperamental artists, Borromini was an anomaly.

Yet when he invited death, at the last moment he rebuffed it. When it came, he found he was not ready. He would die as he had lived and worked: on his own terms and for his own convoluted and very personal reasons.

The few souls who did mourn his death—his servants, his workers, a handful of friends—were bewildered and grief-stricken by the self-destructive compulsions of the *cavaliere*. But for Borromini, there was a lucid, even poetic aspect to his suicide, just as there always was in his architecture—though not everyone saw it or understood it.

The place where Borromini was buried, the church of San

Giovanni dei Fiorentini, is a traditional Roman neighborhood church. It is stately but not imposing, grave but not commanding, neither large nor magnificent in a city bursting with churches that are both. Commissioned in the sixteenth century by Pope Leo X, a member of the Medici family, for the Florentines, who for generations lived in this neighborhood near the Tiber, San Giovanni stands near the north end of the Via Giulia, just where the river makes its lugubrious turn south. Begun in 1509 from a design by Jacopo Sansovino (before he left Rome for Venice) and built of traditional flat Roman brick (now gray with age and grime), San Giovanni is dedicated to Saint John the Baptist, the patron saint of Florence. It sits in a part of Rome that by the nineteenth century had, in Émile Zola's words, "fallen into the silence, into the emptiness of abandonment, invaded by a kind of softness and clerical discretion."

Visiting the church, it's clear why it has been called "so large a church along so terrifying a river." It is wedged into a narrow sliver of land whose constricted dimensions must have demanded a good deal of resourcefulness from the builders: When it was built, its altar end jutted out over the Tiber's riverbed; the stone piers supporting it had to be sunk deep into the muddy shoreline. The result is a church that even now clings tenaciously to its place, like an old, nearly forgotten watchdog that knows he is no longer needed but nonetheless refuses to cede his place at the door.

San Giovanni's two noteworthy architectural details are its elongated, crownlike dome, designed much later by the preeminent architect in Rome at the time, Carlo Maderno, and early on nicknamed the *confetto succhiato*—half-sucked sweet—by residents of the neighborhood, and its curious lantern, a tall, cylindrical shaft of slender windows that alternate with equally narrow stone

buttresses coiled at their base like tightly wound ribbon. This unusual concoction was designed by a Lombard stonemason who worked as Maderno's assistant, a young man named Castelli, who soon began calling himself Francesco Borromini.

Borromini knew this church well. It was one of the earliest buildings he worked on with Maderno, and the church's grandiose Falconieri chapel—its convex high altar, a fantasy in *marmi mischi* (precious materials of brick red travertine and gilding) that presses out into the congregation—celebrates John the Baptist. It was one of Borromini's last great commissions before he died.

For most of his life, Borromini lived in a house next to San Giovanni's high, unwelcoming walls; he was familiar with the fashionable Via Giulia, the boulevard created by Pope Julius II early in the sixteenth century, and the shadowy tangle of streets of small houses stuccoed in the traditional Mediterranean colors of ocher, umber, and dun that twist out from it like cracks in glass. He knew the sounds of shouting river workers and bickering shopkeepers, the lingering odors of fetid water and rotting garbage, just as he knew the traditions and rituals of San Giovanni, which included the annual Easter blessing of the lambs. His lonely figure—always dressed in black, like the chief mourner at a funeral—was well known to the hatters, trunk makers, locksmiths, tailors, grocers, and booksellers who had shops throughout the area.

It was in this *sestiere*, in the house where he lived, soberly and alone, that Borromini died early on the morning of August 3, 1667.

His suicide seemed sudden—impetuous and unpremeditated. But Borromini had taken the first steps toward it years before, during the final, dispiriting phase of his career. A frustrating series of unfinished projects had bedeviled him for nearly a decade. In 1657, as Bernini was working on the breathtaking colonnades

in St. Peter's Square and creating the Cathedra Petri, Borromini was embroiled in increasingly heated arguments with his patrons. He quarreled with the Pamphili, one of Rome's preeminent papal families, over the church of Sant'Agnese in Agone, which was to be the centerpiece of the clan's ambitious rebuilding campaign for the Piazza Navona. The conflict became so acrimonious that Borromini quit the building site in a misguided attempt to force the family to see things his way. The tactic backfired. Rather than compelling Prince Camillo Pamphili, the nephew of Pope Innocent X, Borromini's former papal patron, to see his error and apologize, it incited his dismissal.

At roughly the same time, the Oratorians of Saint Filippo Neri, a reforming religious order that emphasized the inspirational role of music in religion, also sacked him. Borromini had been hired to complete their oratory—a tall, oblong room designed for choral services—that stands to the left of their church of Santa Maria in Vallicella along what is now the Corso Vittorio Emanuele. But the Oratorians were so alarmed by Borromini's behavior that they withdrew their support, giving the commission instead to Camillo Arcucci, an architect of more conservative, and more easily controllable, temperament. Borromini was incensed. In retaliation for this slight to what Joseph Connors calls his *stimolo d'honore*, he transferred his anger to his contract, given to him by Pope Innocent X, to install the bronze doors and high altar at San Giovanni in Laterano, one of the great churches of Rome. Without warning, Borromini stopped work at the Lateran and sent word to Innocent's successor, Pope Alexander VII, that he refused to return to work.

Because San Giovanni in Laterano is the official cathedral of Rome and had been the actual seat of the papacy for hundreds of

years, Alexander was directly involved in its renovations. No admirer of Borromini's work and angered by such behavior, His Holiness decided that he, too, had had enough of this architect's misplaced sense of dignity. He stripped Borromini of the commission and replaced him with Pietro da Cortona, a painter-turned-architect who had once been a friend of Borromini's.

The sting to Borromini's hypersensitive pride at such a rebuke must have been excruciating. Yet from Alexander's point of view, he had no choice: Borromini had behaved badly. His childish antics at San Giovanni were the last of a long line of irritations that a series of popes had contended with when dealing with the talented but troublesome architect. Besides, Alexander had made it very clear early in his pontificate that he preferred the work of another artist, Bernini.

Such behavior, disobedient and headstrong, only fueled Borromini's reputation as a handful, and it made it more difficult for him to attract and keep the few commissions that came his way. During the last decade of his life, he managed to complete only one, that of the Collegio di Propaganda Fide, a school founded in 1622 by Pope Gregory XV for the training of young Jesuit missionaries.

Still, Borromini was not without work. He did have other long-term projects besides Sant'Agnese and the Oratory, including the design and construction of the façade for San Carlo alle Quattro Fontane, his first and perhaps most famous commission. This tiny, intricate church, whose details are as finely wrought and as dazzlingly complex as the facets of a jewel, was Borromini's hallmark building, a work he fussed over during his entire career, from his designs for the small courtyard to the ripples and furrows of its subtle and dramatic façade. But his often disagreeable

manner and his quickness to take offense frightened off other pa-
trons and gave his critics—the loudest of whom were partisans of
Bernini—more ammunition. As Borromini's terrible and prickly
reputation grew, his hopes for papal and noble patronage disap-
peared.

Borromini's opinion of Bernini—and Bernini's of him—was
complicated, tangled as it was in each man's recognition (however
grudging) of the other's talents and their lifelong desire to best
each other. They met early in their careers, thrown together by the
happy chance of working with Carlo Maderno to realize the im-
mense task of finishing and decorating St. Peter's, and for a time
they were even in business together. With such contrary and con-
flicting personalities, it was inevitable that hostility would crop
up between them. Their most public disagreement involved the
scandal surrounding the badly planned bell towers at St. Peter's,
which were designed and built by Bernini on unsteady founda-
tions, which some believed caused cracks in the basilica's façade
and interior. Borromini was his rival's most caustic critic, deliver-
ing, Filippo Baldinucci writes in his biography of Bernini, "his
opinion without esteem or respect. He alone inveighed against
Bernini with his whole heart and soul." The result was nothing
less than a public disgrace for Bernini. The towers were disman-
tled, and with them Bernini's reputation.

Bernini's method of counterattack may have been shrewder
and less public. Like a stone dropped into a pond that causes rip-
ples along the surface, Bernini's own pebble was a well-chosen
word about Borromini's work whispered into the ears of the
powerful: Gothic. The effect was to toss Borromini's reputation
against the rocks of public opinion.

In the post-Renaissance world of seventeenth-century Rome,

the term "Gothic" was a synonym for "corrupt." The style, critics said, ran counter to the rules of classical architecture set down by the ancients. It was a blistering denunciation of an artist's work. Even Pope Alexander VII used such a description for Borromini's architecture. Rudolf Wittkower, the art historian and author, recounts how Alexander, upon visiting Borromini's brilliant and beautiful church of Sant'Ivo alla Sapienza, declared, "The style of Cavaliere Borromini was Gothic. Nor is this surprising, since he was born in Milan where the cathedral is Gothic." The charge is not precisely true, but the fact that it was uttered by the pope at all suggests that someone was responsible for planting such a condemnation in the pope's mind.

Such a judgment spread literally throughout Europe. The French diarist Paul Fréart de Chantelou, who had been assigned by Louis XIV to be Bernini's escort during the artist's famous visit to France in 1665, records that Bernini "discussed Borromini, a man of extravagant ideas, whose architectural designs ran counter to anything imaginable; a painter or sculptor took the human body as his standard of proportion; Borromini must take a chimera for his."

The decline in Borromini's professional fortunes only exacerbated his bouts of depression, which had grown steadily worse over the hot summer months of 1667. In July, Borromini had several attacks of what his friends called "feverish melancholia," and the death on July 27, 1667, of his friend Fioravante Martinelli, a staunch supporter of Borromini's architecture, seemed to push him over the edge.

Lione Pascoli, one of Borromini's biographers, indicates that around July 22 Borromini "had another attack, even more violent, of his hypochondria, which in a few days reduced him to

such a state that no one recognized him as Borromini, so distorted was his body and so terrifying his face. He twisted his mouth in a thousand horrible grimaces, and from time to time rolled his eyes in a terrifying manner and sometimes shook and roared like a lion."

Such a description calls to mind the *Laocoön*, the ancient sculpture of the Trojan priest who, according to Virgil's *Aeneid*, was strangled by sea snakes sent by the gods who favored the Greeks while he sacrificed at the altar of Neptune. The piece, now in the Vatican Museums, has been owned by the papacy for centuries, and Borromini almost certainly saw it during one of his visits to the Vatican. Perhaps he appreciated the irony of a holy man being set upon by serpents for following his own beliefs.

Borromini had been drafting his will when the attack came over him, but he managed to send off a signed version of it to a notary. In late July his friend Martinelli died, and several days later Borromini burned some (though not all) of the drawings he had prepared for the book of his architecture he was planning to publish.

On July 29 Borromini asked the notary to return the will he had recently drafted. A copy of it has never been found, and there is considerable speculation as to what happened to it. Perhaps Borromini burned it with his other papers.

As the summer progressed, his friends grew increasingly alarmed over his health. "His nephew [and heir, Bernardo] consulted doctors, took the advice of friends and called in priests, and all agreed that he must never be left alone so that he should not be allowed any opportunity of hanging himself, and he must at all costs be made to sleep and so to calm his mind," Pascoli wrote. "These were the precise instructions which his nephew gave to the servants and these they carried out. But these measures which were intended

to cure his illness aggravated it, because seeing that he was not be-
ing obeyed, because he was refused everything that he asked for,
and feeling that he was being ill-treated, even if for his own good,
his mania became even more intense and his hypochondria
changed to an oppression in the chest with symptoms of asthma,
and in the end to a sort of continuous frenzy."

Francesco Massari, Borromini's talented *scarpellino*, or stone-
cutter, who was in charge of Borromini's work at San Carlo and
San Giovanni dei Fiorentini, stayed with him as his servant. The
architect's confessor, Father Orazio Callera, visited Borromini,
hoping to soothe his mind and spirit. Nothing helped for long.
Borromini's mind was too agitated; his heart couldn't find peace.

After dinner on August 1, in the glow of lamplight, Borro-
mini began to draft a new will. He wrote it in graphite, preferring
its suppleness to the lines made by ink (he had become the most
proficient architect in Rome with graphite, summoning from it
subtle, evocative elevations and plans). He worked in his room
until late, long after the summer sun had set. This was not un-
usual: Borromini was known to stay up all night, pondering a
particularly thorny architectural problem or working out the de-
tails of one of his plans. The night was quiet and there were few
distractions. No visitors were expected, and none arrived.

Around midnight, Massari, who had already gone to bed,
called in to Borromini.

"Signor Cavaliere, you ought to put out the light and go to
sleep because it is late and the doctor wants you to sleep," he said.

"I should have to light the lamp again when I wake up," Bor-
romini replied.

"Put it out, because I'll light it again when you wake up,"
Massari promised.

As Borromini explained later: "I stopped writing, put away the paper on which I had written a little and the pencil with which I was writing, put out the light, and went to sleep."

But his slumber was fitful: An August night in Rome with its oppressive, seemingly eternal heat is not the most conducive environment for a man struggling to quiet his restless mind.

Borromini woke several hours later and called out to Massari. "Light the lamp," he said.

"Signor, no," the servant said.

Such a small request denied; such a simple promise broken. Out of such insignificant moments come cataclysms.

Because of Massari's refusal, Borromini said later, "I suddenly became impatient and began to wonder how I could do myself some bodily harm, as Francesco had refused to give me a light. . . . I remained in that state . . . when I remembered that I had a sword in the room at the head of the bed, hanging among the consecrated candles, and my impatience at not having a light growing greater, in despair I took the sword and pulling it out of the scabbard leant the hilt on the bed and put the point to my side and then fell on it with such force that it ran into my body, from one side to the other.

"And in falling on the sword I fell on the floor with the sword run through my body and because of my wound I began to scream, and so Francesco ran in and opened the window, through which light was coming, and found me lying on the floor. . . . He with others whom he had called pulled the sword out of my side and put me on my bed."

To paraphrase T. S. Eliot: In Borromini's end were the seeds of his beginning. What came later had its genesis in what had come before.

✳

TWO

Talent and Ambition

❦

THE VIA DEL QUIRINALE IS AN UNLIKELY
place to stumble across an artistic metaphor
for Bernini and Borromini—which is, perhaps,
why it became one. It is a typical Roman street,
undistinguished and easy to dismiss. On its north
side runs the monotonous and rather cheerless
garden wing of the Quirinale Palace—dubbed
the *manica lunga,* or the long sleeve—while
on its south side stand two small churches,
which face the Quirinale's uniformity like well-
behaved schoolchildren waiting for a tiresome
class to begin.

Yet for hundreds of years this prosaic street—
once called the Via Pia after Pius IV, who reor-
ganized this area in the middle of the sixteenth
century—and the two churches along its south
side, Bernini's Sant'Andrea al Quirinale and
Borromini's San Carlo alle Quattro Fontane,
have been sought out by artists and historians,

tourists and dilettantes, the faithful and the curious. They have walked the three hundred paces between the Via della Quattro Fontane and the Via Milano to visit these two churches, whose storied beauties and serendipitous proximity recall the stunning talent of their creators and the enduring connection between them. Each day that the churches are open, visitors can compare the brilliance of both as an appraiser might a pair of mismatched diamonds mounted in the same setting.

But it's impossible not to prefer one church over the other. It doesn't matter if you're a tourist or a scholar, one will touch your soul the way the architect meant it to when he designed it 350 years ago, and the other will leave you with respectful admiration.

This isn't unusual in Rome. It is a city full of churches visited more for their art than for their sanctity. But even though they have been dirtied by city grit and sullied by the inattentions of a profane age, Sant'Andrea and San Carlo are still marveled at, still compared, still judged. These two buildings, together with dozens of others across the city, have given Rome what Rudolf Wittkower describes as "an appearance of festive splendor." If anyone invented the Rome we know today, it is Bernini and Borromini. It was their passion, their vision, which gave us the Rome of extravagant churches of travertine and broad piazzas of granite. The Rome of towering domes that reach toward God and expansive palazzi that declare the power of man. The Rome we remember and the Rome we dream of.

But recognition of such men and their talents does not come without a price. It is human nature to distrust genius. We are suspicious of the exceptional and the brilliant; they unsettle us. Too often we recoil at the extraordinary, alarmed by the originality we see. If we are not prepared for the canvas of a van Gogh or the

poetry of a Blake, we're confused, even angry. It is a rare artist, a rare man, who can produce work that others welcome and that can weather the whimsy of taste and the scrutiny of time. To succeed at such an endeavor, an artist must be equal parts diplomat and sage, someone accustomed to finessing the shortcomings of lesser mortals while staying true to himself and his imagination. He must draw courage from his vision while weighing it against the expediency of compromise that gnaws against every project. For architects in particular, this is crucial: Their art cannot survive in a vacuum. As the architectural historian and critic Sir Nikolaus Pevsner once observed, "For a while a poet and a painter can forget about their age and be great in the solitude of their study and studio; an architect cannot exist in opposition to society."

Gianlorenzo Bernini understood this. Francesco Borromini did not.

The story of these two men, of their exceptional careers and the great rivalry that grew between them, splitting them apart as it grafted them together, is one of ambition and desire, antagonism and hope. It is the contradictory tale of how one artist thrived by embracing the world and how another withered by withdrawing from it. It is the story of their antagonism and of the superb architecture that sprung from it: magnificent churches, chapels, and palaces, buildings that reveal the power of an architect's imagination and that still, nearly four centuries after they were built, have the power to astonish.

LIKE ALL ART, architecture springs from the ability to translate imagination into both physical being and poetic truth.

Gianlorenzo Bernini knew how to accomplish this better than most: His talent was equaled by few and surpassed by still fewer. A man of extraordinary ability, ambition, and charisma, he was sublimely in sync with the rhythms of his time, the seventeenth century. The harmonies he created in architecture, sculpture, and painting—he was master of all three—were at once lively and subtle, energetic and thoughtful, deeply emotional and yet always carefully calculated. He possessed perfect artistic pitch.

The virtuosity he displayed in all of his buildings and sculpture, and the awareness he showed for the emotion and effect they gave rise to in the observer, were so attuned to what Rome and the world wanted at the time that while still in his twenties Bernini became the most celebrated artist in Europe. Rome's taste became his, and his Rome's. He almost always surpassed the expectations of the commissions he took on. But when he failed, he did so spectacularly. His artistic sensibility, coupled with his capacity to charm and to be charming, were nearly flawless—so impeccable that they helped to create a new style, the Baroque, which reflected new ways of thinking about the world and about God.

Bernini was an intuitive artist. He had an almost frightening ability to transform a block of marble or a building site into a piece of uncommon artistry. "Not even the ancients succeeded in making rocks so obedient to their hands that they seemed like pasta," he boasted. Filippo Baldinucci wrote in his *Life of Bernini* published in 1682 that Bernini said of himself that "he devoured marble and never struck a false blow." It's an observation brimming with brisk overconfidence, but it was one that a succession of seventeenth-century popes and princes wholeheartedly agreed with and one that Bernini worked diligently to achieve.

Domenico Bernini, one of Bernini's sons and the author of

his own biography of his father, admits that his father was *"aspro di natura, fisso nelle operazioni, ardente nell'ira"*: stern by nature, steady in his work, passionate in his wrath. It was a sensibility that complemented his physical appearance. Domenico explains that his father had a long, handsome face, a broad, high forehead, and dark hair and eyes, which "could quell an opponent with a look." The early self-portraits of Bernini show such a man, one with perceptive, deep-set eyes and an expressive mouth who seemed poised, even eager, to unleash his ambition.

Perhaps even more remarkable, Bernini's fame actually kept pace with his talent. From papal Rome to the Paris of Louis XIV to the unwelcoming shores of Protestant England, Bernini was known as a master, the *maestro*. He was one of the last of the great artists who made Rome the undisputed artistic center of Europe and was not only proclaimed a genius during his lifetime but also amply rewarded for his efforts, dying a wealthy man.

Francesco Borromini was not so fortunate. Perhaps more of a natural architect than Bernini was, he was the only man in Rome who successfully breached Bernini's artistic supremacy. His approach to architecture was vastly different from Bernini's, and while he worked hard to find a place for his work, he ultimately failed to sustain the favor of Rome's art patrons, the collection of popes, cardinals, papal relatives, and leaders of religious orders that commissioned new buildings. The fault was in Borromini, not his work: He never found a way to adapt himself to the demands of others. His was an unyielding spirit, trapped in an era that demanded obedience. If Bernini had perfect artistic pitch, Borromini was socially tone-deaf. He never understood the value of keeping silent.

Borromini could be suspicious, temperamental, and melancholy;

at times, he was tiresome to be around. He had a hair-trigger sense of honor and an unwillingness to hear criticism about his designs, which made him difficult, even impossible, to work with. Yet his architectural vision was unequivocal, as clear today as it was then.

The antagonism between two such gifted men lasted for decades—nearly all of their professional lives. It evolved slowly, from their early days when they worked together at St. Peter's, the greatest church in Christendom, and deepened as their chances for advancement grew increasingly lopsided.

WHERE DOES SUCH talent come from? What combination of ability, inclination, and environment fuses to produce an artist of the caliber of Bernini and Borromini?

Neither science nor religion offers a clear explanation. But in the early years of both artists there were hints of where each came from and what he might become.

For Gianlorenzo Bernini, the seeds of his talent lie in his family and the city of his birth, and his gifts manifested themselves first in sculpture, then architecture.

He was the eldest son of Pietro Bernini, a sculptor from Sesto Fiorentino, a village north of Florence. Pietro first came to notice as an apprentice in Florence under the now-forgotten sculptor Ridolfo Sirigatti. He eventually moved south to Rome, where he studied painting and sculpture. There he worked under the tutelage of Giuseppe Cesari, the Cavalier d'Arpino, a painter employed by Cardinal Alessandro Farnese.

In 1584 Pietro moved farther south to Naples, which was then ruled by Spain and therefore not under the control of the papacy.

The Spanish viceroy had commissioned the Florentine sculptor Caccini to decorate the church in the massive Carthusian Monastery of San Martino, and Pietro was hired to carve statues and reliefs for it. While living in Naples, Pietro met and married Angelica Galante, a Neapolitan, and on December 7, 1598, Gianlorenzo, named for his grandfather and great-grandfather, was born—"by divine plan," Baldinucci wrote, "this child who, for Italy's good fortune, was to bring illumination to two centuries."

Bernini was born just before the dawn of the seventeenth century, the vibrant, tempestuous era that saw an astonishing outpouring of genius. Rembrandt and Rubens, Descartes and Shakespeare, Galileo and Newton all lived and worked during this age, transforming art and science and how we think of them. It was a period when men of talent and ability were reimagining the world, and it would not be long before Bernini became one of its leading lights—the foremost artist of his age.

Bernini's early years were spent in Naples, which has been called the most beautiful city in the world and the most maddening. Its setting certainly supports the former claim, situated as it is along a dramatic arc of Mediterranean coastline at the base of the San Martino and Capodimonte hills. Its narrow, winding streets hunch up and over the steep hills and narrow valleys of what was known as the ancient city of Neapolis, and its original layout can be glimpsed along the Via dei Tribunali and Via Benedetto Croce, Decumano Superiore, and Via San Biagio dei Librai, Decumano Inferiore.

Neapolitans know what it means to be subjugated by outsiders. The city has a history nearly as long as Rome's, though unlike that of its neighbor to the north, it is a story of defeat and domination. Founded in the fifth century B.C. by Greeks, Neapolis

was first conquered in 327 B.C. by the Romans. The Byzantines came next, followed by the Normans, who combined Naples and the surrounding area with the Kingdom of Sicily. By the thirteenth century, Naples was part of the Holy Roman Empire, and was used offhandedly as a bargaining chip by a succession of kings, emperors, and popes who cared more about consolidating power than ruling the people who lived there.

In 1494 Charles VIII of France invaded Italy and in the next year seized Naples, only to retreat from a coalition counterattack led by Spain, then the most powerful nation in Europe. The political squabbling continued, eventually leading to France ceding Naples and Sicily to Spain in the Treaties of Blois (1504–5). For two centuries Spain ruled the region through a succession of viceroys, one based in Palermo, the other in Naples. Under Spanish rule, the people of southern Italy were taxed heavily, though the nobility and the church were exempt from such treatment. Yet as the church and Spanish and Italian landowners continued to bicker, it only added to the confusion of life there and led to crop failures and widespread famine. Disease flourished almost as robustly as local superstition did. Before long, southern Italy was one of the poorest, most exploited, and most backward areas of Europe.

Naples may not have been the ideal place for even a competent sculptor like Pietro Bernini to work in and live. At the end of the sixteenth century, the city was overcrowded and dirty, on the margins of an empire that a foreign king ruled from thousands of miles away. Rome must have seemed an infinitely more appealing place than Naples: It was the capital of a civilization that had survived for two thousand years and was the center of European art. In addition, the Roman Catholic Church, having

stumbled badly during the Reformation—England, Scotland, Scandinavia, the Netherlands, and parts of Germany had been lost to Protestantism—was regaining worshipers by adopting a kind of robust Christianity to combat those spouting heresy. It began to use art to spread God's and the church's message, becoming the foremost art patron of Europe. Naples, despite being less than 150 miles from Rome, was, by comparison, a relative artistic backwater.

Despite such hindrances, Pietro Bernini was well regarded as a sculptor and found enough work to support his family. He was commissioned to carve a large relief of San Martino and a group of statues known as *Virgin and Child with the Infant St. John,* both for the monastery church of San Martino. In 1600 he carved the satyrs that decorate the Medina Fountain, which at the time of the commission stood outside the residence of the Spanish viceroy, Enrico de Guzmán, near the Arsenale waterfront.

Sometime during the years of 1605 and 1606 Pietro was called to Rome by Pope Paul V. The former Cardinal Camillo Borghese, who had been elected pope in 1605, was determined to restore the city's monuments and churches as a way of reviving Rome as a city worthy of the Church Triumphant.

Though Paul was not known as an aesthete, he was bold and shrewd, and as a city planner he thought in monumental terms. He had no compunction about ordering the tearing down of ancient buildings and co-opting marble and other materials to use in his overhaul of the city. And when he called upon dozens of artists to help him achieve his goals, Pietro was among the sculptors selected. His task was to assist in improving the thousand-year-old Santa Maria Maggiore, the remarkable pilgrim church that sits atop the Esquiline Hill, by working on the Cappella

Paolina, the Pauline Chapel, an elaborate mélange of architecture, sculpture, and painting that celebrates the Virgin as it serves as the Borghese family chapel.

Santa Maria Maggiore is one of Rome's four great patriarchal basilicas, having been built on the site where Pope Liberius witnessed a miracle on August 5 in A.D. 356: The Virgin appeared to him and caused snow to fall on the spot that outlined the plan of the church. Its grand and elegant nave—Henry James called it "singularly perfect"—is as wide as it is tall and is decorated with forty Ionic columns of white Athenian marble and thirty-six extraordinary mosaics from the fifth century that depict scenes from the lives of Abraham, Isaac, Jacob, and Moses. The ornate ceiling by Giuliano da Sangallo—composed of coffered squares arranged in five long rows—is gilded, a gift from Ferdinand and Isabella of Spain, who donated what legend says is some of the first gold brought back from the New World. Countless prayers have been offered and innumerable souls have been unburdened over the fifteen centuries that this church has stood on this spot. It was already one of Rome's glories when Pope Paul V determined that it should also be the site of the Borghese family chapel.

For a decade the church hummed with artistic activity; only St. Peter's employed more artists and artisans. Paul commissioned Pietro on December 30, 1606, to carve a large relief for the chapel depicting the Assumption of the Virgin, the moment when the body of Mary, uncorrupted by death, was taken into heaven. Pietro continued to receive payments for it until 1610. It has been hailed by critics as Pietro's masterpiece; it's certainly his major work in Rome. Using exaggerated perspective and almost painfully contorted figures, Pietro carved what appears to be—to modern eyes, at least—a three-dimensional painting of a perplexed

Mary being escorted to heaven by a disorganized band of harp-wielding seraphim—one of them playing an organ—and several scattered cherubim, who are using their tiny backs to convey her into the clouds. Several apostles gaze up at her with expressions of amazement and concern. It's a portrayal of a miracle captured in stone, caught forever for the faithful. Pietro's treatment of the details in the piece—the curling hair of Saint Peter's beard, the folds of Mary's robes, the delicate flowers that are about to tip off the edge of a tilting table—is confident: Despite the strange-ness of the composition—one of the apostles is actually wearing eyeglasses—there is an assurance to the piece; the artist intended us to see exactly what we do.

Pietro worked on his *Assumption* for four years, and it is tempting to ponder what his eldest son might have learned from its planning and execution, as the relief was certainly in his fa-ther's studio and house during Bernini's formative years from ages eight to twelve. In speculating on what part the youngster may have had in it, Charles Avery, the art historian and expert on Bernini, writes that "the hand of the young Gianlorenzo has been detected in the cherubim bearing the Virgin to Heaven." Given how young Bernini was at the time of the *Assumption*'s carv-ing, it may seem hard to believe, but it is not impossible. There are indications that the young Bernini was already a sculptor—or at least was trying to become one—during this time. Domenico claims that Bernini "at the age of eight, to prove himself . . . made a small marble head of a little angel" (Baldinucci says it was the head of a child). It may be improbable that an eight-year-old boy, no matter how precocious, could have completed a piece in as technically demanding a discipline as sculpture, but there is no question that Bernini grew up immersed in the techniques and

procedures of the art form. Surrounded as he was by the constant drilling and chipping of stone, the carving and smoothing of marble, literally breathing the dust of creation, it is feasible that he could have found a manageable block of marble, perhaps a cast-off stone from a larger commission, and carved a small statue from it.

Bernini was not much older—eleven or twelve—when he carved a life-size bust of Monsignor Giovanni Battista Santoni, an aide to Pope Sixtus V who died in 1592, six years before Bernini was born. He carved the bust from a portrait or death mask to fit into a monument to Santoni that would be hung in Santa Prassede, a small church south of Santa Maria Maggiore.

Even at such a young age, Bernini must have been well enough thought of to be given such a task, and he does not disappoint. He carved a solemn, severe-looking cleric, with a receding line of close-cropped hair and a shaggy beard that shares similarities with the goat's coat on another piece he carved around this time, *The Goat Amalthea Suckling the Infant Jupiter and a Satyr.*

The bust of Santoni has an almost photographic quality to it: Bernini carved the head turned slightly to the viewer's left and leaned it forward out of a tight oval frame. The light falls naturally across the face, giving the impression that the monsignor was about to say something when the artist caught him. Santoni is frowning, his eyebrows pulled together, as if irritated by the interruption or even the questioner himself, and this causes the crow's-feet around his unblinking eyes to appear more pronounced. It is a grave bust, handsome yet off-putting. It is the cautious, correct work of a gifted ten-year-old who is mastering the techniques of sculpture but who has not yet grasped how to communicate his subject's underlying emotions. This is hardly surprising, given how young Bernini was at the time and that he hadn't known Santoni at all.

But as the art historian Tod Marder notes, "Bernini's early portraits must have been valued not only as striking images but also as marvels from the hand of a mere boy"—artistic curiosities from a prodigy in an age that revered portraiture.

As Bernini grew, so did the attention he received. In time, the acclaim heaped upon him reached the ears of Cardinal Scipione Borghese, an aide and favorite nephew of Pope Paul V, who sent for the young sculptor. It proved to be the first stroke of good fortune in a lifetime overflowing with it.

Borghese was always searching for new artists to bring to his uncle's attention, and he had seen the bust of Santoni and wanted to meet the young artist all of Rome was talking about. Borghese was a man of cultivated artistic tastes who had an unsavory reputation for acquiring the art he liked by any means necessary. If he could not buy a painting or a sculpture he wanted, he resorted to other, less civilized methods—no matter who owned it. Late one night in 1608, for example, Raphael's *Deposition from the Cross* disappeared suddenly from the church of San Francesco in Perugia and found its way into Borghese's private collection. And the cardinal had the painter Domenichino imprisoned for several days because the artist was foolish enough—and principled enough—to refuse to sell him his magnificent *Diana*. Borghese greatly admired the painting, but Domenichino had committed the unpardonable sin of promising it to Cardinal Pietro Aldobrandini, one of Borghese's adversaries. It was not long before Borghese made it clear to Domenichino, and to everyone else in Rome, that no one, not even a favored artist, disobeyed the pope's nephew. Borghese got *Diana*, which still hangs in the Villa (now the Galleria) Borghese.

No one could fault the young Bernini or his father if either

felt uneasy about meeting the cardinal, whose influence in the Vatican was as well known as it was feared. But Bernini, Domenico wrote, "carried himself with such a mixture of vivacity and modesty, of submission and alertness, that he captivated the mind of the Cardinal, who immediately wanted to present him to the Pontiff."

When Bernini was brought before the pope and his courtiers, he knelt and kissed the pope's foot and asked for his blessing. Paul "wished to try the courage of the boy by affecting terribleness, and, facing him, he commanded in grave tones that there, in his presence, he should draw a head."

Bernini picked up the pen and smoothed the paper that had been given him. He had just started to draw when he paused, "bowing his head modestly to the Pontiff," Domenico explains.

"What head do you wish?" Bernini asked the stern pope. "A man or a woman? Young or old? . . . And what expression do you wish? Sad or cheerful? Scornful or agreeable?"

The boy's questions surprised and charmed the pontiff. "If this is so," Paul replied, half in jest, "you know how to draw everything." He directed that Bernini draw the head of Saint Paul.

When the sketch was finished in half an hour, and with what Domenico called "a few strokes of the pen and with an admirable boldness of hand," the pope was "lost in wonder, and only said to some of the Cardinals who were there by chance, 'This child will be the Michelangelo of his age.'" It was high praise from the most powerful man in Rome.

(Later in life, when Bernini had been called to Paris by Louis XIV to design an addition to the Louvre, his escort, Paul Fréart de Chantelou, recounted in his diary that "at the age of eight [Bernini] had done a *Head of St. John* which was presented to

Paul V by his chamberlain. His Holiness could not believe that he had done it and asked if he would draw a head in his presence. He agreed and pen and paper were sent for. When he was ready to begin he asked His Holiness what head he wished him to draw. At that the Pope realized that it was really the boy who had done the St. John, for he had believed that he would draw some conventional head. He asked him to draw a head of St. Paul, which he did then and there.")

Paul declared that Bernini was an exceptional artist and that the church must nurture his talents and put them to use. He directed the Vatican to oversee his education and instructed Cardinal Maffeo Barberini to instill "fire and enthusiasm" in the young Bernini for the study of art. The pope then gave Bernini twelve gold coins—as many as the boy could fit in his hands. It was the first gift Bernini ever received from a pope. They held so much meaning for him that he kept the coins until he died, seven decades later. Their symbolic value was more precious to him than their monetary worth.

Cardinal Barberini could not have been a more suitable—or a more important—mentor for Bernini. A powerful and influential papal courtier, he was, like Pietro Bernini, a Florentine. Born in Florence in 1568, Barberini moved to Rome with his mother when he was three years old, shortly after his father's death. He was educated by the Jesuits at the Collegio Romano and was sent to study law at the University of Pisa, receiving his doctor of laws degree in 1589. Clever and capable, Barberini returned to Rome and worked to establish himself in the papal court. In 1604 Pope Clement VIII sent him to France as papal nuncio, where he developed an advantageous rapport with the French king, Henry IV, the politically expedient monarch who renounced his Protestantism

to become king because, he said, "Paris is well worth a mass." In 1606, as an indication of Barberini's accomplishments, Paul V made him a cardinal.

Intellectually curious and attracted to new ideas, Barberini was a friend of Galileo's and published several volumes of his own poetry. He enjoyed art and the artists who created it, and he took an active and sustained interest in fostering Bernini's education. The boy had virtually unlimited access to the Vatican and its peerless art collection: Baldinucci writes that Bernini "spent three continuous years from dawn to the sounding of the *Ave Maria*" studying and copying antique and Hellenistic works and the paintings of Raphael and Michelangelo.

Bernini was particularly interested in mastering *disegno*, the capturing of a piece's psychological moment of highest drama, what the architectural historian Howard Hibbard defines as "the delineation of noble figures in poise and equilibrium." Raphael had used this technique decades before, and Bernini made effective use of it as well, both in his architecture and in his sculpture, untangling many design problems by constant revisions or reimagings of his ideas on paper.

The boy learned quickly, drinking in the great art around him, as if the paintings and sculpture—Roman copies from works by ancient Greek sculptors like Phidias and Praxiteles to those by Michelangelo—had been waiting to pour their secrets into him. He made such swift progress that Barberini once teased Pietro about his son's skill.

"Watch out," the cardinal told Pietro, "he [Bernini] will surpass the master."

Pietro must have come to the bittersweet realization that his great gift was to be the father of an even greater artist. While his

dissatisfaction may have been considerable, he could take pride in his son's exceptional talent, even as it surpassed his own.

Pietro had the wit to reply to Barberini, "It doesn't bother me, for as you know, in that case, the loser wins." It is a father's insight, perhaps born of regret, but tempered by pride.

Still, as an artist, Pietro was not without stature or reputation. When he returned to Rome with his family in 1605, he was elected president of the art association at the Academy of St. Luke. And when his son became a success, he joined his studio.

And it appears that Pietro was an exceptionally able motivator. He understood the importance of instilling in Bernini good work habits. Instead of unalloyed praise, Domenico says, Pietro "expressed both admiration and disparagement" for Bernini's work, "praising the drawings while telling him that he was sure that he could not achieve the same result a second time, as if to say that the perfection of the first efforts was due to a lucky accident, rather than to his son's ability. This was a very clever device as each day [Bernini] attempted to emulate his own virtues, and thus he was in constant competition with himself."

As the light of Borghese patronage shone on him, Bernini attempted more ambitious work, creating some of his first life-size sculptural groups. Though carved when he was young, they are still among his most confident, self-possessed work—remarkable examples of his skill and dexterity. Four of them, *Aeneas and Anchises with the Boy Ascanius* (completed in 1619), *Pluto and Proserpina* (completed in 1622), *Apollo and Daphne* (completed in 1625), and *David* (completed in 1624), were commissioned by Cardinal Sciopine, and three of them are derived from Greek and Roman myths. The first depicts the scene from book two of the *Aeneid* in which Aeneas flees Troy, carrying his elderly father Anchises (who

clutches the family household gods) on his left shoulder as his son Julius Ascanius, carrying the sacred fire of the hearth, the flame of Vesta, struggles to keep up. It's a tall, narrow composition of the three ages of man, and to modern eyes there's an unfinished quality to all three faces, as if the sculptor wasn't confident enough to render each more precisely. Some experts have even argued that this was mostly the work of Pietro: The painter Joachim von Sandrart attributed the piece to Pietro alone in a book he published in 1675.

More successful is *Pluto and Proserpina*. In this vivid, energetic piece, Bernini portrays the moment when Pluto, the god of the underworld, secures Proserpina (also known as Persephone), the beautiful daughter of Demeter, as his wife and carries her back with him to Hades. Pluto's massive hands and thick, greedy fingers dig into the soft flesh of Proserpina's thigh and back as she struggles to escape, pushing ineffectively against the left side of his broad face. She looks terrified—bewildered and desperate— as she tries to break free from his embrace. Every muscle in her is strained, even down to her flexed left big toe. But while it's clear what is about to happen—Proserpina is moments away from being raped—it is equally apparent that her resistance is in vain. In fact, Pluto actually seems to be enjoying her struggle: He is amused by her fear and her hysteria, perhaps seeing them perversely as a kind of foreplay before she submits to him. Behind the struggling figures, grinning in triplicate, is Cerberus, the three-headed hound that guards the entrance to the underworld, a silent witness to this disturbing but compelling depiction of passion and terror.

These two emotions are also explored in Bernini's *Apollo and Daphne*, though more subtly. As a piece of sculpture it's a virtuoso

performance, displaying as much ingenuity as any sculpture of his time—so much so that before Bernini carved it, the tale (from Ovid's *Metamorphoses*) was thought to be suited only for canvas; marble wasn't nearly pliable enough a material to display the requisite nuance and delicacy the story demanded. Bernini proved that assumption wrong.

The story illustrates the tragic inequality of desire. The mischievous Cupid induces the unsuspecting god Apollo—through what Ovid called "savage spite"—to fall hopelessly in love with Daphne, a young nymph of exceptional beauty, while at the same time causing Daphne to detest him. Apollo's desire for Daphne becomes as all-consuming as her aversion is to him. While he pursues her fiercely through the woods, wearing nothing but a swirling cloak, the beautiful and unclothed nymph struggles to keep free of his grasp. Desperate and near exhaustion, and as she feels Apollo gaining on her—literally breathing down her neck—Daphne pleads to her father, the river god Peneus, to save her. "Change and destroy this body which has been too much delight," she pleads.

Her appeal is heard and granted. Just as Apollo catches the despairing Daphne, his left hand reaching triumphantly from behind to touch her waist, the nymph is transformed into a laurel tree. In an instant, Apollo's exultation turns to despair as he feels the nymph he has caught slip from him. According to Ovid's version, Apollo can still feel Daphne's beating heart as her fingers become leaves, her legs the trunk and bark, her toes the roots.

By portraying the story's decisive moment—of the eternal struggle between conquest and loss, possession and independence, lust and chastity—Bernini captures a wealth of human experience. He shows what it feels like to be young, to exult in the

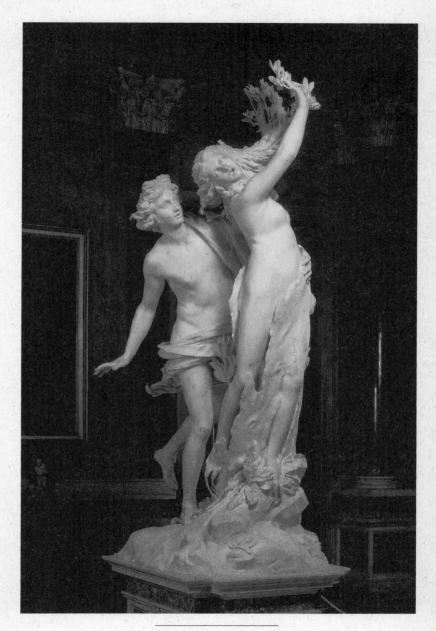

APOLLO AND DAPHNE

chase, and to ache with longing for another. At once physically powerful and psychologically subtle, *Apollo and Daphne* is also a technical wonder, a virtuoso performance in marble. Bernini renders the smooth, polished bodies of Apollo and Daphne with great sympathy and tenderness; he communicates an almost palpable appreciation for their beauty. From the delicate spit curls along Apollo's jaw to Daphne's outstretched fingers that transform into fragile leaves, Bernini masters the cold and unforgiving stone, imposing on it a range of emotions that are deeply human. It is a giant leap forward from his father's accomplishments; by comparison, Pietro's *Assumption* appears trifling and lackluster.

When *Apollo and Daphne* was complete, it surpassed the work of any other artist in Rome in its dynamic realism. Bernini had managed to fashion marble into flesh and bone. The two figures give the impression, according to one critic, "of having been modeled, as though by the adding of wax or clay, rather than the subtracting or chipping away of stone." So revolutionary was Bernini's work, Baldinucci wrote, "only the eye and not the ear can form an adequate impression" of the drama Bernini caught.

One drama that attempted to take attention away from the sculpture was whether Bernini was willing to share the praise being heaped upon him. According to the art historian Jennifer Montagu, while Bernini was responsible for the concept and execution of much of the piece, the "metamorphosis of the block of marble into delicate roots and twigs, and into floating tresses, was largely the work of Giuliano Finelli," a sculptor from Carrara: "Bernini, perhaps because he was jealous of Finelli's obvious talents, or because he was wary of his prickly personality, held him back from the advancement he had promised." Montagu notes that this is the first time a talented artist left Bernini's employment

"revolting against the menial position to which his talents had been confined." It would not be the last.

There were other concerns about *Apollo and Daphne* that went beyond dividing the credit. Some worried that such a depiction of pagan—and provocative—myth had no place in the art collection of a cardinal. Chantelou reported that François d'Escoubleau, Cardinal de Sourdis, was so disturbed by the piece that he told Borghese that he would not allow it in his house: "The figure of a lovely naked girl might disturb those who saw it." To prevent such criticism, a couplet written in Latin by Borghese's friend Cardinal Maffeo Barberini, later Pope Urban VIII, was carved into the statue's base:

> *Quisquis amans sequitur fugitivae gaudia formae,*
> *Fronde manus implet, baccas seu carpit amaras.*

> *The lover who would fleeting beauty clasp*
> *plucks bitter fruit; dry leaves are all he'll grasp.*

Cardinal Borghese had no such difficulty with Bernini's *David*, as its subject sprung from the Bible, not from mythology. Unlike Michelangelo's famous sculpture of David, which stands aloof and dignified and became a symbol of Florence, Bernini's *David* is a study of the power of the human spirit and an object lesson in how art can involve the viewer. This is a young David preparing to hurl the fatal shot. His body is tense, ready. His face handsome but ordinary, his brow furrowed in concentration, his lips pressed together tightly, and his hair disheveled. (The story has circulated among Bernini's early biographers, including Baldinucci, that the head of this *David* is a self-portrait, and that Cardinal Maffeo

Barberini held a mirror so that Bernini could model his own head.)

In his left hand, David holds a stone taut in its sling. He is poised to step into battle with Goliath, into his fate, into history. Unlike the proud, masculine nakedness of Michelangelo's *David* or even the leisurely nudity of Donatello's *David*, Bernini's version of David is draped. There is nothing noble or renowned here; this is a young man of humble birth called upon to perform a miracle. No one knows if he is up to the challenge, least of all David himself. And yet he doesn't wear the cuirass, the traditional warrior breastplate, which Saul had lent him (and which stands conveniently upright at the rear of the sculpture for Bernini to use as support for his figure).

But David's lack of armor is beside the point. His purpose is clear; his aim will be—must be—true. The viewer's eye is drawn to David and the intensity of his vision, both literally and metaphorically.

What Bernini has done, which few other artists at the time had attempted, is to *involve* the observer in the event. Bernini's David gazes behind and beyond the viewer, to a Goliath in the distance. The space between the art and the observer has been psychically charged; the observer is in the middle of the battle. Even the toes on David's right foot—bare and dirty, the foot of a shepherd, not a hero king—curve over the statue's base, as if to signal that a wall has been breached.

The brilliance of the piece isn't enough to quell questions about the statue's stance. Richard Norton, an early-twentieth-century art historian, posited that while *David* is based on the pose of the famous Greek sculpture known as the *Borghese Warrior*, it would rival the greatest of ancient Greek sculpture "had Bernini

not made one mistake. The figure is turned to the wrong side. As he stands, the right arm drawn back, the left hand holding the stone in the sling in front of the body, the sling must fall loose and dead, the body must again be flung forward and the right arm swung upwards before the youth can get the momentum to hurl the stone at his enemy. Had Bernini turned the figure the other way with the left hand behind and the right in front of the body, this sense of ineffectiveness in the pose would not have existed, and the whole body would have been tensely set at the moment of rest between the action of drawing back for the aim and the instantaneously following motion of the cast."

Bernini's *David* is a very different kind of sculpture from those carved by Michelangelo and Donatello. We aren't meant just to admire Bernini's work; we *encounter* it. We are brought into its sphere, forcing us to confront the feelings it prompts.

It is this talent for engaging the observer, for drawing people into the work—be it the sculptures of the Villa Borghese or the Baldacchino at St. Peter's—that made Bernini as famous an architect in his day as he was a sculptor. Though he did not set out to become a master builder, when he was prevailed upon to turn his talents to architecture, he approached each commission with imagination and diligence. As he had been known to quote, *Nihil est melius quam vita diligentissima* (There is nothing better than a very diligent life). And just as he did with a block of marble, he searched for—and eventually found—the sublime in the possibilities before him. Bernini the architect consumed space, devouring it in ways that dazzled. And as with his own sculpture, he almost never struck a false blow.

When he did—when he miscalculated—the failure was spectacular, and its effects were far-reaching, reverberating across the building sites of Rome and echoing through the corridors of the

Vatican. Such a misstep is often also an opportunity, and no one understood this more profoundly than the only other man in Rome who could lay claim to being its preeminent architect: Francesco Borromini.

THE MAN WHO became known as Francesco Borromini was born in Lombardy on September 25, 1599, on Lake Lugano in Ticino, the southernmost canton of Switzerland that is part of what the art historian and Borromini scholar Joseph Connors calls "the jagged and illogical boundary" that divides Italy and Switzerland. He was the son of Giovanni Domenico Castelli Brumino, a master stonemason who probably worked for the influential Visconti family, and Anastasia Garovo (whose name over the years was also spelled Garvo, Garvi, Garogo, and Garuo), whose family was related to Domenico Fontana and Carlo Maderno, two of the great Late Renaissance architects who had moved to Rome and who helped design and build St. Peter's.

Borromini was born in the village of Bissone, which sits on a small furrow of land on the southeastern shore of Lake Lugano. It was one of a loose string of small settlements that dot the area, which at the time of Borromini's birth had been under Swiss domination for more than fifty years.

Bissone has never been a destination that visitors have flocked to in droves; the village's beauty is not as polished as that of others along the canton's lakes, being less pleasingly situated than Bellagio on Lake Como or even the town of Lugano, which sits along the northern shore of Lake Lugano, smug and well turned out like a plump, complacent countess. Its alleyways, called *contrade*, and vaulted stone promenade along the town's main street,

which roughly parallels the lakeshore, are attractive but not worth a special visit. In fact, the village provokes a certain tension, even anxiety, in a visitor. This is partly due to its narrow layout—barely two streets wide—and its cramped location along the coastline. But it is really the mountains that disconcert. They tower over the town, sheer, heaving walls of stone softened only slightly by the cypress and palm trees that grow on them. Their damp, omnipresent shadows besiege Bissone like silent warriors. The place feels occupied; it is a stronghold, not a sanctuary.

This is the world in which Borromini spent the first years of his life, living on a contradictory landscape, at once stark and lush, among the proud, skillful masons and stonecutters who for generations supplied central and southern Europe with the talented artisans who built and carved the great churches and imposing palaces that still stand today, from Palermo to Vienna, Prague to Istanbul.

In 1609, when he was ten years old, Borromini was sent to Milan by his father to apprentice with Andrea Biffi, a sculptor who carved many of the reliefs that decorate the elaborate choir screen and the monument to San Carlo Borromeo in Milan's Gothic-influenced cathedral, the Duomo. (Some believe that Borromini changed his name from Castelli because of his devotion to, and pride in, a fellow Lombard, Archbishop Carlo Borromeo of Milan, who would be canonized in 1610.)

When Borromini arrived in Milan, the city appeared to be one large building site. In addition to the continuing construction on the Duomo, the Basilica of San Lorenzo Maggiore, an early Christian church, was being rebuilt, after having collapsed in 1573. Called the Pantheon of Northern Italy, San Lorenzo was, at the time of its construction in the fourth century A.D., the

largest centrally planned building in Europe. Built on an octago-
nal plan, the church drew inspiration from several architectural
styles, from Byzantine to Romanesque, and it had an ambulatory,
or arcade, that surrounded the church's central space. The re-
building of the octagon-shaped church was given to the architect
Martino Bassi, and his interior arrangement of the church shows
a subtle architectural ballet: Four columns are arranged as shal-
low concavities on each side of the main sides, while flatter but
nonetheless slightly concave diagonal walls connect them. The ef-
fect is of a restrained but distinct undulation to the central space,
and it calls to mind Borromini's first and perhaps greatest com-
mission, the church of San Carlo alle Quattro Fontane in Rome.

Construction on San Lorenzo proceeded until 1589, when
Bassi's designs were publicly criticized by Monsignor Guido
Mazenta, the *prefetto della fabbrica* who oversaw the church's re-
building, and Tolomeo Rinaldi, a rival architect. They argued that
Bassi was turning the sturdy church into a Gothic building, mak-
ing it too delicate and too unconventional.

It was a characteristic criticism for a conservative architect to
level against a building and an architect who wanted to break
with tradition. Yet Bassi used a clever tactic to defend himself. To
justify his ideas, he called upon the rules of nature, "maestra di
tutte le cose," the mistress of all things, which classical architec-
ture used as its foundation. Nature, Bassi argued, assembles "struc-
tures that are durable even though they seem to stand on nothing,
like the branches on a tree or the nose on a face."

Bassi's persuasiveness eventually won the day, and during
the era that Borromini was in Milan, San Lorenzo was rebuilt to
his designs. While it was being completed, Borromini attended the
school for children of the master stonemasons affiliated with the

Duomo. While there, he most certainly heard the endless debates that swirled around concerning San Lorenzo and the discussions that dissected two architectural traditions: the Lombard, which was influenced by the Northern Gothic; and the Roman, which reached back to ancient Rome. These differing cultures and customs, these two strands of artistic DNA, combined in Borromini.

Before he became an architect, Borromini was a decorative sculptor, an *intagliatore*. It was Biffi who trained Borromini, and it was a skill the young man used to support himself when, in 1619, without telling his parents, he left Milan using money he had collected on a debt owed to his father and traveled south with friends to Rome.

Filippo Baldinucci, in his account of Borromini's life, which he wrote late in the seventeenth century, doesn't explain what prompted the young Lombard to travel south except to note that by age sixteen Borromini "was already so enamored not only of that trade [stone carving and masonry] but of everything having to do with design and drawing, that, seized by the desire to see and study the stupendous antiquities of Rome, he resolved to go there. Thus, together with some other young men of his own age, and perhaps also of his profession, he undertook the trip at that time, without, however, saying a word to his parents. Rather—if indeed what has been recounted to us by someone in his confidence is true—he went and found a man, in the same city of Milan, who owed his father a certain sum of money, due in fixed payments, and in his [father's] name received the payment in full up to that date, and with this allotment he departed."

The young man stayed in Rome with Leone Garovo, a relative of his mother's who lived on the Vicolo dell' Angello (Nolli 542)

between the Ponte Sant'Angelo and San Giovanni dei Fiorentini. This proved lucky for Borromini. Garovo's father-in-law was Carlo Maderno, then one of the most prominent artists and architects in Rome and since 1612 the architect of St. Peter's. It was inevitable that the young Borromini would come to the attention of the *maestro.*

Borromini began his career in Rome working for Maderno at St. Peter's as a decorative sculptor. During his early years at the basilica, Borromini carved coats of arms, putti (young angels), and balustrades for various spots in the colossal basilica. After a while, Maderno began to allow his young relative to try his hand at designing some of the myriad details that fell under Maderno's supervision as architect of St. Peter's. By the time Maderno died in 1629, Borromini was one of the ablest draftsmen in Rome, having worked on the Porta Santa, the Holy Door, which is opened only at the command of the pope (usually once every twenty-five years), several angels around the doors at St. Peter's—*"spiritosi e vivaci"*—and the oval base for Michelangelo's *Pietà.* Maderno also allowed Borromini to design some of the wrought iron that decorates St. Peter's and to come up with designs for projects at other churches the master was working on concurrent with St. Peter's, including San Andrea della Valle on the Piazza Vidoni, at which Maderno let Borromini design the lantern for its dome, the second largest in Rome after St. Peter's.

Maderno's guidance was both benevolent and instructive, and under such supervision, Borromini thrived. As Maderno aged and his hands grew crippled with gout, the older man relied increasingly on Borromini's emerging skills as a draftsman and on his imaginative suggestions. His respect for Borromini's abilities grew so deep that he put the young stonecutter in charge of overseeing

all of the designs and planning that came from Maderno's office. (Some of the designs for details of St. Peter's are in Borromini's hand.)

By virtue of his talent and hard work, Borromini had become, in the few short years following his hasty flight from Milan, Maderno's favored assistant.

Still, after Maderno's death, it was a surprise to no one but Borromini that he was overlooked by the pope for the post prized above all others, that of *architetto della fabbrica di San Pietro*. Borromini was certain to have felt cheated and convinced that he deserved the position. He had worked so long and so well for Maderno, and only he knew the details of St. Peter's, its possibilities and its limitations. Such an important post should not be given to an upstart sculptor whose knowledge of architecture was negligible. It should go to a man who knew both architecture and engineering. Such a plum should not be given to the Neapolitan Bernini.

But it was.

Yet to the surprise of many, Borromini was persuaded to join Bernini's workshop, working under his contemporary as his assistant. The reasons they joined forces, like the men themselves, were mysterious and complicated, and the partnership was destined to fail. One thing is certain: It's likely that Borromini didn't consult Giuliano Finelli before accepting the job.

THREE

The Perpetual and the Beautiful

⊰⧯⊱

THE EARLY DAYS OF BERNINI'S AND BORRO-
mini's association were dominated not by what
they thought of each other but by the forces that
threw them together in the first place. Those were
nothing less than the ambitions of one pope and
his vision for two of Rome's monumental build-
ings, St. Peter's Basilica and the Palazzo Barberini.

For more than two centuries, the hulking
form of the new St. Peter's grew stone by stone.
As it did, it loomed over Rome like a Gulliver
of marble, pinned to the ground by miles of
scaffolding and ropes, worried over by hun-
dreds of laborers who struggled to create a suit-
able temple to the Almighty.

Construction on the new St. Peter's had be-
gun almost a century before Bernini and Borro-
mini were born, in 1506, and work continued on
it for the next 150 years. It commanded the atten-
tion of a dozen popes and a parade of talented

architects, painters, and sculptors from all over Italy. Artists of the caliber of Bramante, Raphael, and Michelangelo all had a hand in the church that stands on the spot Peter is said to have been buried around A.D. 64, though the historical records are irritatingly inexact on this detail.

St. Peter's is a church of superlatives. It is more than 186 meters (610 feet) long and 58 meters (190 feet) wide across the aisles and nave. Its dome is 136 meters (446 feet) from its base to the top of the cross, and arranged under it throughout the church are 44 altars, 778 columns, 395 statues, and 135 mosaic panels. While it seems to have dominated Rome forever, as everlasting as the life in heaven it promises the faithful, St. Peter's is, by the standards of the Roman church, relatively new, being only five hundred years old—a young home for a religion founded two millennia ago. And it is not the first church to occupy the site. The original was a T-shaped building begun around A.D. 315 by Constantine, the first Christian Roman emperor, at the request of Pope Sylvester I.

The legend or miracle surrounding the first building's genesis begins with the vision Constantine saw on his way to battle against his rival Maxentius. As he rode toward what became known as the Battle of Milvian Bridge, Constantine saw a cross in the sky with the words *in hoc signo vinces* above it: under this sign you shall conquer. Constantine triumphed in battle, and he converted to the upstart faith of Christianity. In thanksgiving, he founded a basilica over the tomb of Saint Peter.

Despite the imperial imprimatur, the site for St. Peter's was hardly the most desirable in Rome, at least by the standards of the time. The basilica was built on the Ager Vaticanus, the marshy plain between the Tiber and the Vatican hill across the river and northwest from the city proper. The area was meagerly

settled, with a few minor wharves along its riverside and small kilns and modest farms inland. It was a less than promising region for development because the mercurial Tiber often overran its banks.

At the time of the church's construction this was suburban Rome, insignificant and inauspicious, though the wealthy owned a handful of houses and gardens that lent the neighborhood a certain low-key cachet. Agrippina, the mother of the legendarily debauched emperor Caligula, had built a villa and garden nearby, and the whole countryside was traversed by roads lined with an impressive string of tombs. This area was already accustomed to death because its chief attraction during the pagan days of Imperial Rome was the Circus of Caligula and Nero, the nearly oval-shaped stadium south of the current St. Peter's where countless Christians were killed—crucified and burned for the enjoyment of those Romans amused by such spectacle.

These bloodthirsty diversions demanded brisk, efficient removal of the bodies and a convenient place to bury them—the ancient Romans were nothing if not well organized—and it was not long before a necropolis, or burial place, was established north of the circus. It was there, the legends tell, that the body of Peter, the simple fisherman called by Jesus to spread the word of God, was brought to a tomb west of the great round, squat mausoleum of Hadrian (now the Castel Sant'Angelo), after having been crucified near what is now the church of San Pietro in Montorio.

Soon after Peter's burial, the faithful and the curious began to visit the site to pay homage to the Prince of the Apostles. Nearly two centuries after Peter's death, after he formally recognized the religion in A.D. 313 with the Edict of Milan, the now-Christian emperor Constantine directed that a church be erected over Peter's

tomb and that a road be laid from Rome to it via the Pons Aelius, the Roman bridge that spanned the Tiber (which eventually was replaced by the Ponte Sant'Angelo).

The original basilica was a typical early Christian church, and at 118 meters long and 64 meters wide (about 400 feet long and 200 feet wide), it was roughly half the size of the current church. A tall, rectangular central nave that looked much like those of other Roman public buildings was lined on both of its sides by two lower-ceilinged aisles, which were separated by marble columns, twenty-two in each row, connected by stone arches. Peter's tomb was placed in the center of the choir at the far end of the church, just beyond the altar, so that the faithful could see it. The church was decorated with impressively elaborate mosaics and frescoes, and it was lighted by nearly a hundred oil lamps; in the eighth century, Pope Gregory II had several dozen olive yards planted nearby to keep the Vatican supplied.

The church faced east, and outside its entrance was a broad stone staircase that led from the road to a square arcaded courtyard. Near the courtyard's center, under an elaborate baldachino, or canopy, stood an immense bronze pinecone, the *Pigna*. Originally the *Pigna* had been a fountain in the Campus Martius near the Pantheon, and was probably moved to the atrium outside the old St. Peter's in the eighth century. (It now holds pride of place in an enormous three-story niche at the Belvedere Courtyard at the Vatican Museums.) Beyond the *Pigna*, closer to the main door of the church, was a fountain, which acted as a kind of spiritual barricade: No unbaptized person—that is, no non-Christian—was allowed beyond it. It marked the line between the secular and sacred worlds.

Such rules of separation in the early church were not uncommon. Indeed, for the first fourteen hundred years that the Catholic

Church existed, clear distinctions remained between the church of San Giovanni in Laterano, the official seat of the pope as the bishop of Rome, and the basilica of St. Peter. Where San Giovanni was the pope's official residence and church, St. Peter's was its ceremonial center. This distinction was maintained throughout the Middle Ages, notes Jonathan Boardman, the author and Anglican chaplain of All Saints Church in Rome, "with St. Peter's preserving its close connection with royalty and fostering the concept of Christian kingship. Thus it was on the steps of St. Peter's, not at the Lateran, that Charlemagne was proclaimed Holy Roman Emperor" on Christmas Day A.D. 800. St. Peter's, Boardman writes, "was primarily an imperial shrine under papal protection."

Over the years, as Peter's tomb and the church that memorialized it attracted a growing number of visitors, additional houses and hospices—early inns—were built along the road from Rome to lodge and feed them, including the Scholae Francorum, Frisonorum, Saxonum, and Langobardorum. Monasteries also began to settle in the area. Charlemagne himself had an imperial palace built during his second visit to Rome in 781, almost twenty years before he was crowned emperor.

Even though the papacy's spiritual home remained on the other side of the Tiber at the Lateran and the land around St. Peter's was discouragingly boggy—with underground springs that a millennium later would make the area the cause of a provocative and public clash between Bernini and Borromini—the papacy found it increasingly difficult to ignore the growing numbers of pilgrims who made their way to Peter's shrine. Constantine's basilica of St. Peter's grew in splendor and repute, with its impressive mosaics, precious metalwork, and other art treasures making it a

shrine nearly equal to Rome's other patriarchal basilicas. It had, in short, become a tourist attraction.

Pope Symmachus (498–514) was the first pontiff to build a residence at the Vatican, having been forced to abandon the Lateran Palace during the barely remembered Laurentian Schism in 501–506. He began the trend of adding papal accommodations around St. Peter's, thus ensuring the eventual and perhaps inevitable move from San Giovanni to St. Peter's. By the middle of the fifteenth century, the Vatican became the pope's principal residence.

Though the pope's residence changed, St. Peter's did not—at least not for its first thousand years. As with much in the Catholic Church, it took a crisis, the Avignon Exile, to bring about action.

During the fourteenth century, the kings of France exerted considerable influence on papal and church affairs, so much so that in March 1309 the papacy moved from Rome to Avignon. When the popes finally returned to Rome almost seventy years later in 1377, St. Peter's had fallen into great decline. It wasn't until after the Western Schism (1378–1417) had been resolved, that Pope Nicholas V (1447–1455) determined that St. Peter's was unsalvageable and had to be rebuilt. In 1451 he selected the architect Bernardo Rossellino to draw up plans for a new choir for St. Peter's, which was to be constructed beyond the western wall of the church as it then existed. Nicholas clearly had plans to enlarge the church, not just rebuild it. But when he died in 1455, and with the Turks advancing west, new priorities took hold and the new choir was suspended—though the choir walls were already 1.5 meters (about 5 feet) high. Not until the early sixteenth century, when it became imperative that something be done before the church collapsed, did a new pope focus attention on the problem.

In 1505 Pope Julius II, one of the most influential popes of the Renaissance, made the daring—and controversial—decision to scrap the old St. Peter's completely and build a brand-new basilica. The reasons were as much pragmatic as spiritual. In addition to the church being unsalvageable in its present condition, the artist and historian Giorgio Vasari noted that Julius—the former Cardinal Giuliano della Rovere, a man not known for his modesty—wanted a St. Peter's that could house the massive and magnificent tomb that Michelangelo, the greatest sculptor of his age, was carving for him. The pope commissioned Donato Bramante, a painter-turned-architect who was one of the period's most gifted artists, to draw up plans for it.

Bramante was the man for the task. A talented architect and engineer who was sympathetic to his time's humanistic leanings and the renewed interest in classical culture, he inserted illusionistic features more typical of painting and stagecraft into his architecture. For the new St. Peter's, Bramante said, he wanted "to perch the Pantheon on top of Constantine's basilica." It was a radical idea to alter the tradition-bound longitudinal church of the old St. Peter's so drastically. No doubt he was inspired by Leon Battista Alberti's seminal treatise, *On the Art of Building*, published in 1452, which argued that the layout of a church should symbolize "the heavenly Jerusalem" and be designed according to rational mathematical rules and geometric forms. Following such principles, Bramante selected as the central form for St. Peter's a Greek cross, a square X shape composed of four wide aisles, each beginning as a semicircle (though rectangular on the church's exterior), all leading toward a huge cylindrical space at the center of the church that would be crowned by a dramatic central dome. Four smaller but still impressive chapels, also

planned as Greek crosses, were to be placed in each corner of the church and covered by lower domes; tall towers would be built at each corner of the immense, cubelike edifice. With its campanili and assortment of domes, the church's plan had an exotic, almost Byzantine look to it: a Hagia Sophia for the Western church.

Bramante's plan on paper looks like a piece of finely stitched needlework, with the four monumental central piers anchoring the delicate-looking threads of columns that connected the main church to its chapels. It was an inventive blend of bulk and delicacy, darkness and shadow, and it represented a new way of thinking. The Renaissance had been invited into the Vatican.

Bramante imbued his design with symbolism that he borrowed from the ancients and their traditions. The entire building represented the world, the four broad arms the four compass points and the towering dome the human reach for heaven. It was an apt metaphor for a Renaissance church, combining as it did the purity of reason, the beauty of geometry, and the mystery of faith.

Work on the new church began in 1506—the same year that another long-standing Vatican institution, the Swiss Guard, was founded—with a special ceremony on April 18 that found Julius himself laying the foundation stone for the first pylon, the northwest cornerstone of the central pier that housed the relics of Saint Helena. (The foundations for the other three pylons were laid the next year.) To oversee its building, Julius created the office of the Fabbrica di San Pietro, and in 1523 Clement VII selected a committee of sixty men to the Congregazione della Reverenda Fabbrica to oversee the church's construction and administration.

Even as Julius was solemnly setting the first stone into the ground, there were those who felt that the Constantinian-era basilica should have been preserved as a physical connection to

the early Christian church. Others objected to what they saw as Bramante's cavalier dismantling of parts of the old St. Peter's that they thought could have been—and should have been—incorporated into the new building. Because of his seeming lack of concern for the old St. Peter's, Bramante earned the nickname of Bramante Ruinante—Bramante the Destroyer—an epithet that clung to him for the rest of his life.

By the time Bramante died in 1514, a year after Julius, the four central piers and the arches between them to support the dome had been completed. But it was several years before work on St. Peter's proceeded much beyond that. Future popes had their own ideas for how the new church should look, and they employed other architects whose tastes and visions differed from Bramante's. Over the next four decades, various artists and popes joined in on what seemed an interminable debate about the new St. Peter's. In fact, Rome became so used to the unfinished—and perhaps to some unfinishable—church that Raphael, even during Julius's pontificate, used the domeless center of St. Peter's as the background for his magnificent fresco *School of Athens*, which he painted in 1510–11 for one of the pope's rooms at the Vatican.

With the church's four central piers in position, like unchanging sentries of stone, the church's location was determined. But what form would the completed church take? Would it have a centralized plan, like a Greek cross, as Bramante had planned? Or would it be a longitudinal one, like a Latin cross, as Constantine's original church had been?

Most Renaissance architects favored a central plan. It fit the times, blending in one supple design the logic of the ancients with the innate theatricality of the Mass and other papal celebrations. It also offered a new—and to some a welcome—antidote

to the Gothic tradition, which had held sway in northern and western Europe for two centuries. Though the Gothic's influence had never been felt significantly in Rome, its tendrils had reached into Milan: The Gothic-tinged Duomo that was being built sparked disdain in Rome. Gothic architecture was based on geometry and mathematics, not on the proportions of man, as classical architecture was and which Renaissance architects preferred.

Still, the central plan for St. Peter's was not a unanimous choice. Other architects favored a longitudinal plan, believing that the new church should more closely approximate the old St. Peter's and that a longer church would serve as a dramatic setting for processions. Over the next fifty years, such favored papal artists as Raphael (in 1514) and Baldassare Peruzzi (in 1520) provided designs. Raphael submitted to Pope Leo X a design that was in the shape of a Latin cross; after Raphael's death in 1520, Peruzzi took over and reverted to the Greek cross. In 1538, under Pope Paul III, Antonio Sangallo the Younger submitted another version of the Latin-cross plan, even going so far as to construct an enormous wooden model of his design (736 centimeters [24 feet] long, 602 centimeters [19.5 feet] wide, and 468 centimeters [15 feet] high), which still exists in the Vatican. But when Sangallo died in 1546, Paul appointed the aged Michelangelo, the unrivaled *maestro* of an exceptional artistic age, to finish the church.

In his early seventies and infirm, Michelangelo, who considered himself first a sculptor, returned to papal service solely to complete St. Peter's. Like the ceiling of the Sistine Chapel, it was an assignment worthy of a genius, but it was a commission for which Michelangelo would accept no payment.

Michelangelo returned to Bramante's design, adopting once again the Greek cross, but he simplified his predecessor's layout, creating a more organic flow that tied the corner chapels more closely to the larger church. He designed a façade based on the Pantheon, the most complete ancient structure in Rome, using two rows of massive columns, and he reimagined the dome. As a Florentine, Michelangelo knew the dramatic silhouette of the church of Santa Maria del Fiore—Brunelleschi's dome—and understood what a profound impact such a silhouette can have on a city's skyline. To Michelangelo, previous proposals for the dome on St. Peter's weren't grand or ambitious enough. So he razed what had been built of the dome and revised it. His vision was taller, stronger, more vigorous, reaching toward heaven with a confidence and a fervor that Bramante's proposed dome did not have: Michelangelo seemed to believe his work could touch God, and that it was man's right to try. He also strengthened the church's central piers and its outer walls so that they could carry the building's massive weight, and he reduced the inner walls to allow in more light, giving the immense interior a lighter feel and a greater sense of space.

By the time of Michelangelo's death in 1564 a few weeks before his eighty-ninth birthday, only the dome's drum had been completed. But such was Michelangelo's reputation that the architects who finished the dome—first Pirro Ligorio, then Jacopo Barozzi, known as il Vignola, and Giacomo della Porta, assisted by Domenico Fontana—completed it in large part as Michelangelo had envisioned it (though with a steeper profile), making it as personal and as passionate a piece of sculpture as he ever devised. (Though the dome was considered finished in 1590, it wasn't until December 12, 1614, that its last stone was put into place,

prompting church bells to be rung around the city and cannons to be fired in celebratory salute from Castel Sant'Angelo.)

Michelangelo's profoundly personal artistic vision had once provoked critics to call him *l'inventore delle porcherie,* an inventor of obscenities, but Giorgio Vasari's observation of another of Michelangelo's architectural commissions, the Medici family chapel at San Lorenzo in Florence (which Vasari had worked on as a pupil of Michelangelo's, beginning in 1525), holds true of St. Peter's: "He made it very different from the work regulated by measure, order, and rule, which other men did according to normal usage and following Vitruvius and the antiquities, to which he would not conform. . . . Therefore the craftsmen owed him an infinite and everlasting obligation, because he broke the bonds and chains of usage they had always followed." Even more important to future artists like Bernini and Borromini, Michelangelo demonstrated a personal approach to architecture, prompting Vasari to write that "he departed so much from the common use of others, that everyone was amazed."

But Michelangelo did not have his way over all aspects of the new St. Peter's. His revised Greek-cross plan languished after his death, and it was nearly half a century before the form of the basilica was actually decided. By then Paul V, the former Cardinal Camillo Borghese, was pope.

When Paul was elected pontiff in 1605, the dome had been considered complete for a dozen years. Much of the old St. Peter's was still standing beneath it, though barely, including the now hopelessly out-of-fashion atrium at the front of the church. When a portion of the old church actually fell during a service on September 17, 1605, the original basilica literally crumbling before the eyes of the church fathers, the Congregazione della

Reverenda Fabbrica declared that the remainder of the old church should be knocked down. It had become a public—and papal—safety hazard.

Paul V showed little public regret at demolishing what remained of the old St. Peter's, but he exhibited considerable sympathy for the church's contents. He directed the cardinals to oversee the removal and preservation of the basilica's considerable number of ancient relics, tombs, and works of art. A venerated medieval wooden crucifix and a picture of the Madonna painted on one of the columns of the old basilica (which was purported to work miracles) were taken from the old St. Peter's and stored until they could be returned. And the human remains of the pontiffs and saints interred in the church over the centuries were moved with considerable pomp. New burial places were found for Saint Gregory the Great, Saint Petronilla, Saint Boniface IV, and Saint Leo the Great.

This was a relatively swift process, for several months before, in October 1605, the demolition of the nave and the tearing down of Michelangelo's still incomplete façade had begun, under the supervision of Carlo Maderno, Paul V's handpicked successor to Giacomo della Porta. Though not as famous as some of the men who held the post, Maderno nevertheless filled the position of architect of St. Peter's ably. He was the last of the great Renaissance artist-engineers. Though talented in his own right—he designed the beautiful and carefully proportioned façade of Santa Susanna—he didn't have the peerless originality of a Michelangelo, the sculptural virtuosity of a Bernini, or the passionate inventiveness of a Borromini. But he was an excellent choice to undertake the herculean task of completing St. Peter's because his talents tended toward the pragmatic rather than the high-minded. He was a practical artist

who worked to satisfy the pope while adhering as carefully as he could to Michelangelo's concept. He had the commendable capacity to combine the practical with the transcendent.

In many ways, Maderno's career was similar to both Borromini's and Bernini's. All three of them began their professional lives by transforming stone into their own notions of beauty. Like Borromini, Maderno was born in the north—in 1556 at Capolago, a small Lombard village along the banks of the Lago di Lugano near Bissone. He was trained as an artisan in the local specialties of stonecutter and stuccoist—a *stuccatore*. Like Borromini, Maderno traveled south to Rome, and by 1576 he was working for his uncle, Domenico Fontana, one of the favored architects of Pope Sixtus V. Almost thirty years later, in 1603, Maderno was appointed architect of St. Peter's by Paul V.

Although Maderno was one of his era's preeminent artists, relatively few portraits of him have survived. But if the popular view of him is accurate, including a likeness that appeared on a five-centime Swiss stamp in the 1950s, he was handsome, with dark, appraising eyes framed by well-formed eyebrows, well-tended hair, a neatly trimmed mustache, and a clipped triangular beard that lent his face a somewhat puritanical appearance. He looked remarkably like Anthony Van Dyck's portraits of Charles I of England. But where Charles exhibited a certain superciliousness—an arrogance born of a blindness to his own limitations—Maderno appeared poised, direct, vigorous. He was a man who took himself seriously and expected others to as well.

Maderno became architect of St. Peter's at one of the most decisive points in its evolution: Finally, after a century, the church's final form would be, *must be*, decided. When della Porta died in 1603, it fell to Maderno to implement that decision.

After considerable debate among the Congregazione, the pope and cardinals determined that a Latin cross would best suit the needs of the church. Their reasoning was logical, almost businesslike. The church needed a nave large enough to accommodate all of the faithful who crowded church services and ceremonies. They also grasped the symbolism that a Latin-cross church would have, which the Council of Trent had recommended as the proper layout for new churches. (In 1595 the Papal Master of Ceremonies Paolo Mucanzio complained that the Greek-cross plan disregarded the ceremonial and sacramental rituals that were a part of the church, and argued for altering it because, if built, the Greek-cross church would not be constructed "according to ecclesiastical rule.") The pope and the Congregazione also wanted a benediction loggia, which the pope could use to bestow blessings on large crowds gathered in front of the church. It was a design detail some believed was inconveniently absent from Michelangelo's Greek-cross plan.

Those who continued to uphold the tastes of the Renaissance, including Cardinal Barberini and the architects Paolo Maggi and Fausto Rughesi, lobbied for Michelangelo's plan. Rughesi argued: "One sees that in the present building of Saint Peter's Michelangelo certainly turned his eye to the perpetual and the beautiful, but much more to magnificence, not concerning himself with convenience, since he knew that magnificence must be the principal goal of the temple building, being as it is the house of God and the place where men congregate to render Him glory."

In the end, convenience won.

After a century, Michelangelo's vision of a centralized domed church, a Pantheon for the faithful, was cast aside, superseded by the more earthbound needs of a revitalized church. But the idea

of a Greek cross would not be completely forgotten—nor could it be ignored. For by the time the Congregazione had decided definitively on a nave, the new St. Peter's had progressed too far to change course; its western end and dome were nearly complete. The only logical way to turn the Greek cross into a Latin one was to lengthen the church at its eastern extremity, to add six more chapels (three on each side) beyond where Michelangelo had determined the church should end.

A number of architects were called upon to offer their ideas for how the church should be added onto, among them Maderno, Flaminio Ponzio, Domenico Fontana, Girolamo Rainaldi, Niccolò Braconio, Orazio Torriani, Giovanni Antonio Dosio, and the Florentine painter Lodovico Cigoli. In the end, Maderno's suggestions were adopted, and in the spring of 1608 his work began by tearing down Michelangelo's façade.

In his designs for St. Peter's, Maderno understood, perhaps better than anyone else in Rome, that with a Latin-cross plan, St. Peter's would become the end of a *procession.* As the pilgrim emerged from the tangled, narrow streets of the Borgo, the neighborhood around St. Peter's, he would suddenly find himself in front of the new church. From there, his eye, and perhaps his soul, would be drawn forward, past the ancient Egyptian obelisk in the middle of the piazza (which had been moved from another site nearby and reerected by Fontana), up a shallow flight of stairs to a portico in front of a series of gigantic columns of white marble, through one of its five doors—the same number as in the original St. Peter's—and along the sweeping nave to the dramatic altar, which stands under Michelangelo's immense, irresistible dome and over the mortal remains of Saint Peter. It was the final step in a pilgrimage for the faithful, a deliverance from

sin into the embracing arms of a forgiving God. When the pope, the leader of God's church on earth, says Mass, he is literally surrounded by the words that proclaim the reason for his church's existence: *Tu Es Petrus et Super Hanc Petram Aedificabo Ecclesiam Meam et Tibi Dabo Claves Regni Caelorum* (You Are Peter and Upon This Rock I Will Build My Church and I Will Give You the Keys to the Kingdom of Heaven).

Maderno and his workmen faced huge obstacles in extending the church, one of which was dealing with the underground springs that meandered through the sandy soil, making the ground unstable. Apparently the pope and his courtiers expected St. Peter's to stand on faith alone.

Work on the façade and the nave proceeded quickly. At one point, 866 laborers were employed on the basilica, some of them working at night by torchlight. Unlike Michelangelo, Maderno made room in his design for a benediction logo, designing a façade that was both dramatic and restrained.

But not perfect. Because the church was lengthened and the façade and nave are so tall, the new St. Peter's is too tall for anyone standing right in front of the church to see the dome. Le Corbusier, the French modernist architect, complained that Maderno had ruined Michelangelo's design. St. Peter's, he wrote, should "have risen as a single mass, unique and entire. The eye would have taken it in as one thing. . . . The rest fell into barbarian hands; all was spoilt. Mankind lost one of the highest works of human intelligence." The façade, he maintained, "is beautiful in itself, but bears no relation to the dome. The real aim of the building was the dome: it has been hidden!"

Despite such criticism, the exterior is majestic. But as the major work on the exterior reached completion, attention inevitably

turned to the interior, which deserved to be equally impressive. But first it had to be decided who would determine that.

After a brief two-year reign Gregory XV, who had succeeded Paul V in 1621, died. On August 6, 1623, in the thick of a sweltering and malaria-ridden Roman summer and after more than two weeks of one of the more rancorous conclaves in papal history, Cardinal Maffeo Barberini received the votes of fifty of the fifty-five cardinals who had convened in the Sistine Chapel and was elected pope. To the surprise of many, Barberini chose not a name that had already been associated with the Barberini family, but Urban, telling intimates later that he wanted to follow the lead of Urban II (1088–99), a French pope who had rallied Christianity against the Turkish conquest of the Holy Land six centuries before.

The new pontiff wanted to restore the Roman church, which had stumbled badly a century before as the Reformation had torn at the Catholic Church and the political map of Europe. As a cardinal who had worked for the papacy for nearly two decades, Urban understood what a pope was capable of, both as a politician and as a spiritual leader. He had a reputation as a capable scholar (having been educated by the Jesuits), a shrewd diplomat, and an occasional poet (a book of his poems, *Maphei Cardinalis Barberini poemata*, was first published in 1620 and was reissued in 1631 with a title page designed by his friend Gianlorenzo Bernini).

When he became pope, he embraced a new role, that of crusader. Urban VIII had recovered from the "malarial fever" he had succumbed to after his election, and he believed he would be a pope who proved his worth to God and to his followers through his public accomplishments. One place he demonstrated this was at St. Peter's. And one of the first artists Urban turned to was Bernini.

Domenico writes that on the day that Urban was elected pope, he called the twenty-four-year-old Bernini into his presence and told him, "It is your great fortune, Cavalier, to see Cardinal Maffeo Barberini Pope, but our fortune is far greater in that Cavalier Bernini lives during our pontificate."

The story may be apocryphal—it certainly sounds like artistic hyperbole—but even before he became pope, Cardinal Barberini told Bernini, "Whoever becomes pope will find he must necessarily love you if he does not want to do an injustice to you, to himself, and to whoever professes love of the arts." There is no question that Bernini could visit the pope virtually at will. According to Domenico, Bernini was allowed unlimited access to the pope. Howard Hibbard, in his biography of Bernini, wrote that Urban "liked to talk to Bernini during the dinner hour until he was overcome with sleep; then it was Bernini's task to adjust the window blinds and leave."

Soon after becoming pope, Urban "informed Bernini that it was his wish that he dedicate a large part of his time to the study of architecture and painting so that he could unite with distinction these disciplines to his other virtues," Filippo Baldinucci wrote. It was a request that revealed an enormous amount of confidence in the young sculptor, who until that moment had shown no particular inclination toward either discipline. But that did not concern Urban.

By 1623, when Urban became pope, Bernini had grown from the gifted youngster into a handsome, poised man: outgoing, diplomatic, and tactful; bright, intelligent, and witty—a consummate, if occasionally headstrong, artist and papal courtier. Urban certainly preferred Bernini to Maderno, who was still the official architect of St. Peter's. The pope had never been an

enthusiastic devotee of Maderno's work: During his years as a member of the Congregazione, Urban made no secret that he preferred Michelangelo's Greek-cross plan to Maderno's (and Pope Paul's) able if cautious solution for lengthening the church, and the cardinal had taken no pains to hide his disdain for Maderno's execution. So strong was his opposition to Paul V's decision to transform St. Peter's into a Latin-cross church that his views found their way into a dialogue that appeared in a biography of Urban VIII written by a Monsignor Herrera in which the then cardinal countered Pope Paul's arguments for laying aside Michelangelo's design:

> Pope Paul objected that Michelangelo had not made a sacristy. He [the cardinal] responded that in the space occupied by two large spiral staircases it was possible to make two sacristies, leaving still two other spiral staircases of the four there, and that near the tribune there were two ample rooms with others above that could likewise serve this purpose. . . . Pope Paul said that furthermore in Michelangelo's design there was no choir for the canons. The cardinal responded that the choir could be put below, around the bodies of the apostles, where the *confessio* is today, giving it light from different sides. . . . Pope Paul also added that the bell tower was lacking. The cardinal replied that there were four most beautiful ones, that is, the four small domes that surround the great one. Finally, the pope said that it was unfitting that any part of the earlier church should remain visible as would be the case with Michelangelo's design. He [the cardinal] responded that not even this followed, because Michelangelo had planned a projecting portico or ante-temple, as is seen today at the church of the Rotonda [the

Pantheon], which was to hide the old church. . . . [The cardinal]
said to Pope Paul that another pope would demolish Maderno's
new design to restore that of Michelangelo. Paul V responded
that he would make such a work around it that no pope would
think of demolishing it.

Despite his public scorn for Maderno's work, Urban retained
the aging master builder as the chief architect of St. Peter's. Per-
haps the pope didn't want to dismiss someone who had such a
wide knowledge of the building and its construction. He even en-
gaged Maderno to transform the Palazzo Sforza, a palace near
the Quattro Fontane that the Barberini family had purchased,
into a palace worthy of the family of a pope. Urban also assigned
his young protégé Bernini to work with Maderno and his tal-
ented young assistant, Francesco Borromini, on the basilica and
the new Palazzo Barberini.

But the pope's generosity wasn't boundless. Urban told
Maderno that he had selected Bernini as the artist to design a
huge canopy to stand over the altar at the literal and spiritual cen-
ter of St. Peter's. For the ailing Maderno, this was a galling, even
humiliating, blow. It was a commission that he had long aspired
to. Giovanni Baglione quoted Borromini in 1642 as saying that
Urban also told Maderno—so ill with kidney stones that he had
to be carried around Rome—that "he would have to resign him-
self to see Bernini do this work." It was a slight to Maderno that
Borromini never forgot and probably never forgave.

FOUR

A Collaboration in Bronze

— ⚜ —

MEASURED AGAINST THE SPAN OF THEIR careers, the time that Bernini and Borromini worked together at St. Peter's was relatively short—only nine years, from 1624 to 1633. But for both men the experience could not have been more defining—or more abiding. For the rest of their lives, what went on during the design and construction of the enormous bronze Baldacchino—more than 28 meters (almost 92 feet) tall and weighing more than 63,000 kilograms (almost 70 tons)—influenced their careers and what the two thought of each other. It became the figurative backdrop for the almost operatic rivalry that wove through their lives, binding them together in ways neither could have predicted.

In its final form, the Baldacchino is the melding of two artists' creativity and inventiveness, but it is more than that. It is the first great emblem of

the Baroque, the beginning of a new kind of art—one that relied
on emotion more than intellect, on drama more than logic, on
the expression of passion more than the stability of reason. It be-
came the commanding presence at St. Peter's, and its profile
transformed the central space of the church into a place of pil-
grimage and worship. The Baldacchino does for the interior of St.
Peter's what Michelangelo's dome does for the exterior: It pro-
claims the miracle that lies beneath it.

In 1682 Filippo Baldinucci declared that "what appears to the
viewer is something completely new, something he never dreamed
of seeing." The French historian Victor-L. Tapié said that Bernini
"turned something provisory and mobile into something stable,
strong and gigantic, and finally united two qualities which might
seem irreconcilable—lightness and hugeness—without impair-
ing either." Even Henry James, not a writer known for an abiding
interest in Catholicism, was so struck by the Baldacchino during
his several visits to St. Peter's that he wrote in 1873: "There are
days when the vast nave looks mysteriously vaster than on others
and the gorgeous baldacchino a longer journey beyond the far-
spreading tessellated plain of the pavement, and when the light
has yet a quality which lets things loom their largest. . . . [Y]ou
have only to stroll and stroll and gaze and gaze; to watch the glo-
rious altar-canopy lift its bronze architecture, its colossal embroi-
dered contortions, like a temple within a temple, and feel
yourself, at the bottom of the abysmal shaft of the dome, dwin-
dle to a crawling dot." Not every American was overwhelmed by
its splendor, however. One tourist in 1853 pronounced it a "huge
uncouth structure."

For Bernini, the Baldacchino was his first, and arguably his
greatest, architectural triumph at St. Peter's. But Borromini's

ST. PETER'S BALDACCHINO

work on the Baldacchino, which was considerable, has been largely overlooked—glossed over or ignored by a combination of intent and laziness. While the Baldacchino is inevitably and rightly credited to Bernini, it cannot have come from just one mind, one imagination.

Even as a young man, Bernini didn't shun the limelight. While it was said he never suffered from professional jealousy—as one critic put it, "he had no reason" to—he did little to make sure that credit for the Baldacchino was apportioned fairly. It was an oversight that rankled Borromini as much as it had Giuliano Finelli.

Indeed, Bernini's work on the Baldacchino was nearly always collaborative: first with Maderno, from whom he inherited the commission and with whom he worked on at least one of the temporary structures; then with Borromini, who after Maderno's death became an active collaborator in the structure's design and casting. Both Maderno and Borromini were talented and capable, and at the time both were more skilled at the technical aspects of casting bronze than Bernini was. Yet popular history deems this Bernini's Baldacchino.

This oversight is due in large part to the difficulty in determining precisely who is responsible for what parts of the Baldacchino. While Vatican records reveal a great deal about how this unique piece of architectural sculpture was designed, cast, built, and paid for, they are tight-lipped about the origins of its myriad details. This much is clear: Gianlorenzo Bernini was the pope's chosen artist for the Baldacchino. Francesco Borromini was his deputy.

Borromini's time at St. Peter's wasn't nearly as professionally profitable as Bernini's. For a good deal of his time there, he was one of the thousands of Vatican laborers who toiled in the chaotic and dusty building yards surrounding the church, the carpenters

and carvers and stonemasons and ironworkers who carried out the designs the great men planned. But while most of his fellow workmen were content with their lot, Borromini was not. He wanted more.

Though he was not a precociously talented sculptor who had caught the eye of the pope, Borromini nevertheless took advantage of the extraordinary opportunities that providence threw in his path. When he arrived in Rome, the man he turned to for help was his maternal uncle, Leone Garovo, a respected stone carver from Lombardy. Garovo took in Borromini, allowing him to live at his house, and hired him as his assistant at St. Peter's.

Garovo's father-in-law was Carlo Maderno.

It was Maderno's task to complete St. Peter's, and he needed as many skilled and trustworthy masons, carvers, stuccoists, and surveyors as he could find. A young kinsman vouched for by his son-in-law could be valuable.

Borromini worked closely with his uncle, but it wasn't long until tragedy occurred: In 1620 Garovo fell from the scaffolding at St. Peter's and died.

From such misfortune sometimes springs opportunity. Borromini bought Garovo's tools and continued working at St. Peter's. In 1621 he partnered with other stone carvers from Lombardy—marmorarii—to found a società di arte del marmo, per servizio di qualunque persona: a quasi cooperative of masons and carvers. The talented stone carver from the north was becoming an entrepreneur.

And in due course he became a valued assistant. Whether Maderno had heard of Borromini's abilities, or perhaps because Garovo's death brought home how tenuous life can be, when his son-in-law died, Maderno engaged Borromini to work for him. Over time, he grew to rely on Borromini both as a carver and,

more important, as a draftsman, turning to him to create finished drawings of the *maestro*'s plans. Borromini became such a proficient draftsman, impressing Maderno with vivid, precise renderings of his designs (using Maderno's preferred finish of a final, colorful wash), that eventually Maderno replaced Filippo Breccioli as his first assistant, putting Borromini in his place. (Breccioli was demoted to the less favored role of *misure*, or measurer.) Even today, the plans that Borromini produced for Maderno are full of nuance and subtlety, and make clear that the young artist was as exceptional on paper as he was in stone.

THAT THE BALDACCHINO is in St. Peter's at all is due as much to serendipity as to design. By the rules of ecclesiastical architecture, it shouldn't exist at all. In the original Constantinian basilica, the end of St. Peter's is where the current main altar and tomb stand, and attention was called to it by a ciborium, a permanent domed structure that used columns to support a solid dome. A drawing from 1581 by Sebastian Werro now in the Bibliothèque Cantonal et Universitaire in Fribourg, Switzerland, indicates that the original ciborium at St. Peter's was a square of four Doric columns that bore the weight of a tall dome embellished with thin, ridged ribs and topped by a narrow (possibly metal) Greek cross. On each of the square's sides, at the base of the dome, four nearly semicircular screens, which come to a Gothic-like point at their apex and curve down on either side in a flourish, are decorated by delicate vinelike patterns of leaves. The effect is reminiscent of an eighteenth-century garden temple on an estate in the English countryside.

In 1594, when the wall that protected the old St. Peter's from the recent construction was finally dismantled, a new, more

prominent ciborium was needed. The old ciborium was replaced by a grouping of eight columns, their bases and capitals made of papier-mâché, and four pilasters, covered by a domelike canopy of wood and canvas. Though the exact design of the new ciborium has been lost, the goal was to give the altar more prominence in the church.

Pope Paul V also directed that a second ciborium be built at the end of the church, away from Saint Peter's tomb. This one was probably similar to an elevation drawn later by Borromini. Eight tall, twisting columns—which, legend has it, had been brought to Rome by Constantine from the Temple of Solomon in Jerusalem—were arranged in a square. The right angles of the square were cut, blunting the corners of the ciborium by short, angled sides that turned a square into an octagon. Reusing these columns was a skillful example of *spolia,* a kind of architectural recycling. Four impressive arches push through each long side of the square and are topped by carved pediments and an elaborate, elongated dome that looks similar (at least in Borromini's elevation) to the dome of San Giovanni dei Fiorentini. Above the columns on the short sides of the octagon are set discrete oval openings. Extending straight out from both sides of the ciborium are screens of traditional columns.

Borromini was clearly struck by the details of this design. He even used some of the same motifs, particularly the blunted corners, in his own independent commissions later in his career.

By 1606 Pope Paul V took the bold step of disregarding church architectural tradition by replacing the ciborium with a distinctly different kind of covering, a baldachino. A baldachino is traditionally a cloth canopy, often of silk, that is either suspended from above or held aloft by people (or statues) holding

staves at the four corners to support the canopy. It is often used to protect, or call attention to, a sacred relic or an important person in a procession. By its definition, a baldachino is flexible or movable. But the Baldacchino, as Paul wanted it built, was neither.

W. Chandler Kirwin, an art historian who has written extensively about the Baldacchino, describes this interim Baldacchino as "a wooden armature with a tasseled canopy, supported by four upright staves held by four stucco angels. The angels knelt on elevated bases, which were decorated with the coat of arms of Pope Paul V." At nearly 11 meters (36 feet) high, it was taller than any ciborium had been before at St. Peter's, which made sense: It was only after the dome was complete that its designers and builders, Maderno chief among them, knew how truly mammoth the space under the dome actually was. And even though the Baldacchino couldn't be moved, the inclusion of the angels in the design gave the impression that it *might*—if God and the pope deemed it worthy.

Maderno probably designed the first Baldacchino, before Bernini came to St. Peter's, and its size and profile helped to delineate the ciborium in the apse and the marker for Saint Peter's tomb, which included the *confessio*, a double set of curved stairs that Maderno had designed that descends to an iron grille below and in front of the altar, which allows pilgrims to lower things to touch the saint's tomb. This canopy was likely the one Bernini knew as a child, and as Baldinucci writes somewhat breathlessly:

It happened one day that he [Bernini] found himself in the company of Annibale Carraci and other masters in the basilica of St. Peter's. They had finished their devotions and were leaving the church when that great master, turning toward the tribune, said, "Believe me, the day will come, no one knows when,

that a prodigious genius will make two great monuments in the middle and at the end of this temple on a scale in keeping with the vastness of the building." That was enough to set Bernini afire with desire to execute them himself and, not being able to restrain his inner impulse, he said in heartfelt words, "Oh, if only I could be the one."

In 1622, during the brief papacy of Gregory XV (1621–23), a full-size though temporary model of the planned Baldacchino was built. Again as he built, Maderno modified some of the details and increased the height of the entire structure, making it only 2 meters (6.5 feet) shorter than the final version seen today. He also fluted the staves that support a tasseled canopy and decorated them with cherubs and what Kirwin calls "vegetation." The four stucco angels now knelt rather than stood, as if they were holding steady the supporting pier of a tent no one but they could see. Maderno left the sculpting of these statues to Bernini, who thus appears first in the history of the Baldacchino as a sculptor.

The Baldacchino that Bernini is eventually credited with designing and building with Borromini's help was actually the fifth structure over the main altar of the new St. Peter's, and its design and construction, like everything else at the basilica, sparked its own debate and controversy.

Maderno was supposed to design the Baldacchino; in fact, on July 3, 1623, a month before Urban was elected, the Congregazione had approved a new type of baldachino, designed by Maderno, which used wooden columns, not staves, to support a cloth canopy. The minutes of the meeting record that "the four columns made for supporting the baldachin above the high altar are to be put in place to be gilded in accordance with the idea of the architect."

But like everything else in St. Peter's, the construction of this baldachino didn't progress as expected. It, too, fell victim to circumstance and a change in regime. After Gregory XV's death in 1623 and before Urban's election, no work was done on the Baldacchino; in fact, it is unlikely that this structure was ever installed. And when a new pontiff sat on the Throne of Peter, with new ambitions and new ideas for the basilica, other proposals for what should stand above the main altar took center stage.

Urban was not a pope willing to be overlooked or overruled. A complicated man of enterprise and conviction, he could be hard, even ruthless: It was said that after he became pope he demanded that every bird in the garden outside his bedroom be killed because their chirping disturbed his sleep. Yet he believed that one of his duties as leader of the church was to improve the city of Rome, to embellish it for the greater glory of God. He understood that whatever form the final Baldacchino took, it must be a rousing symbol of the church, simultaneously poignant and dramatic, inspiring and breathtaking. He wanted it to draw the eye upward and the spirit toward the eternal. "From the day of Urban's election ceremony, the actual spherical crossing of the new St. Peter's became for him Catholicism's sacred square, the interior piazza where he would erect an elaborate defense both of the tomb below and this office above, with its universal claim to spiritual authority," Kirwin notes. On that stifling night in August, Urban sat under a temporary wooden canopy that had been built by Maderno at Paul V's command and proclaimed a new sensibility, what Kirwin calls "a wise conjunction of the Academy and the court" where religion and art met as equals to honor God.

Urban VIII, according to his biographer Andrea Nicoletti, "wanted not only to emulate them [his predecessors] but with

more marvelous ornaments and the most splendid memorials to augment more and more the majesty of that temple [which had] become for all occasions the most celebrated of Christianity; and especially to show his devotion toward the Apostles Peter and Paul, he applied his mind to ennoble the place where their bodies were conserved, which is called the Confessio, situated in the center of the basilica."

Urban's choice of Bernini to create such ornaments and memorials was shrewd. He was talented enough to be useful, undeveloped enough to be molded, ambitious enough to be adaptable. But as capable as Bernini was, the pope knew he had much to learn about the *mechanics* of art, particularly architecture. He needed to become an artist who had broader mechanical and technical experience than sculpture had given him so far. So less than two months after Urban assumed the papacy, the pope set about expanding Bernini's expertise. On the first day of October 1623, Urban made Bernini *soprastante*, or overseer, of the Vatican foundry—a post for which the twenty-four-year-old sculptor had no qualification whatsoever. Six days later, the pope appointed Bernini superintendent of the Acqua Felice, one of the city's main water supplies. Bernini suddenly found himself supervising two vital aspects of seventeenth-century Roman life. The young artist was being forced to learn how to be a competent administrator.

Bernini's appointments undoubtedly raised eyebrows within the Vatican. But the pope had his reasons. He wanted Bernini to become an expert in bronze casting and how to administer a complicated bureaucracy. It wasn't coincidence that the Congregazione debated again the disposition of the Baldacchino the day before Bernini's appointment to the Acqua Felice. Urban

attended the meeting, and it was decided that "the four columns made to hold up the baldachin in the middle of the church should be set in place so that if His Holiness had some better idea, it may be obeyed."

Two months later, Urban had a better idea.

Just before Christmas 1623, another temporary baldachino, the last one built, was constructed over the altar, probably from another design by Maderno. To stand atop the tall pedestals at the baldachino's base, which Maderno had fashioned of travertine and marble, Urban directed that Bernini sculpt four angels, which appeared to support the staves. By the next Easter, April 10, 1624, Bernini had completed—in stucco, a lighter, less permanent medium than his usual marble—four oversize angels, which were placed at each corner of the baldachino, looking as if they might suddenly come alive and follow the pope as he walked down the nave, holding the canopy above him.

Even though Maderno had designed this temporary altar covering, the sun was setting on his days as the first architect of Rome, just as it was dawning on Bernini's. Though Maderno retained the post and title of *architetto della fabbrica di San Pietro* for the remainder of his life (he died in 1629), it was Bernini who held the pope's confidence. It must have been a bitter mixture of regret and disappointment for Maderno to accept. There was no question that a seismic shift of taste was under way.

Yet Maderno—who in addition to gout suffered from painful kidney stones—still found it within him to be generous, even gracious, to the sculptor-turned-architect. He worked amicably with Bernini—at least there are no stories that tell of any enmity between the two. In fact, Kirwin notes that "Maderno no doubt took Bernini under his wing and oversaw his first commission

inside the building, namely his participation in the decoration of the temporary baldachin," which Maderno had designed.

Soon Bernini wouldn't need Maderno's help.

ON JUNE 7, 1624, the Congregazione della Reverenda Fabbrica di San Pietro announced a contest, what was called an "open competition," to find the best design and architect for a permanent baldachino. The Congregazione declared "a proclamation in which it is made known that he who has intentions in architecture, inventions or the like to make the baldachino above the altar of the most holy Apostles in St. Peter's, may make some models and take them to the next Congregazione, which will be held in fifteen days, at which they [the members] will give by voice their own opinion and advice."

A little over two weeks to devise and prepare *modelli* (a word that at the time could mean both three-dimensional models or a set of drawings) for a structure that would stand above the most important tomb in Christendom seems rushed at best. Such haste after centuries of caution and debate fueled speculation that the pope had already selected an architect: Bernini, that "creature of the pope," as one commentator called him.

Such suspicion seemed well founded, an aggrieved Borromini said later, when Urban told Maderno around this time that the elder architect "would have to resign himself to see Bernini do this work."

On June 17, ten days after the contest's announcement, Bernini's name was mentioned in documents as the monument's designer and regular payments were made to him that referred to his "work of metal that will be made for the altar of the Apostles."

By that September, a model column was put in place to determine how the finished column would look, and by November an agreement was reached with the bronze founders for the first two columns. The contract stipulated that the work "in its size, proportion, and quality [is] to be supplied by Cavalier Bernini." In a few short months, the pope's favored sculptor had become his architect of choice.

Despite his youth and inexperience, Bernini was not a complete architectural neophyte. Through his membership in the Academy of St. Luke, an elite organization of Roman artists, he had met the city's best architects, and in December 1621 he helped in the design of a catafalque for the body of Paul V to lie upon in the Pauline Chapel at the church of Santa Maria Maggiore. Later, in February 1624, Bernini received his first actual architectural commission: to refurbish the church of Santa Bibiana. Though the appointment came from the chapter of Santa Maria Maggiore, it had the unmistakable imprimatur of Pope Urban, who clearly wanted his architect to get some experience.

This small shrine to a now obscure saint sits snugly—some might say uncomfortably—against the western access tracks that slither into Rome's cavernous train station. It stands in forlorn and forgotten surroundings—at the south end of a small, oddly shaped courtyard—and suffers the indignities of noise from passing trains and traffic.

The church honors Saint Vivian, a fourth-century martyr who as a modest girl of fifteen refused the advances of Apronius, a Roman official. For her rebuff, Vivian—Bibiana in Italian—was tied to a column and whipped to death with a leaded cord.

Such a public death of a young Christian virgin at the hands of a pagan authority prompted a righteous fervor, and by the eighth

century a cult had sprung up around Santa Bibiana. A contemporary guidebook to Rome called *Itinerario Einsidlense* mentions that by then a shrine already existed on this spot. Visiting the shrine was further encouraged during the Counter-Reformation by Cardinal Cesare Baronio, who took every opportunity to emphasize the simple faith of the early Christians as examples for people distracted by the criticisms of the Reformation: Defending Christ's virtue against man's lust can transport one's soul to paradise.

Shrines for saints who met their deaths at the hands of cruel heathens were especially popular stops for pilgrims. And because Santa Bibiana stood between the larger churches of Santa Maria Maggiore and the city gate that led to San Lorenzo fuori le Mura, and was set (at the time) in an agreeable suburban setting aloof from the city's disorder and cacophony, Urban determined that the church should be restored for the Holy Year of 1625.

Bernini designed a new façade for the building and carved a life-size statue of the saint, his first major religious statue. Today the sculpture stands above the church's main altar, in a narrow niche scalloped at its top. The saint's right arm is raised as she leans against a section of a column representing the one against which she was killed. To a modern eye her gaze is one of disbelief, like a guest of honor at a surprise party, though she undoubtedly was supposed to look transfixed by the vision of her martyr's reward. She gazes heavenward, her lips parted in a mix of rapture and astonishment.

Despite the statue's cramped setting, the saint's face is well lighted: a filtered white light shines down upon it from a hidden window. This marks the first time that Bernini used a hidden light source to illuminate his work and suffuse it with metaphorical meaning. Its effect is dramatic and attention-getting,

particularly in the cool shadows of Santa Bibiana. It was optical ingenuity he would use again—and more spectacularly—at the Cornaro Chapel.

Santa Bibiana was Bernini's first public religious architectural commission. In his 1627 work *La vita di S. Bibiana vergine, e martire romana*, the scholar Domenico Fedini explains that Urban, who as a cardinal had written poetry extolling the virtues of Bibiana, wanted to "rescue" the church from obscurity. By assigning the task to Bernini, the pope succeeded.

Bernini's new front for the church is an enterprising contrast of light and shadow, surface and space. It is a somber yet supple two-story wall of stone, with a trio of ground-level arches supporting a second story that is accented by three tall, narrow, rectangular windows. A broken pediment above the central window topped by a simple cross of gold is the only obvious ornament.

Today, in a city of churches saturated with decoration and drama, the classic lines of Santa Bibiana appear restrained, even humdrum. But in its time, it was seen as a lucid, imaginative example of church rebuilding and decoration. Bernini created a façade with a subtle, cunning rhythm of movement; its thick, blocklike pilasters advance toward a visitor as the deep arches recede into shadow. The impression is one of anticipation and reticence, boldness and hesitancy, and it recalls one of Maderno's most famous churches, Santa Susanna on the Via XX Settembre, which was completed in 1603. Even as a young man Bernini knew the wisdom of following in the footsteps of more experienced architects.

This is a lesson he used at the Baldacchino. Bernini's first plan for it resembled Maderno's earlier proposal, which had its genesis, Borromini claimed, with Paul V. It was the pope's idea, Borromini asserted, "to cover the high altar of St. Peter's with a baldachin

of proportionate richness to the opening made at the confessional and tomb of Peter." Borromini added margin notes to a manuscript copy of Fioravante Martinelli's guidebook of Rome where he indicated that Maderno had designed for Paul V a baldachino with twisted columns in which the actual altar covering "touched neither the columns nor their cornice." Borromini doesn't say how Maderno pulled off such an engineering trick; no plans for this design legerdemain exist.

What is clear is that Maderno had taken the risky step of blending the columns of a ciborium with a baldachino, starting a process that culminated in the Baldacchino that still stands in St. Peter's.

Some architectural purists were troubled by this fusion. They felt that the elements of the ciborium and the baldachino should never be combined. It was like pouring red wine into a decanter of white: No person of taste saw any advantage.

Such criticism did not bother Maderno—it was, after all, his idea—and it certainly didn't worry Bernini. So when Bernini began his own designs of the Baldacchino, he took the lessons he had learned from Maderno's plans. He envisioned a quartet of four high, twisted "Solomonic" supports topped by small winged angels, each contrived to look as if it were supporting one of four cross ribs that sweep up in a graceful arch, meeting above the center of the altar. For the top of the structure, Bernini envisioned a large statue of Christ the Redeemer, which would stand on a pedestal. Cloth was to be draped over the cross ribs, like finery discarded by some disorganized deity. A line of decorative pieces, shaped rather like a child's bib, each with a tassel dangling from it, hung between the columns in orderly rows, giving a slightly military hint to the design, as if the Baldacchino were the battlefield tent of a mighty potentate. All of this was to be fashioned in gilded bronze, the metal

of choice when embellishing important churches, shrines, and reliquaries. Church legend has it that Constantine himself ordered Saint Peter's remains placed in a cypress coffin encased in a casket of bronze: a cross of gold, inscribed as a gift from the emperor and his mother, Helena, was said to have been arranged on it.

To see how a permanent baldachino might look, Bernini oversaw the construction of a temporary version of his design. By June 1624, workers had built an experimental column at St. Peter's and by September 10 it was standing on a pedestal at the altar. Not long after it was garnished with five clay putti. Less than two months later, on November 5, 1624, bronze founders were engaged to cast two columns. Their design called to mind the so-called *colonna santa,* or holy column, which held pride of place in the northeast niche of the dome. This ancient piece of translucent marble, carved to twist like a tightly wound spiral, was revered because it was thought that Jesus had leaned against it when he preached at Solomon's Temple in Jerusalem.

Within less than eighteen months of his becoming pope, Urban, with Bernini as his architect, had progressed further in creating a permanent baldachino than either Paul V or Gregory XV had in working with Maderno.

In an engraving from 1625 that commemorates the canonization of Elizabeth of Portugal, the trial baldachino appears, standing conscientiously over the altar like a new soldier at his first skirmish. There's little of the robust confidence, the high-spirited jubilation, the witty detail that are such important parts of the Baldacchino of today. It is a cautious first attempt, tentative and unconvincing but interesting enough to proceed with further.

Perhaps contributing to Bernini's prudence was the apprehensiveness of some less adventuresome observers who felt that

Bernini's combining of elements from the ciborium and bal-
dachino was too bold, too unconventional. Borromini in particu-
lar found fault with Bernini's early design. As Maderno's
assistant, Borromini had seen firsthand the *maestro's* early designs
of the Baldacchino, and he believed that Maderno had handled the
blending of the two properly; he didn't overdo it. Bernini, on the
other hand, didn't know his limits.

As evidence of this, Borromini quoted the painter Agostino
Ciampelli, who remarked that baldachinos "are not supported by
columns but by staves, and that the baldacchinos should not run
together with the cornice of the columns, and in any case he
[Bernini] wanted to show that it is borne by angels: and he added
that it was a chimera."

Such a critique today sounds quaint, almost charming. But it
was the seventeenth-century equivalent of libel. Church tradition-
alists were uncomfortable with this mélange of styles: They felt the
two were too different, their roles too diffuse. It was an "uncanon-
ical" solution for a structure that would stand literally at the center
of Christian orthodoxy. And to place such an important commis-
sion in the hands of a neophyte architect who knew little about ar-
chitecture and even less about bronze casting was foolhardy.

The criticism that Bernini had created a "chimera" was a re-
buke that stung and lingered. It is possible that Bernini remem-
bered it years later when he used the same word to describe
Borromini's work. He knew the word's power and its effect.

Bernini continued to revise his designs on the Baldacchino, and
he continued to rely on Maderno for assistance, taking advantage
of the elder architect's expertise. Though Maderno had been re-
lieved of the commission, he continued to act as Bernini's consul-
tant on the Baldacchino. As Kirwin points out, "if the Baldachin

tells us anything, it is that Bernini was an excellent listener and ob-
server, and a quick learner."

On November 18, 1626, Urban consecrated the completed St.
Peter's (though its decoration would continue for decades), 120
years after Pope Julius II had laid the foundation stone for the first
pylon of the new church. By the next spring, three years after
Bernini began preparing them, the four towering bronze columns,
gilded and decorated, were installed atop corresponding marble
pedestals 2.6 meters (8.5 feet) tall that were carved by Borromini
and Agostino Radi, Bernini's brother-in-law—huge blocks of stone
taller than the pope himself. At the bottom of each column, where
it meets the pedestal, which the pope could see easily when he stood
at the altar, Bernini placed small figures in the bronze: a rosary and
a medal on the southwest column; a lizard on its northeast coun-
terpart. Bernini added this sort of witty detailing all over the Bal-
dacchino, primarily for Urban's amusement. And he made effective
symbolic use of the bee, an insect thought to be drawn to the sweet
aroma of sanctity—and not incidentally the new emblem of the
Barberini family (Urban having changed it from a horsefly). It fig-
ures prominently throughout the Baldacchino's decoration. The
Barberini crest of three bees is carved into the stone shields on
the outer sides of the pedestals, and they're set in bronze all over the
columns, pollinating the seeds of divine wisdom as they wander
through twisting vines and proclaim that the Baldacchino sprung
from the buzzing energy of Urban VIII.

(Such personal aggrandizement in church building and deco-
ration wasn't unusual. Borromini did the same thing later for
Pope Alexander VII at the church of Sant'Ivo alla Sapienza, even
though it was not begun during Alexander's pontificate.)

On June 29, 1627, on the Feast of Saints Peter and Paul, Urban

celebrated the Baldacchino's unveiling (though not its official completion). By then, the bronze columns must have been an impressive sight: some 26 meters (85 feet) tall, cast in massive sections of base, capital, and three center sections at *la fonderia*, the special foundry that stood behind the barracks of the Swiss Guard to the north of Piazza San Pietro, and embellished by gilded laurels that seem to grow up out of the columns' grooved, gilded bases as they spiral up toward the dome.

There's a theatrical realism to the decoration, intentionally so. Bernini chose a casting process that allowed him to place an actual item—a tree branch, even a lizard—into the columns to achieve a kind of sculptural verisimilitude. Using what was called the lost-wax process, he created a mold by placing wax between a heat-resistant core and cover and pouring molten bronze into the mold. The fauna and flora would be consumed by the liquefied metal, leaving behind nothing but the outline, caught forever in bronze. The Swedish art historian Torgil Magnuson notes that "one of the largest items in the accounts [of the Baldacchino], over 3,800 ducats, was for the great quantity of 'best yellow beeswax' needed for the casting, and that this cost about twice as much as the gold acquired for the gilding." Bernini destroyed nature to create a magnificent artifice, and in the process, vast sums of money literally melted away.

Using real things prompted Bernini's critics to deride him for not being enough of an "artist"—many believed that an artist should mimic reality, not use it to generate an effect. Another complaint was that Bernini relied too heavily on others for his casting. He had very little experience with bronze, and there were renewed mumbles of protest over Urban's order that the recently installed bronze ribs that support the dome be removed and

melted down to use in the Baldacchino's casting. The grumbling grew louder still when the pope directed that the bronze beams of a roof truss at the Pantheon be dismantled and melted down— a task that Borromini was in charge of carrying out. Such papal disregard for an ancient and well-loved Roman landmark prompted Giulio Mancini, the pope's physician, to wisecrack, possibly in the presence of the pope himself: *Quod non fecerunt barbari fecerunt Barberini* (What the barbarians didn't do, the Barberini did). And when additional supplies of bronze arrived in Rome from Venice, providing more than enough bronze for the Baldacchino, the quip seemed even more apt.

By the end of 1627 Bernini could boast that he had built small- and large-scale models of the Baldacchino and columns, and "operated at the beginning to make the clay, wrap [it] in iron, to lower, to guide, to cook, to bury, to melt the metal, and to cast the pieces, which were twenty in number." He had spent two years supervising the columns' casting, using several assistants, including his father, Pietro, who oversaw the books and materials. Bernini may have been perceived as a dilettante by some, but the long, at times arduous process of building such a mammoth structure helped make him an able administrator—a skill he used effectively in his own workshop, which in time became one of the most efficient and profitable in Rome.

Despite such a promising beginning, completing the Baldacchino took another six years, and its design would evolve further still. There were several reasons for this. In part it was due to the difficulty of finding a satisfactory solution to the top of the Baldacchino—it took longer than expected, and in the end Bernini needed Borromini's help. Also, other commissions began to come Bernini's way, distracting him from finishing the Baldacchino. By

1629 Bernini had been commissioned to design and sculpt Urban's tomb, and to construct two small campanili—bell towers—for the Pantheon (based, Magnuson says, on Maderno's designs). He was also working with Maderno and Borromini on the plans for the Palazzo Barberini, the enormous palace the Barberini family was building for itself on the east side of the Quirinale Palace.

But the most significant reason for the length of time it took to finish the Baldacchino was a human one: a death.

When Carlo Maderno, old and sickly, died on January 31, 1629, an artistic age died with him. Urban spent little time mourning the loss of the architect who in his view had "ruined" St. Peter's. Only five days after Maderno's death, Urban appointed Bernini principal architect of the Reverenda Fabbrica and architect of the Palazzo Barberini. The young sculptor and architect was suddenly the most influential artist in Europe.

To be so talented and so successful at such an early age—he was just thirty—was astonishing, nearly unprecedented, and certainly unheard of in Urban's Rome.

For Borromini, Maderno's death was an earthquake, a seismic blow with all of its unexpected aftershocks. Maderno was the man Borromini had grown to revere, the father figure who had noticed his talents, fostered them, and given him unprecedented opportunities to use them. Now he was gone. Never again would Borromini be so close to, and so welcome at, the confluence of the city's worlds of art and religion. Compounding his loss, he had to see his *maestro*'s place taken by a coddled contemporary, the pope's lapdog who, Borromini thought, knew so little about the practical side of architecture. In Borromini's opinion, Bernini was not the man to replace Maderno. He was.

It is one of the ironies of Borromini's life that he was the only

man in Rome convinced he should have been selected to be architect of St. Peter's—a certitude that is both naive and self-indulgent. The choice of Bernini to complete the decoration of St. Peter's was inevitable and unavoidable. Joseph Connors observes that Urban "had no intention of promoting what he must have thought of as the *'setta madernesca'* [the Madernoesque sect] when his protégé, the new Michelangelo, was available and willing." How could Borromini not see what everyone else did?

Perhaps he chose not to. Or perhaps he couldn't. To see the world so differently from how others see it, to miscalculate the behavior of others so utterly, was a heartbreaking habit of Borromini's. It is one of the ironies of his life that the vision that made his work so distinctive was often what made his life so intolerable.

With Maderno dead and Bernini now in charge at St. Peter's and the Palazzo Barberini, Borromini was cast adrift. What was to become of him? And what would the Baldacchino finally look like?

There are documents suggesting that Borromini, as Bernini's most important assistant, contributed substantially to the ultimate solution of the Baldacchino's final silhouette. But his contribution isn't clear-cut or obvious. It turned out that the statue of the Risen Christ that Bernini envisioned for the summit was much too heavy to be held aloft by meager arches. Bernini the artist had been too theatrical; here he needed to be pragmatic. So he was forced to rethink his design.

After more experimentation on paper, which Borromini assisted with, Bernini replaced the large statue with a smaller golden sphere topped by a cross. It was a more manageable solution, addressing the problem of weight and support, and it had the added benefit of mirroring the image atop St. Peter's itself. A

medal struck in 1633 shows the final outline of the top of the Bal-
dacchino, a magnificent curling confection of gilded S-curved
scrolls of wood dressed with patinated copper and strengthened
by a metal bar inside each one. Their shapes were reminiscent of
diving dolphins, thicker at their base than at their tail-like pinna-
cle. This arrangement supports the orb and cross nicely as it con-
tinues the sense of upward movement.

It was a neat solution that sprung in significant part from Bor-
romini. According to Paolo Portoghesi, Borromini's active role in
the design process is supported by at least one drawing at the Al-
bertina in Vienna, which looks very much like the finished Bal-
dacchino. Others agree that this drawing reveals Borromini's
collaboration in the design, and according to Portoghesi, Borromini
"contributed decisively not only to the execution but also the inven-
tion of the crowning, in which the four ribs of dolphin-like curva-
ture replace the crossed arches surmounted by a statue of Christ the
Redeemer originally proposed by Bernini."

The dolphin, like the bee, had long been a Christian symbol,
though its unusual, elegantly fluid use atop the Baldacchino—
like a dolphin diving back into the water—had few precedents in
ecclesiastical architecture. Nevertheless, it was used to good effect
in the Baldacchino, and Borromini employed the same motif in
future commissions, bolstering the assertion that the top of the
Baldacchino was Borromini's invention. Borromini was deeply
proud of his own work and acutely protective of his ideas—
Baldinucci wrote that Borromini considered his designs *come i
propri figli*, like his own children. It was extremely unlikely that he
would co-opt a design created by another for his own buildings.

Borromini also found an opportunity to be creative at the
Palazzo Barberini. In 1626, a year after Cardinal Francesco

Barberini bought a palazzo from Duke Alessandro Sforza, he gave it to his brother Taddeo, and Maderno (despite the pope's reservations about him) was commissioned to build a new palazzo on the site. Bernini was again assigned to assist him. Maderno, of course, had Borromini at his right hand.

The site was an unevenly sloping hill near the Quirinale, and Maderno, with the help of both of his young colleagues, designed a massive H-shaped residence, one that looked more like a suburban villa than the standard palazzo that had been built in Rome since the beginning of the Renaissance.

The Palazzo Barberini is, in fact, two rectangular villas connected by a three-story arcade and loggia, which looks as grave and as serious as a mausoleum. It sits back from the street and is angled away from it slightly. This is disconcerting to a visitor until one notices that the building faces St. Peter's and the Vatican, the home of Maffeo Barberini, who as Urban VIII was involved in a building campaign of his own.

Maderno exploited the irregular site to advantage, a trick Bernini learned well and used throughout his career. On the north, sloping side of the hill, Maderno designed and built a four-story wing. In this way he allowed both wings of the palazzo to appear from the front to be three stories tall while gaining an extra story of livable space. And space was needed, because the north wing was to house the secular side of the Barberini family—Taddeo Barberini; his wife, Anna; their children; his mother, Costanza; and their servants and attendants. The southern wing, which was shorter than its northern counterpart and had one less story, was designed to accommodate the clerical side of the family, in the person of Cardinal Francesco Barberini. Though the cardinal lived a quieter life than his more worldly relations, his

refined tastes demanded an elegant lifestyle. His suite of rooms must be large enough to accommodate a library, a theater, and an art gallery. A man of the church may be denied the pleasures of the flesh—at least in theory—but he is free to indulge in the delights of the mind, if he has the resources, which the good cardinal certainly did.

Behind the vertiginous three-story loggia, which today appears as narrow and cramped as a nineteenth-century shoe factory, stands an enormous two-story hall with a deeply coved ceiling. This *gran salone* is a gigantic rectangle-shaped room whose most arresting feature is *The Triumph of Divine Providence*, the magnificent (and magnificently large) ceiling fresco painted between 1633 and 1639 by Pietro da Cortona. It was Cortona's brilliance—no doubt with the Barberini's blessing—to place in the fresco three outsized golden bees—from the floor they look monstrous, as large as soccer balls—that trumpet (perhaps hum) the superiority of the Barberini. The whole composition of this room moves, as "the figures dart between the painted entablatures, the mock carytids, and the clouds," the art historian Giulio Carlo Argan writes. "Decoration is no longer fable, but prayer and spectacle."

Two large staircases, a square one in the northern wing and an oval one in the southern, are found on either side of the central arcade, and they lead directly from the forecourt to the *piano nobile*—the main story—and the families' private apartments. The arrangement allows the wings to be used like connected town houses. Such ingenuity was used later by other architects, including Robert Adam, John Nash, and John Soane in London, and McKim, Mead, and White at the Villard Houses in New York.

Imposing though the Palazzo Barberini is, to a modern eye it appears ungainly—cheerless and top-heavy, more penitentiary than

palace. Perhaps that's because the building had so many people, so many opinions, superintending its design and construction. The palace is very tall, and the windows along the entrance front make the main front look crowded. Though Maderno oversaw the arrangement of the rooms and designed the building's elevations and its loggias, Taddeo Barberini was deeply involved in its design. Cardinal Francesco Barberini claimed in a biography of his brother that "the entire fabric was the work of his mind. . . . There was not a day that he did not go there and see the drawings; and what was being done, if it was the idea of others, was approved and verified by him."

That may or may not be true. What is true is that dozens of drawings for the palazzo exist in Borromini's and Bernini's hands. Their contributions are all over the building. Bernardo Castelli, Borromini's nephew, indicates that many of the working drawings for the palazzo are by Borromini. And there are hints that Borromini's role may have been more than just that of a draftsman. Cardinal Francesco Barberini told Cardinal Virgilio Spada, who was a friend of both Bernini and Borromini, that the palazzo "was in great part the design of Borromini."

Borromini is known to have designed the two small, square windows, one at either end of the entrance front's top floor, whose rounded pediments angle out away from the building at 45 degrees, creating a unique and completely Baroque invention. In addition, he was given the task of designing the oval staircase in the south wing, a dynamic spiral that the British art critic Anthony Blunt says was inspired by the Ottaviano staircase in the Quirinale Palace. Its curving, supple arc of marble draws the eye upward. Though it's made completely of stone, the stairway feels organic, like a flower growing toward the sun. Even the sets of

paired Doric columns set along the balustrade seem to pull the visitor higher.

By contrast, Bernini is known to have designed the stately marble staircase in the north wing. The climb to the *piano nobile* up the sixty-two stone steps that line the four sides of a square, cramped courtyard feels like more of an effort than climbing Borromini's stairway. The stairway struggles to be grand, but it can't pull it off. It's a halfhearted effort, more utilitarian than ingenious.

Despite Borromini's contributions, and those of Maderno early on, most of the credit for the Palazzo Barberini was showered onto Bernini. Borromini himself never took specific credit for the palazzo. In his annotations to the manuscript of Fioravante Martinelli's guidebook, where Martinelli had written that the palazzo had been "achieved by many and especially Bernini," Borromini added only the words "and others." However, Connors notes that "in later years [Borromini] used to say that Palazzo Barberini was all his design."

It's certainly true that when Maderno died, Bernini knew that he would need help. He knew that Borromini was as vital to Bernini's successful completion of both St. Peter's and the Palazzo Barberini as he had been to Maderno.

"Knowing what Borromini had accomplished for Maderno at the fabric of St. Peter's," Castelli wrote, Bernini "begged [Borromini] not to abandon him . . . since he was already so well-informed about everything. And Bernini attended to his sculpture and in architectural matters he left everything for Borromini to do; and meanwhile Bernini feigned the role of architect . . . before the Pope, when in fact he was quite innocent of the profession at the time."

Given Bernini's extraordinary talents, this reads a bit like grandstanding—hyperbole among partisans. Yet Portoghesi quotes

a section of an early draft of Baldinucci's biography of Borromini deleted from the final manuscript, which casts a different spin on the relationship between the two men. Baldinucci wrote:

> Urban ... appointed him [Bernini] architect of Saint Peter's and finding himself charged with this task and aware of his inability, since he was a sculptor, and knowing that Borromini had worked for Maderno at Saint Peter's and had again for Maderno managed and followed up the work on Palazzo Barberini, he begged Borromini not to abandon him on this occasion. Promising that he would recognize his many labors with a worthy reward, Borromini allowed himself to be persuaded by his solicitations and promised to continue the work already begun in Saint Peter's.... Bernini therefore tended to his sculpture and left the architecture to Borromini, and Bernini played the role of architect to the pope and Saint Peter's, whereas, in fact, Bernini was at this time extremely unenlightened in that profession. But since Borromini carried out the building works of that pontificate so well, Bernini drew the remunerations and salary for the building works of both Saint Peter's and the Palazzo Barberini, as well as the pay for the work of compiling the measurements. And never did he give Borromini anything for his labors of so many years, except good words and grand promises. And seeing himself thus deluded and derided Borromini completely abandoned Bernini, saying, "I do not mind that he has the money, but I do mind that he enjoys the honor of my labors."

Why would Baldinucci recount such an unfavorable tale, only to delete it later? He offers no explanation. However, it could have something to do with Queen Christina of Sweden, who

hired Baldinucci to write a biography of Bernini. As a man who understood the exacting standards of royal patronage, Baldinucci may have reconsidered his public castigation of the subject of a royal biography, particularly when the subject had been a personal friend of the most important Catholic convert in Europe. (Christina had renounced the throne in 1654, became a Catholic in 1655, and eventually settled in Rome.)

Equally revealing are the comments of Giovanni Battista Passeri, another seventeenth-century Borromini biographer. He was even blunter than Baldinucci had been initially. Of Bernini's dealings with Borromini after the death of Maderno, Passeri wrote, *"Lo procurò suo adherente"* (He procured his allegiance)—a phrase disturbing in its repercussions. In addition, Passeri indicates that Bernini believed in "the exceptional talent of his assistant[,] almost feared his competition and tried to retard Borromini's ascent by keeping him bound to his own service, while taking full advantage of his extraordinary technical capabilities"—a tactic that sounds similar to Bernini's treatment of Giuliano Finelli.

Bernini was, Passeri wrote, "like the dragon guarding the Gardens of the Hesperides, who worked against anyone attempting to gain the golden apples of papal grace, and spat poison and sharply pointed darts of hatred all over the path that led to possession of the highest favours."

The actual inducements Bernini used to keep Borromini as his assistant aren't known. What is plain is that there was always a discrepancy between what Bernini was paid for his work and what Borromini was for his. On Borromini's last payment record for his work on the Baldacchino, dated January 22, 1633, is the notation: "To Francesco Castelli (Borromini) 25 *scudi* for the present month of January for the drawings in full scale of the

curvatures, the plants, mouldings, foliage, and other details that are to go on the ribs and cornices, and in addition he is obliged to make designs on the copper, and these are to be done so that the carpenters and those who beat the copper cannot err." For the same month's work, Bernini received 250 scudi, ten times what Borromini did.

If money was an issue for Borromini—and despite his later insistence that it was not, its indication of the *value* the pope and the Barberini family placed on his and Bernini's work was impossible to ignore—his one attempt to seize the opportunity to improve his own fortunes was a debacle and helped end his relationship with Bernini.

Because finishing the interior of St. Peter's was such an enormous undertaking—as difficult for Bernini as completing the exterior had been for Maderno—the basilica demanded a ceaseless supply of marble and an equally long list of capable stonecutters and marble workers to fashion the stone. Satisfying such a boundless need for stone afforded Borromini his chance to profit from the basilica's—and Bernini's—need.

According to Passeri, Borromini joined with Agostino Radi, a *scarpellino* who took advantage of the happy opportunity of being Bernini's brother-in-law. Bernini hired the partnership to provide some of the marble and stone he needed for the basilica. Such a business arrangement wasn't unusual in Rome, but there is no evidence that Borromini attempted such a venture when Maderno was architect of St. Peter's. Perhaps he felt at the time that he was too young for such audacity. Perhaps he respected or feared Maderno too much even to broach such an idea with him. Perhaps Maderno refused to agree to such arrangements. Whatever the reason for Borromini's past reticence, he showed no such

reluctance when the Cavaliere Bernini was in charge and the opportunity presented itself.

Bernini gave a considerable amount of work to the men, which must have gratified both Borromini and Radi. Yet the enterprise continued to lose money—or at least to be not as profitable as it should have been. Borromini was puzzled by this. He began to investigate, and it could not have taken him long to discover that Radi and Bernini had come to a secret arrangement separate from the agreement Borromini was aware of: Radi was paying Bernini a portion of the partnership's profits in exchange for the honor of supplying marble to the architect. It was the seventeenth-century version of a kickback.

Once Borromini learned of this subterfuge, his response was swift and unforgiving. In Passeri's words, he "abandoned every [sculptural] *impresa*, the friendship of Bernini, and the *fabbrica* of San Pietro and gave himself over entirely to architecture." Virgilio Spada wrote later of the dispute: "Despite the fact that they fell out with each other, that is, Bernini and Borromini, and their love changed into the greatest [canceled: mortal] hatred, but for other reasons than architecture."

The breach had come; the outcome was as inevitable as it was irreparable. The honor of his labors came at a very high price.

Borromini left both the Palazzo Barberini and St. Peter's for good. But seventeenth-century Rome was a very small town, and the two men's professional and personal paths would cross again.

FIVE

The Circle and the Triangle

⟿

BORROMINI'S HASTY EXIT FROM THE TWO
most important building projects in Rome
showed an almost breathtaking recklessness. It
seemed rash, even self-destructive, for a man
with so few prospects and connections to leave
what was at the time two high-profile posts.

But if the world thought Borromini was
foolish—precipitate and headstrong—he didn't
seem to care. Nothing in his or others' writing
about him gives any clue that he regretted his
decision to leave Bernini's employment. In fact,
he had achieved what Paolo Portoghesi de-
scribes as "a relative economic independence";
his abstemious life as a stonemason at St. Pe-
ter's and the Palazzo Barberini had given him
the luxury of being choosy about where—and
for whom—he worked.

Besides, Borromini would have found staying
on at either site intolerable. Bernini's dishonesty

and his refusal to give him his proper credit offended Borromini's fragile pride, lacerating his artist's thin skin. For the rest of his life, his rancor toward Bernini was a wound that never healed.

Their rift appeared to be less of a problem for Bernini. He seemed immune to such emotional hypochondria. He had neither the time nor the temperament to wallow in such sanctimony. He had the Baldacchino to finish, a palazzo to complete, and a string of other commissions that the pope wanted him to start. Being the most successful artist in Italy inoculated him from the virus of artistic umbrage.

Pay records at the Vatican indicate that Borromini's collaboration with Radi lasted until the end of 1632, and his final payment for his work at St. Peter's was made on January 22, 1633. After that, he was on his own.

He had two options. One was to pray that a saint's relics would be found—uncovered, perhaps, during a church renovation or the construction of a palazzo—and that he would be chosen to build (or rebuild) a shrine to house and display them. This was what happened to Bernini with his commission for Santa Bibiana. But there's no way to prepare for such good luck, as it depends too heavily on the whims of the Almighty or the attentiveness of a ditchdigger to be reliable. Prayer could take Borromini's career only so far. He needed an effort to start it.

The other alternative open to him was to offer his talents for free to a religious community that needed a new building but couldn't afford to hire an architect to design one. This is the course that Borromini took. In 1633 he approached an order called the Sodalizio dei Piceni and volunteered his services to renovate the order's church of Santa Casa di Loreto. Not much is known of what Borromini actually built, as the church has since been destroyed and

Borromini's efforts have been lost. But a happier outcome began the next year when Borromini offered to aid the Trinitarii Scalzi del Riscatto di Spagna, the Discalced (or Barefoot) Trinitarians.

This small community of friars seems a curiosity today, one of those religious orders peculiar to its time, like something out of Homer or the pages of Cervantes. It was founded in 1198 in France by Jean de Matha, a Provençal priest who during his first Mass had an extraordinary vision: *Vidi majestatem Dei et Deum tenentem in manibus suis duos vires habentes cathenas in tibiis, quorum unus niger et deformis apparuit, alter macer et pallidus.* Joseph Connors translates this as "He saw the Majesty of God, holding in his hands two men chained at the ankles, one black and deformed, the other white and thin." Matha's interpretation of this vision was clear: His purpose was to redeem Christians who had been captured by Moorish pirates that plundered the Mediterranean.

The order grew, and by 1611–12, one of the *scalzi*, or reformed sects, had established itself in Rome, in a cluster of modest houses near the Quattro Fontane, on the southwest corner of the intersection of what was then the Via Pia and the Via Felice, near the Quirinale Palace. These Barefoot Trinitarians—though this distinction was more symbolic than actual (they wore sandals)—acquired a house that they used as their church. They dedicated it to San Carlo Borromeo, the reforming archbishop of Milan who had been canonized in 1610. (It was the first church consecrated to the newly minted saint.) Across the intersection from the site was the palazzo of Cardinal Francesco Barberini, who was an early, if lackluster, contributor to the Trinitarians: Anthony Blunt notes that the cardinal "lost interest" in supporting the order, which may have contributed to the fact that construction on their site took the better part of four decades to complete.

Fra Juan de la Anunciación, the order's leader in Rome, became Borromini's first and most constant patron. A man of perplexing, even enigmatic, contradictions, he could be both reticent and dynamic, self-effacing and conceited. As procurator general, he exhorted his order to embrace, even revel in, an uncompromising level of poverty and humility, though he could be distracted by the trappings of power and position. When rumors circulated throughout the city that he was to be made a cardinal, Fra Juan could hardly contain his excitement. But when France vetoed the idea and the story turned out to be nothing more than idle gossip, he chastised himself bitterly for his arrogance and pride. From then on he wore a habit that was near rags and spent the rest of his life in his simple cell. The only time he left it was to travel to Urban's deathbed.

If others found Fra Juan difficult to please, Borromini did not. He was able to satisfy Fra Juan's vision for San Carlo alle Quattro Fontane, fulfilling the abbot's and his order's need for economy, plainness, and austerity while giving them grandeur, intricacy, and drama. Fra Juan believed that just as man should be humbled on earth, God should be exalted; he thought in rich, even extravagant terms. If the Trinitarians had had the money for a large and grandly decorated church, Fra Juan would have gladly paid any price to build the most lavish house of worship in Europe: "as rich as Solomon's temple, with a floor of emeralds and precious stones." But he did not. By selecting Borromini as his architect, he achieved something rarer than emeralds, and more precious: a church that captures the unknowable face of God.

Borromini's first project for them was more ordinary. He designed for the Trinitarians a *quarto di dormitorio*, the monks' residence. This grave, practical, four-story wing stands at the rear of

the complex away from the intersection, which was noisy even in the summer of 1634, when work began.

At first glance, Borromini's plan is functional but hardly imaginative. He devoted each floor to a particular purpose. But it is in the decoration of the wing's façade and in the rooms themselves where Borromini begins to find his architectural voice.

The façade is a clever manipulation of simple materials used to maximum effect. Along the center of the ground floor, Borromini planned a line of tall windows, set several feet off the ground, an arched doorway at both ends. The windows are framed by double bands of stucco, which create shallow arches around the windows and narrow pilasterlike vertical strips that trick the eye into thinking the space between the windows is wider than it really is. Between these faux pilasters Borromini placed slightly recessed panels, which look like spaces for paintings that had just been taken down.

Above the ground floor, against a wall empty of decoration, Borromini placed two stories of nine square windows. These spare, sober openings let light into the monks' cells. At the top of the building, above the monks' dormitory and the flurry of everyday life, Borromini placed the order's library. It's not as wide a floor as the ones below it, which allows Borromini the chance to place at either end of the library stone flourishes that curve up from the end of the building to the library's roofline. These large, bracketlike supports—actually buttresses—are a surprising embellishment and an ornament that few would see; the wing, after all, isn't visible to passersby.

Borromini devoted a great deal of attention and creativity to the rooms behind the façade. On the ground floor facing the garden, Borromini placed a dining room, called the refectory, a kitchen, and a washroom, with a small spiral staircase connecting

to the floors above. Though the layout is practical, even run-of-the-mill, the details of the rooms are not. They have been thought out carefully. For Borromini, the delight was in the details.

This is particularly true in the refectory. At first glance, the largest room on the ground floor is little more than a tall, rectangular box painted white. Along the exterior wall three high windows open to the southeast, which allows Rome's agreeable morning light to filter in. Its most prominent decoration is a shallow arched niche at the north end of the room, decorated along its curved top by two semicircles of stuccoed flowers, nine blossoms in each arc. They look like May Day decorations.

Yet such a description doesn't do the room justice; its ornamentation is more ingenious than that. It takes a moment to realize that there is hardly a right angle in the room. The room's four corners are concave, rounding into where the angle normally would be. Torgil Magnuson notes that Borromini is reputed to have claimed that "the corner is the enemy of all good architecture," and this room offers credible evidence that he practiced what he preached.

Borromini's ceiling decoration is also unusual for a room devoted to the task of feeding a religious community. Ringing the room, where the ceiling and walls meet, is a high molding (again decorated with stucco flowers) from which springs prominent vaults, fashioned in stucco, that follow the graceful coving of the ceiling. They meet in pointed, rather Gothic-looking arches that give an ecclesiastical feel to the room. At the flat center of the ceiling, Borromini planned a cross, though this may have never been completed. It certainly isn't in the room now.

The effect is a room that surprises, but gently. It is grander than one expects in a monastery, and there's an understated

movement to it. It calls to mind Joseph Addison's observation that "among all the figures in architecture, there are none that have a greater air than the concave and the convex.... [P]illars and vaulted roofs make a great part of those buildings which are designed for pomp and magnificence." The room is an odd place to encounter such grandeur.

Construction on the *quarto* took a little over a year and was nearly complete by the autumn of 1635. By that February, it was far enough along that Borromini could tackle his next project at San Carlo: the cloister.

The cloister is an anomaly, being both a public and a private space. Standing to the right of the church and built of travertine, it is actually a two-story courtyard, open to the sky, which connects to the passageway behind the church and to a staircase near the courtyard's entrance to the street that leads upstairs to a chapter house, a room to store linen, and a loft. Like the refectory and the church itself, the cloister is tall and narrow, with two rows of arches and stone columns enclosing the space, creating colonnades on both the ground floor and the floor above.

But the cloister is more dynamic than that. Six high archways—one in the center of the rectangle's short sides, two each on its long sides—are supported by pairs of refined but sturdy Tuscan columns, which ring the space. The arches dominate the cloister and give it a gravitas that its modest dimensions normally rule out. It's a similar decorative rhythm that Borromini used throughout his career, and it would prove to be an inspired solution to the problems he would encounter at San Giovanni in Laterano twenty years later.

At San Carlo, Borromini is being inventive. He intentionally complicates his cloister design by *not* placing all of the columns side by side. He positions the outside column on each side at a

SAN CARLO CLOISTER

45-degree angle from its partner, again blunting the corners, but this time curving the line between the columns out into the cloister. As a result, Borromini has taken what should be a rectangle and turned it into a narrow octagon that feels energetic, dynamic, *alive*. He has made a space that is traditionally thought of as a quiet place into one that is vibrant and unexpected. He has surprised us.

Borromini was equally surprising with the cloister's decorative details. On the upper story of the cloister, he designed pillars that are shorter and thinner than the ones below, and with octagonal capitals that skillfully mimic the shape of the courtyard. Perhaps the cloister's most inventive detail is Borromini's design for the balustrade that rings the upper floor. The balusters in it are pear-shaped—three-sided and wider at the bottom than they are at the top, their edges blunted and rounded. They look like a series of false noses, bulbous and pliable, as if they were made of putty instead of stone.

They may appear oddly shaped at first glance, but Borromini designed them for a particular reason of his own.

Borrowing from Michelangelo, who was the first architect to ignore the Renaissance tradition of centering the bulge of a baluster by lowering it to give the baluster a more solid profile, Borromini goes a step further. He alternates these oddly shaped balusters, flipping them top to bottom, so that, Blunt explains, "in one the bulge comes at the top and on the next at the bottom, thus producing an effect of movement rather than of stability"— what has been called "flickering movement." It's a small detail, easily overlooked, but it's an ingenious, even daring, design decision, as it ran counter to every architectural convention of the time. It certainly went beyond anything Bernini was working on.

For Borromini, it was both an aesthetic and a practical decision. He is said to have explained later that the alternating balusters offered anyone sitting behind the balustrade the opportunity to see what was going on in the courtyard below more easily. That may or may not be true. What cannot be argued is that the unusual balustrade contributes to the cloister's sense of arrested motion, of powerful forces frozen in time. Borromini's cloister is a vigorous and original creation, simultaneously oversize and snug, precise and elastic, understated and overwhelming. With it, he begins to find his own architectural voice, which, with the church of San Carlo, he would modulate further into the most distinctive of his generation.

LA CHIESA DI San Carlo alle Quattro Fontane is a church of singular imagination and rare, perhaps disturbing, talent. The intelligence and passion that Borromini displays in this building, which is so small that it's said it could fit into one of the piers supporting the dome of St. Peter's, is obvious as soon as one enters it.

But if San Carlo's size is overshadowed by St. Peter's—prompting Romans to call it "San Carlino"—its inventiveness made it the talk of Rome when it was built. It was "perhaps discussed more than praised," the British art historian Sacheverell Sitwell notes, but it's nonetheless a remarkable achievement. Nothing else like it had been seen in Rome.

Borromini began work on San Carlo in February 1638, when he was thirty-eight and two years after he had finished the cloister, which by June 1636 was essentially complete. Over the next several years he worked on the church, creating something distinctive at a reasonable cost. Accounts indicate that in the end,

the total cost of the church was 11,678 scudi—a bargain by the standards of the day.

Part of the church's modest cost was defrayed by a donation that Francesco Barberini made to the order, but as the Trinitarians acted as their own builder, and as Borromini took no money for his designs or for overseeing construction, they saved money there as well. Even if the order had hired an overseer for the project, Borromini would still have to be involved, so complex and sophisticated were his plans. Even today it's difficult to decipher on paper precisely what Borromini envisioned without seeing the finished church firsthand.

This is unquestionably Borromini's church, as personal an expression of the divine as can be found in Rome. Like St. Peter's, San Carlo is essentially a domed church, but that is where the similarity between them ends. Unlike St. Peter's, which began as a centralized round-domed church, San Carlo was envisioned and built as an ellipsis, with the entrance and the altar at opposite ends of its long axis, neither of which is more than twenty paces from the center of the floor, where a small shield with a red cross at its center—the symbol of the Trinitarians—is placed. The church has no side aisles, no transept; instead, subtle undulations in the walls create indentations that would allow two shallow side altars to be placed in them.

Like other architects from northern Italy who were familiar with (and still used) Gothic building techniques, Borromini used geometry as the basis of his designs for San Carlo. He began by placing two equilateral triangles of the same size so that they shared a side, creating a diamond. Using the center of both triangles, he drew two circles, which in turn created the outer curves of an ellipsis.

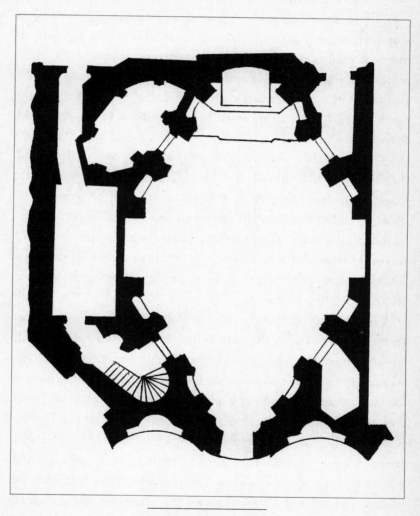

PLAN OF SAN CARLO

It has been an exercise that geometry students have learned for centuries. But in Borromini's hands, this technique becomes something more. His use of the circle and the triangle employed metaphor as well as mathematics: In addition to being two of the elemental shapes in geometry, they represent two of the most important images in Christianity. The triangle has long been a symbol of the Holy Trinity—the Father, the Son, and the Holy Spirit—while the circle represents the eternity of God, of a world without end.

These figures and images are everywhere in San Carlino, and they reach their figurative and literal zenith in the dome itself. Looking up from the center of the church, a visitor sees a dove, its wings outstretched, enclosed in a triangle, which in turn is surrounded by a circle. Borromini placed a potent symbol of God surrounded by the Trinity and the Infinite at the point in the church closest to heaven. It is a stirring reminder of the order's, and Borromini's, faith.

Nothing in San Carlino is there by accident, and nowhere is this truer than around the walls. Though the church's plan is oval, its walls don't strictly follow Borromini's elliptical outline. Instead, they seem to surge out at, and pull back from, the visitor, like waves crashing against a jetty. They are almost completely free of color: The entire church is of white stucco, broken up by black, lightly gilded wrought-iron grillwork, the subtle red Trinitarian cross, a gray stone floor, and the altarpieces, including the painting by Pierre Mignard of Saints Carlo Borromeo, Jean de Matha, and Félix of Valois. Around the perimeter of the church, Borromini positioned sixteen tall columns with Composite capitals, which stand against the walls like trees at the edge of a clearing. The capitals have the same dolphin-backed supports found

on the Baldacchino and jut out at an angle, just as the lintel does on Borromini's window at the Palazzo Barberini.

Borromini arranged the columns in odd, ambiguous rhythms, which agitate rather than soothe. The eye struggles to group them, first in clusters of two, then three, then four, depending on where it's looking. Between the columns, high up in the walls, Borromini placed a series of niches. Some are filled by statues, some lie empty; some have rounded tops carved to look like tongues of fire; others are shaped to look like three neatly arranged scallop shells. Beneath some of them, doorways lead out of the church (to the sacristy, the living quarters, to the stairway that descends to the chapel and crypt). More than two dozen angel heads, one of Borromini's favorite motifs, gaze down absently. They look as if they have other things on their minds than who might be wandering through—or praying—here.

Even the floor didn't escape Borromini's attention. In an oval at the center of a small field of white marble, he placed gray stones that radiate from the center and that act as a counterpoint to the dome above, the church's most elaborate, most magnificent feature.

The dome teems with detail. As with a theorem proven with exceptional ingenuity, every piece fits precisely in its place. For the dome, Borromini tossed aside simplicity and designed an intricately arranged series of octagons, hexagons, and crosses, each outlined in gold, to fit into the dome's oval like the pieces of a puzzle.

It is based on a Christian mosaic from another Roman church, Santa Costanza, but Blunt notes that "Borromini was the first architect to use it in three dimensions and on a dome rather than on a barrel-vault." The design suggests a honeycomb. If he intended

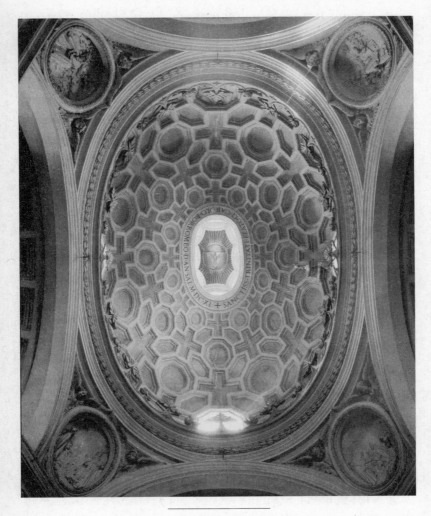

SAN CARLO DOME

it—and Borromini was fascinated by the symbolic—it's a witty homage to Cardinal Barberini's family and patronage.

The dome is also an optical trick: The sizes of the shapes in it diminish as they get closer to the pinnacle, making the dome seem taller and deeper than it actually is. Like the tall columns that ring San Carlo, the dome was another visual trick Borromini employed to make the church seem larger and more imposing than its size would suggest. He managed all of this by not providing a single window in the church (most of the light enters from the lantern atop the dome and from octagonal windows invisible from the floor that nestle behind a ring of stone leaves at the base of the dome). The result is a space rich with light, even though its source is mysterious and unknown, like the existence of God.

While Borromini worked at San Carlo, other patrons began to take notice. One was Ascanio Filomarino, a protégé of Urban VIII whom the pope appointed archbishop of Naples. Filomarino engaged Borromini to design an altar for the church of Santissimi Apostoli in Naples. Borromini planned and built the altar—a restrained, rather tentative concoction in white marble (Portoghesi calls it "subtly aristocratic") that displays relatively little of the power and passion of his later work—in Rome and shipped it south, where it was installed in the church's transept, possibly by Borromini himself. Blunt contends that the architect's demanding personality and work habits made his traveling to Naples to oversee its construction and placement likely. He argues that it would be "completely out of character for Borromini to produce a work without knowing the setting for which it was destined, the architecture of the church in which it was to stand, the lighting and all the other pre-existing factors which were always for him the starting-point for any design."

In addition, "the altar fits the transept . . . so harmoniously that it seems unthinkable that it should have been designed by someone who had not actually seen the setting in which it was to be placed." It is a tall, slightly concave marble screen anchored by two Corinthian columns on each side of a marble altar that bows out toward the viewer. The columns support a heavy cornice and an unusual pediment of two quarter-circles that support a triangle above—a smaller, earlier version of the pediment over the entrance to the Oratorio di San Filippo Neri in Rome, which Borromini also designed. This altar is one of Borromini's few works outside Rome and his only commission in Bernini's birth city.

Count Ambrogio Carpegna was another early Borromini patron. In 1638 he chose Borromini to enlarge a palazzo on the northeastern side of the Piazza Trevi (where the Trevi Fountain is today), but he died suddenly in 1643 before Borromini could make much headway on the project, managing only some stucco work at the entryway and an unusual curving ramp.

The count's brother, Cardinal Ulderico Carpegna, proved to be a more constant—and longer-lived—supporter. In 1644 he engaged Borromini to turn his talents to the altar at Sant'Anastasia, a church that stands not far from the Tiber near the bottom of the south side of the Palatine Hill. One of Rome's first *tituli*, or parish churches, which Urban rebuilt when he became pope, Sant'Anastasia has a long history. A church was built on the site in the fourth century A.D., where it emerged as one of the upstart religion's first public places of worship in Rome. Saint Jerome, called one of the Doctors of the Church, is reputed to have been its first parish priest. (Nothing of Borromini's work currently exists at the church.)

By May 1641 the interior of San Carlo was essentially complete. It was hailed as a success immediately, a brilliant synthesis

of talent and execution. According to Fra Juan de San Bonaventura, who closely followed the work at San Carlino, the church was "judged by all to be of an art so rare that it seems that nothing similar exists in all the world for its rare and extraordinary artifice and fantasy." Proof of the achievement, Bonaventura said, was "those of different countries who continually, as they arrive in Rome, beg for drawings of it. Very often we receive such requests from Germans, Flemings, Frenchmen, Italians, Spaniards and even Indians, who would give anything to have a drawing of this church, which when they see it desire to have it even more than when they had heard it praised in their country."

Borromini, the cleric wrote, "is continually harassed by both foreigners and natives who wish to have the drawing. Signor Francesco would have given great satisfaction and pleasure to the world and to cultured and curious intellects if he had printed a drawing of his church which is so intensely desired by so many." It would have been shrewd of Signor Francesco to have done precisely that. Yet he didn't.

Bonaventura offers two explanations. One is that Borromini was too generous. He "worked on his buildings and labored without any concern for economic gain, a fact that can be affirmed with many examples, but particularly with the case of our building, for which he has never wished to receive a *giulio.*" If Borromini didn't accept money for designing San Carlino, the argument goes, why should he accept money for copies of the plans?

The other is that by the time San Carlino was complete, Borromini had established himself as an architect and had other commissions elsewhere.

A third possibility is his anxiety that others would take credit for his church's inventiveness and creativity. Given how he reacted

to his treatment at St. Peter's, Borromini could have feared that
another architect would call Borromini's work his own. One way
to prevent it would be to keep the plans away from others.

He needn't have worried. At the time that the interior of San
Carlino was completed, Borromini received all the admiration he
could have hoped for. Giovanni Baglione, in his *Le vite de' pittori,
scultori, architetti, ed intagliatori* (1642), wrote that San Carlino was a
"*bella chiesetta, la quale è leggiadra, e capricciosa architettura di Francesco
Bor[r]omini Lombardo*" ("beautiful little church, from the fantastic
architecture of the Lombard Francesco Borromini"). Bonaven-
tura wrote that the church had been "well founded on the antique
and on the writings of the best architects." It was, he said, "a
work so excellent that just as it was the first that Signor Francesco
had made in his life, so was it first for its design."

The Discalced Trinitarians were pleased: Their church's renown
prompted Urban to grant them full independence from the other
sects of Trinitarians. When the church was consecrated in 1646,
Cardinal Francesco Barberini, the nephew of the pope, performed
the ceremony.

Borromini's future as an independent architect seemed
hopeful, even rosy—a surprising turn of events in the life of a
man known for being neither of these. Sitwell notes that Gio-
vanni Battista Passeri, Borromini's contemporary, understood
that Bernini and Borromini were "set apart by instinct, [Borro-
mini] being cerebral more than sensual, silent by nature, celi-
bate, deeply religious, and difficult to know. He frightened
people, was dressed in funeral black like a Spaniard, and only
sported red garters and rosettes in his shoes." But sometimes
even misfits can succeed—or at least be offered the opportu-
nity to succeed.

✳ ✳ ✳

FOR MOST OF the time that Borromini was toiling as an architect for a small religious order, Bernini was working as a sculptor for the great. At least during the early years of Borromini's independent career, the two didn't compete head-to-head. In fact, Bernini is known to have assisted Borromini in trying to obtain a post. In 1632, as one of the last favors he did for his former assistant, Bernini wrote a letter recommending that Borromini be offered the position of architect of La Sapienza, Rome's university.

Bernini's motives for such a collegial gesture aren't precisely clear. Perhaps he wanted to keep Borromini from leaving St. Peter's (the logic being that if Borromini had another post he owed to Bernini, he might be willing to stay on at St. Peter's). Perhaps it was a quid pro quo, a reward for Borromini's silence concerning Bernini's questionable activities at St. Peter's and the credit he took for Borromini's work there. Or perhaps Bernini honestly felt that Borromini was the best man for the post.

Whatever the reason, Bernini's letter secured the papal appointment for Borromini and provided Borromini with the opportunity to create his other great ecclesiastical masterpiece, Sant'Ivo alla Sapienza.

But Sant'Ivo was several years in the future. While Borromini was at San Carlino, Bernini was working on Urban's tomb. Even before Borromini had left St. Peter's, Urban had assigned Bernini the task of carving his monument, which would be placed on the main floor of the basilica. What Bernini fashioned over the next twenty years—completing it four years after Urban's death—was a reinterpretation of Michelangelo's Medici tomb in Florence.

Sitting atop a marble plinth a dozen feet in the air and garnished with a handful of bronze Barberini bees is a huge statue of Urban. Twice life-size and made of gilded bronze, the statue depicts the pope dressed in the heavy, formal garments of his office, his right hand raised in a final, eternal benediction. The sculpture has a dark, brooding presence, at once sober and sobering, and is in sharp contrast to what is set beneath it, closer to the ground. Arranged on either side of a bronzed and gilded sarcophagus are statues of two women, both of white marble. On the left is Divine Love or Charity, who holds in her arms (rather awkwardly— it looks as if she's about to drop it) an overlarge and unwieldy baby. Her attention is distracted by a crying toddler at her knee, who reaches up to her for attention. Across from her is Justice, who gazes heavenward, as if pondering the inequities of man's brief time on earth. Her head leans on her right hand, while her left holds loosely a stone Sword of Truth, which leans almost casually against her upper arm.

The silent, solemn centerpiece of the monument itself, the figure that commands attention, is the shrouded bronze skeleton that lies on top of the sarcophagus, its gilded wings resting lightly along it, as if it were there only long enough to record in the Book of Life the passing of *Urbanus VIII Barberinus Pont. Max.* It is a pointed reminder of the transience of power, fame, and life itself.

In 1632, while he worked on Urban's tomb, Bernini began his most extraordinary ecclesiastical bust, that of Cardinal Scipione Borghese, Bernini's first patron.

Given the amount of work that Urban was pressing on Bernini, it is remarkable that the pope allowed his prodigy time to carve the bust for a private patron, powerful though Cardinal Borghese

was. But the cardinal was a friend of both Urban's and Bernini's, so it's possible that the commission was pressed upon Bernini by the pope himself.

It was a propitious choice, as Bernini carved a bust that Howard Hibbard called "a milestone in the history of sculpture and one of the finest portraits of all time." This is doubly true, perhaps, because there are actually *two* busts of Borghese, and the story behind their creation is as extraordinary as the existence of the busts themselves.

According to Filippo Baldinucci, Bernini had been working on the bust of Cardinal Borghese and "was almost completed when a mishap occurred. A crack appeared in the marble across the whole of the forehead." Bernini, who, Baldinucci said, was "very bold," decided not to scrap the bust, as most sculptors undoubtedly would have. Instead, he ordered another piece of marble and, "without telling a soul," began to carve another, nearly identical bust.

"In order to free himself, and even more the Cardinal, from the embarrassment resulting from bringing such news [of the imperfect bust], he completed the bust in a little more than two weeks," though there is some question about the actual time it took him to complete it. The second one was, Baldinucci notes, "not one jot less in beauty."

When the cardinal arrived at Bernini's studio to see the finished work, Bernini blithely showed him the first bust, "whose defect in the polished state appeared even more prominent and disfiguring." Such was the cardinal's esteem for Bernini that the cardinal hid his anguish "in order not to distress" the sculptor, Baldinucci says.

The sly Bernini—in one version of the story, the translator

used the word "astute"—feigned ignorance at the cardinal's disappointment. Instead, Bernini chatted amiably with him, never acknowledging or even mentioning the defect in the bust, which is obvious even today, marring the forehead like a gash.

A few minutes passed, the story goes, and Bernini finally took pity on his disillusioned friend. Without warning the cardinal, he uncovered the second bust. The response, Baldinucci says, was immediate and enthusiastic, "since relief is more satisfying when the suffering has been most severe." The joy that Borghese "displayed upon seeing the second portrait without defect made very evident how much pain he had felt when he beheld the first one," Baldinucci explains. "The diligent care that Bernini employed to avoid offending him pleased the cardinal so much."

In both busts Bernini managed to capture the essence of Borghese. Even though there are subtle differences—the two are on view at the Galleria Borghese—they achieve a verisimilitude, a vitality, that other busts of the time lack.

Bernini once described how he approached trying to capture his subjects in stone by using a metaphor of light and shadow: "If of an evening you put a candle behind a person so that his shadow is thrown onto a wall, you will recognize the person from the shadow, for it is a true saying that no one has his head on his shoulders in the same way as anyone else, and the same is true of the rest. The first thing to keep in mind, to achieve resemblance in a portrait, is the whole person before the details."

But in the busts of Borghese, Bernini accomplished more than just capturing the shadow of a man. What he did was *involve* Borghese in the drama. Perhaps better than any other artist of his time, Bernini understood the psychological impact that surprise has on a viewer and his reaction; it can be everything.

Bernini understood how to manage a person's response, be it in front of a sculpted piece of marble or inside a church.

It is this skill, this intuitive ability to control, even manipulate, a person's reaction, that was one of Bernini's great gifts. Few of his contemporaries understood it; fewer still shared it, least of all Borromini. Bernini was an exceptional artist who was also a master showman. He was a conjurer par excellence, the Houdini of his age. Throughout his career he used this genius for surprise, and always to his advantage.

Borromini had no such aptitude. It was a talent he could never hope to learn. He would pay the price for such a deficiency throughout his career.

But first he would enjoy the triumph of seeing a rival stumble.

SIX

"Ignorant Persons and Copyists"

AS BORROMINI WAS FINISHING THE DORMI-
tory wing and cloister at San Carlo, he was of-
fered an even more important commission: the
Oratorio di San Filippo Neri, which was to be
built on the western side of their church, Santa
Maria in Valicella, still known today as the
Chiesa Nuova, the New Church. It was a plum
appointment to design an impressive hall de-
voted to the performance of sacred music, and
the Oratorians were a more visible order than the
Trinitarians. Their church and other buildings
were close to the Via del Papa, which at the time
was one of the best-traveled streets in Rome.

Like the Trinitarians, the Oratorians (or the
Filippini, as they were also called) were a rela-
tively new order. Founded in 1561 by Filippo
Neri, who had long worked with the poor of
Rome, it was a loose association of like-minded
men who wanted to help the city's needy and

hoped to promote learning to a wider audience. These Filippini were not cloistered as the Trinitarians were; they lived in the world but existed as simply as they could—a difficult and complicated balancing act, given the temptations posed by Rome and the worldly papal court across the Tiber. Nevertheless, Neri's goal, according to Anthony Blunt, was to "spread among all classes of society, rich and poor, learned and ignorant, rulers and servants," the value of the arts in disseminating the church's teachings.

In 1575 Pope Gregory XIII gave Neri and his followers the crumbling medieval church of Santa Maria in Valicella and a Franciscan convent nearby. The church stands along what is now the crowded and busy Corso Vittorio Emanuele just west of the Pantheon, but in the sixteenth century it was surrounded by a choking warren of jumbled (and equally crowded) streets in a rough neighborhood of laborers and artisans. The Oratorians engaged Matteo di Città di Castello to design a new church for the order, which he did and which another architect, Martino Longhi the Elder, built. The foundation stone for the new church was laid on September 15, 1575, and over the next quarter century Castello's church (including a rather grim façade designed by Fausto Rughesi and built between 1594 and 1606) rose as the Filippini established themselves in the neighborhood.

Neri died on May 27, 1595, but the order's mission continued. By the beginning of the seventeenth century, the Filippini had established a firm presence in the neighborhood and had become known for their pious works and impressive collection of paintings by the likes of Caravaggio, the Cavalier d'Arpino, even Rubens. But by then they had also outgrown their cramped and old-fashioned lodgings, which hugged the walls along the east side of the church. In addition, because the order placed a great

deal of importance on music as a convincing "art of persuasion"—
Neri believed musical reform should go hand in hand with reli-
gious reform—the order's leaders wanted to add more space to
the west of the church to build a *casa*, or new residence, which
would include an oratory, "where religious gatherings of a non-
liturgical nature could be held," and a library.

They focused their attention on several irregularly shaped
blocks of small houses near the church—Borromini calls each of
them *"isola"* on his site plan for the Oratory—and convinced the
pope to issue a papal bull that allowed the order the opportunity
to acquire the land.

In 1622 Neri was canonized by Pope Gregory XV, and Vir-
gilio Spada, a young nobleman from Brisighella, a town in the
Romagna north of Florence, joined the order. Both events proved
fortuitous: Neri's recognition as a saint brought greater attention
to the Filippini, and Spada would become one of the most influ-
ential arbiters of architectural taste in Rome. His sense of what was
good design—appropriate, well-proportioned, and dignified—
influenced construction in Rome for the next half century. Per-
haps more important, his opinion of *who* was a good architect
would carry almost equal weight. And to Borromini's great good
fortune, Spada saw talent in the young architect.

It was not long after Spada joined the Oratorians that he be-
came the order's primary negotiator with the architects and builders
it employed: Spada's father had been an enthusiastic builder, and
from his example the young cleric learned construction pro-
cedures and processes that were useful to the Oratorians. For
more than a decade, Spada worked closely with Paolo Maruscelli,
the order's initial architect of choice for the construction of the
new wing. From 1624 to 1637, they developed what became an

ambitious 131-room plan for a complex that included new living quarters for the order's members, a library, a refectory, and an oratory, which Maruscelli placed at a 90-degree angle to the church along its southwest side, where it stands today.

But Maruscelli was neither its builder nor, in the end, its architect.

There is some question as to how Borromini came to be the architect of the Oratory. According to Fra Juan de San Bonaventura, the Oratorians posted "throughout Rome and the most noble cities of Italy" declarations that they were holding a competition to choose an architect for their new quarters.

"A great number of architects entered the competition," Bonaventura wrote, "even Signor Francesco Borromini, who was never recommended by anyone nor even known to the fathers"—a claim that may or may not be true, as they must have known of his work at San Carlino.

"All having made their designs according to the measurements and requirements given by the fathers," Bonaventura says, "they were presented to the congregation." The selection, by what the call for entrants had indicated would be a "secret ballot," was Borromini, whose design "had the advantage over all the others." Even more remarkable, Bonaventura notes, was that the architect had been chosen "without ever having been recommended by any cardinal or prince, but only by his actions and labors"—a revolutionary thought in seventeenth-century Rome.

Yet Maruscelli had been the Oratorians' architect since 1624 and had designed an entire complex for them. So why in 1637 did they engage Borromini? The explanation is complicated.

What is undisputed is that Borromini came to work for the Oratorians in 1637 to address some of the details Maruscelli was

too busy to work out, such as the altar and the *credenzi* in the sacristy, an oblong room west of the church's transept that stands along the north side of a small cloister. But not long after Borromini arrived on the scene, he began to make his presence—and his ambition—felt.

He told the order's *preposito*, or prior, Padre Angelo Saluzzi, that Maruscelli's designs were riddled with defects. Particularly terrible, Borromini charged, were the designs for the Oratory and the placement of its windows.

He had a point. The Oratory was to be placed between the street and the same cloister that the sacristy opened onto, and the Oratory's northern windows, which looked out into the courtyard it shared with the sacristy, didn't correspond to the windows of the other room—an architectural mortal sin.

To be fair, Maruscelli didn't cause this problem. The initial placement of the Oratory was determined by the architect Mario Arconio in his 1621 plans for the building. Maruscelli was simply trying to conceal this problem (or at least de-emphasize it) by putting an arcade between the two mismatched wings—a solution that didn't please Borromini or, in the end, the Oratorians.

In his own *Opus architectonicum,* the book of Borromini's works written by Spada with Borromini's help, the two explain that the Oratorians "had diverse designs drawn up [for the complex, including the Oratory], both by their own architect and others. But they were little satisfied, because, as it was necessary to accord with a loggia on the inside, no way was found [in the Oratory] to order the windows so that they would have symmetry, or to locate the door conveniently. After long study, designs, and meetings, the best, or rather the least objectionable, was found to be a design by Signor Paolo Maruscelli." This was not exactly a rousing

endorsement, but it seems clear that Maruscelli won whatever competition there may have been.

Spada and Borromini continue: "In this situation I was proposed as an alternative.... And although I encountered the same difficulties of conforming to the loggia inside the building complex ... nevertheless, after having labored over it for some time, I finally found a solution that satisfied everyone and which resolved all the difficulties."

According to Paolo Portoghesi, Maruscelli never found what he calls "a rhythmic concordance" between the courtyard's arches and the Oratory's windows. The Oratorians consulted other architects—including Girolamo Rainaldi, with whom Borromini would clash later in his career—and perhaps held another competition, the result of which was Borromini's appointment. On May 11, 1637, the order voted to have Borromini assist Maruscelli. According to the minutes of the meeting:

> The Prior said that since the building of the Oratory had to proceed they had a number of drawings made by various architects, and since one still had to determine which was the best, to this end were asked ... the Padri Marsilio Honorati Pietro Jacomo Baci and Virgilio Spada, and all the designs having been diligently studied it was unanimously concluded that the most appropriate was that by Sig. Francesco Borromini. And in order that the said building be fabricated with all the diligence and exactness possible it was decided that Sig. Paolo Maruscelli must be informed that for all that would be necessary for the building of the house he should have as associate the said Sig. Francesco Borromini, since the congregation has in effect seen his value ... and if the said Sig. Maruscelli should not consent

to have for associate the said Sig. Borromini, the entire care of the building should be given to Sig. Borromini.

It was a public rebuke to the elder architect. But as far as the Oratorians were concerned, his work hadn't been satisfactory. The younger architect, as brash and opinionated as he was—and whom Spada supported so enthusiastically—would be given a chance to see what he could design.

"Partly through his brilliance at problem-solving in . . . small matters and partly through the amazing precision (*essattezza*) of his drawings," Joseph Connors says, Borromini was the natural choice. It did not hurt his chances, of course, that Spada thought highly of his talents. He must have seen Borromini's remarkable work at San Carlino and realized that he was an architect of unusual, even unparalleled, talent.

Spada was perhaps the only man in Rome who remained a loyal friend and supporter throughout Borromini's difficult life. He became Borromini's most steadfast advocate, particularly later in his life, when the architect's professional behavior became erratic, even self-destructive.

By deciding to have two architects on the project, the Oratorians created an arrangement destined to fail. And it did. Even though Borromini's initial duties were to execute Maruscelli's plans, he began almost immediately to suggest alterations. Soon after Borromini's appointment, Maruscelli resigned his post, but not before claiming that the vault Borromini was envisioning for the Oratory's ceiling was too weak and would crack.

Writing later in *Opus architectonicum,* Borromini defends his critique of Maruscelli's work, particularly his contention that Maruscelli mishandled the original sacristy: "With [Maruscelli's] advice

and design, they [the Oratorians] established for the Sacristy the form and location that is seen today . . . without deciding, so far as I know, the rest of the design of the building, which has caused a certain disruption in the correspondence of the windows and the levels of the entire house." Borromini even had the audacity to reprove Maruscelli for criticizing his counterproposal, writing, "It is common for ignorant persons and copyists to blame the novel inventions of good men because, given the fact that they cannot invent new things because they are bereft of the ability to design and of real understanding of the art [i.e., architecture], they set about blaming those who are real architects and masters of the art."

This is bombast for many reasons, not the least of which is that the Oratory as built is in large part Maruscelli's creation. He had determined where it would stand and how the rooms around it should be arranged. What Borromini added was a greater sense of importance, of seriousness. Connors indicates that "Maruscelli's oratory had been a simple vaulted room with a small chapel for an altar. Borromini's was instead a daringly skeletal structure with tall slender loggias for singers at one end and space for visitors at the other." Two rectangular cloisters—a large one placed to the north of the sacristy, a smaller one south of it, abutting the new Oratory—had the necessary rooms for comfortable domestic living (the refectory and dormitory) arranged around them. The more public rooms were to the south, closer to the street: the Oratory and several guest rooms for visitors.

Despite considerable experimentation, Borromini was forced to leave the Oratory where Maruscelli had put it, along the front of the new building, but he tried to make the wing's façade more imposing and logical while keeping it from competing with the church next door, to which it was attached by a narrow, spinelike

passageway that ran the length of the complex. And to a certain extent he succeeded. For example, the entrance that he placed in the middle of the façade appears—at least from the busy *corso*—to be the main entrance to the Oratory. But it isn't. The visitor expects to enter the room and gaze down its main axis, as one does in a church. He doesn't because he can't. The axis of the Oratory is, in fact, 90 degrees to the left of the entrance. A visitor must turn to enter the room. It's like entering a school auditorium from a side door: While the entrance is serviceable, the drama and impact of the room are blunted.

The Oratory itself—Portoghesi calls it "a prismatic hall"—is relatively simple and is similar in important ways to the refectory at San Carlino. It is a rectangular box of two stories, with narrow bands of pilasters organized in strange but logical rhythms that

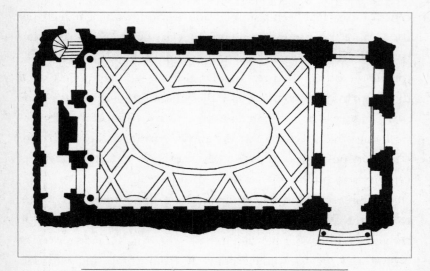

PLAN OF THE ORATORIO DI SAN FILIPPO NERI

encase the room. These square, staid pilasters, which stand along the walls like shy bystanders at a public meeting, are arranged in pairs, but the central pair is set slightly wider than the others. This was Borromini's solution to a thorny problem that had stumped Maruscelli and had contributed to the congregation asking for Borromini's help: How can the Oratory's windows synchronize with the arches of the courtyard just outside on its north side?

His solution was both clever and cost-effective. By adopting an understated but definite cadence of wall, pilaster, and statuary niche (large enough for a statue of San Filippo to be placed in it), Borromini succeeded in doing what Maruscelli could not: placing the Oratory's windows in a logical, symmetrical pattern that allows them to coincide with the courtyard outside. His solution was similar to the arrangement of pilasters he created for the façade of San Carlino's domestic wing. The Oratory's slight strips of stucco and stone climb up the walls like vines, moving past the high windows that let in light while keeping out distractions, and meeting at the center of the ceiling in a curious oval painting (which Borromini had left empty) whose central image is a shining triangle from which rays of golden light emanate.

Borromini also borrowed ideas he had used from his refectory, using similarly solemn pilasters to dissolve the corners, thereby "smoothing the transition between the long and short walls," Torgil Magnuson notes.

But that was only part of Borromini's solution for the mismatched courtyard and windows. The windows that looked out into the south *cortile* from the sacristy—the same courtyard that the Oratory shares—were asymmetrical, and here Borromini used some architectural legerdemain to solve the problem. He placed false windows next to real ones. It was a simple but effective

deception: The result was to fool the inattentive eye into seeing broader windows than are actually there. "One thinks that with a bit of perspective made of stucco, one can bring about some kind of solution," Borromini said, and he was right.

In addition, Borromini curved the two northern corners of the courtyard outside the sacristy, creating two small, shadowy caverns, one on top of the other, which pull the eye toward the center of the wall and disguise the ungainly angle where the sacristy and courtyard meet. He understood, perhaps better than most architects, how to camouflage a building's faults.

He also knew how to reuse materials in imaginative ways. During construction, four ancient columns had been uncovered, and it was determined that they would be appropriate for the stairway vestibule. But they were too short. To solve this, Borromini carved travertine bases of leaves for the columns. It made the columns look as if they were sprouts.

The new Oratory was completed by 1640, and almost immediately it began to be modified. A richly decorated singers' gallery, a fantasy of polychrome marble that Borromini did not design and argued against, was added to the room's western end, and the windows that gave out onto the courtyard were closed up, making the reason for Borromini's neat solution irrelevant. And the longer that Borromini worked with the Oratorians, the less he and his ideas appealed to them. The monks, Magnuson explains, had always "insisted on approving the smallest details" of new construction, even after the Oratory was completed, and apparently they thought that their architect's peculiar and unorthodox outlook could be seen by some as "an expression of frivolity and pride." Even worse, they found him unhelpful, even disloyal. During a disagreement in 1650 with their master mason over costs for

the façade of the clock tower, Borromini refused to let the Oratorians see his *libri delle misure*—his construction account books—which the order found insulting.

For his part, Borromini found the Oratorians equally exasperating, writing in the preface of *Opus architectonicum* that "I beg whoever should read these sayings of mine to reflect that I have had to serve a Congregation of souls so restrained that they have stayed my hands from applying ornament, and consequently in many places it has behooved me to obey their will rather than art."

By the middle of 1652, the Oratorians had become so unhappy with Borromini's manner that on August 23 they appointed Camillo Arcucci as their official architect "in place of Borromini, who has refused to serve, in the future, as architect of our congregation." This came as a surprise to Borromini and to Spada, who by then was living in the Vatican as one of Pope Innocent X's most trusted aides.

But this was all to come. Borromini still had to address the Oratory's façade. Though it, too, has been modified from its original elevation, it is still one of Rome's most refined and sophisticated buildings.

Borromini's intent was clear: *Ingannare la vista dei passaggieri.* I resolve to deceive the sight of passersby. He had two main challenges: He must adhere to the monks' dictum that the Oratory not compete with the travertine front of their church and that it be as unadorned as possible. He was up to the task, in great part because of his ability to balance a building's practicalities with its aesthetics.

He used a flat, polished brick that could be laid with so little mortar that it was almost invisible. He was allowed a bit of travertine only for the columns around the Oratory's center door, but the monks admonished him not to use marble, which would

be insufficiently modest. Such micromanagement might have prompted Borromini to comment in part in *Opus architectonicum,* "How wonderful it would be if one could construct a whole façade out of a single piece of terracotta."

Borromini saw his Oratory façade in very human terms. "In giving form to said façade," he wrote, "I created the figure of the human body with open arms as if it embraces everyone who enters; and this open-armed figure is divided in five parts, that is, the chest in the center, and the arm, each in two sections [arm and forearm] as they open out." It curves in subtly, carefully, giving it, Blunt says, "the springiness of a sheet of metal which has been slightly curved under pressure."

The façade stands three stories tall and is capped by a triangular pediment bracketed at its side angles by two curving sections of a circle. As in most of Borromini's buildings, the central section of the façade pushes away from the piazza it stands in, the walls drawing away from a visitor like a shy child into its mother's skirts. Yet the façade is alive with incident and detail, such as the portico over the central door, which is topped by a pediment that is a miniature version of its big brother above.

Like the Oratory's interior, the façade is dominated by two sets of six monumental pilasters, which stand between the three stories of arched windows, each story arched with a different top. They are shallow and also made of brick, their capitals almost inconsequential. The central part of the façade is concave and looks like a narrow tower of a medieval castle; but on the third story, at the level of the Oratorians' library, Borromini defies expectations by placing a tall, concave niche that stands behind an oval balcony, which bows out over the tower below. (The balcony's balustrade has the same bowling-pin-shaped balusters that

Borromini used in the cloister balcony at San Carlino.) The niche itself resembles the niche he installed in the refectory at San Carlino, but here, instead of making room for a serving table, he places a large wooden door, which stands beneath an elaborate stone pediment that looks like a livelier version of what sits above the main door of the Chiesa Nuova. Above this pediment is a wide, scalloped near circle, with a similar set of two rows of stone florets that Borromini also used at San Carlino, which allow just enough room beneath them to place a dove, its wings outspread, its face turned to the east to catch the morning sun. Here, though, it looks as if a piece of the façade has been scraped away, like a scoop of gelato from a tub at a neighborhood kiosk.

Magnuson calls this "one of Borromini's most remarkable façades." It's surprising and unconventional, drawing in the visitor with its odd, curious look. But the whole effect of the building itself never really comes together. Creative and inventive though the façade and the Oratory are, they feel as if Borromini tried too hard. He's too clever by half. His work here is both too cautious and too vigorous, like that of a talented student who studied too thoroughly for an examination and feels compelled to shout out the answers even before the questions are posed.

Perhaps if Borromini's creativity had been allowed more freedom, the Oratory would seem less calculated, less confined. But although the restraints imposed by the Oratorians proved too strict for him, he would have other opportunities to indulge them.

AT THIS TIME, Bernini's experience was the opposite of Borromini's: He was living a life that wasn't strict enough. It was too

self-indulgent, and he risked losing everything and being branded a murderer.

While Borromini was known throughout Rome for his chastity, Bernini was a man who enjoyed women and their charms. When he was in his sixties, he admitted that in his youth he had "a great inclination to pleasure." Nowhere else in his life was this more evident than in his passionate, tempestuous affair with Costanza Bonarelli, the wife of Matteo Bonarelli, one of the assistants Bernini hired in 1636 to work on the monument to Countess Matilda of Tuscany that he was carving for St. Peter's. Costanza became, if not the love of his life, at least his most public expression of his passion.

Several of the men caught up in the drama that surrounded Bernini and Costanza were involved in the carving of the tomb dedicated to Countess Matilda, a medieval noblewoman who donated her money and property to the church. According to Filippo Baldinucci, most of the marble statue of Matilda (except the head) is the work of Luigi Bernini, Bernini's brother, who worked in Bernini's studio and was his brother's *soprastante* at St. Peter's. The two putti holding the coat of arms were carved by Matteo Bonarelli, Costanza's husband.

Little is known about Costanza or the details of her life before she met Bernini. And there's nothing in Bernini's writings to indicate what he really thought of her—no unsent scrap of poetry, no forgotten melody scratched across a piece of paper. His feelings for her are clear when he expressed them in the idiom he communicated in best: sculpture. Some speculate that Bernini used Costanza as a model for the statue of Divine Love that adorns Urban's tomb.

Around 1635, at about the time that Matteo Bonarelli began working in Bernini's studio, the Cavaliere—he had been knighted by Gregory XV, receiving the Order of Christ and what Filippo

Baldinucci called a "rich pension that went with it"—carved a bust of Costanza, who at the time was his mistress. According to Domenico Bernini, Bernini "was then inflamed with desire for this woman," and nearly four centuries later, it is still possible to see why. The bust is an irresistible expression of the bewitching power of desire.

It is one of the few portrait busts of a woman that Bernini carved, and it is the only known bust he carved as an adult that was not for a specific commission. One need only to look at it to know that Bernini created it for reasons that went beyond money or status. In fact, what makes the bust so profound, so unambiguous, is its startling intimacy. Sensuous and unapologetic, the rendering of Costanza's head and shoulders is free of the formality of his papal busts or the pious majesty of his religious figures. This is no idealized portrait of a prince of the church or a martyr to the faith. This is the likeness of a woman of her time with an appetite for the pleasant temptations that life can offer.

Bernini's portrait seems to catch Costanza unaware, exposed and unguarded. Her simple dress is open at the neck, offering the slightest glimpse of the top of her breasts. Her hair, free of ornament, is pushed away from her face, as if she had not yet arranged it for the day, and an untidy braid is curled into a bun at the back of her head. Her sturdy but graceful neck is un-adorned by jewelry. There's a hint of concern in her face: Her brow is furrowed slightly, her large, well-spaced eyes are wide open and watchful, and her lips are pursed, as if she is about to speak.

The entire effect calls to mind Bernini's own advice for how to sculpt a human being: "To succeed with a portrait, you must

fix an attitude and try to depict it well. The finest moment you can choose for the mouth is when the sitter stops speaking or when he starts to speak."

Costanza looks as if she is afraid the visitor she had waited so long to see might leave soon—sooner than she expected. Though carved from a block of cool, white marble, the bust swells with vitality; it's youthful and forthright, passionate and tender. A contemporary letter indicates that Bernini was *"fieramente in-amorato"*: inflamed with passion for her.

But this passion extended to other members of Bernini's family, with tragic consequences.

In May 1638 word had spread throughout Rome of a horrific altercation between Bernini and his brother Luigi, who had also developed an interest in the young woman. Bernini began to hear tales about the two and was determined to find out if they were true. He announced to his family one day—Bernini at age forty and his brothers still lived with their widowed mother in the house Pietro had bought next to the church of Santa Maria Maggiore—that he was going to the country early the next day. But on the morning of his supposed departure, instead of leaving the city, he directed his coachman to take him to Costanza's house near the Vatican. There he lingered, watching.

He didn't have long to wait. After a time, he saw his brother Luigi come out of Costanza's house. The young woman, Charles Avery notes delicately, "accompanied him amorously to the door in a suggestively dishevelled state." Costanza had proven to be inconstant, her love as empty as the devil's promises.

Angry and humiliated, Bernini pursued Luigi to St. Peter's, where the younger man was working. He attacked his brother with a crowbar. Bernini's intent was clear: He wanted to kill, to

maim. The man who was "notorious for his ruthless ambition and the lengths to which he would go to defeat his rivals" wanted to vanquish the man who had betrayed him. Rome's great creator was poised to become its most public destroyer.

Yet, because of a stroke of luck, or incompetence, or a sudden realization of what he was doing, Bernini did not kill. The most serious damage he inflicted on Luigi was breaking two of his ribs. Eventually Luigi managed to escape—or perhaps Bernini allowed him to—and the incident was over.

But Bernini was not done with his revenge.

What happened next shocked Bernini's family and delighted the gossips of Rome. Bernini ordered his servant to return to Costanza's house and to cut her with a razor. Overnight the "inflamed passion" he had had for her turned into something volatile and dangerous. Costanza's beauty must be destroyed. Just as she had ruined his trust in her by her infidelity—with Bernini's brother, which must have shocked him deeply—Bernini wanted to ensure that she never again appealed to another man. That she had already been unfaithful to her husband seems not to have played a part in Bernini's reprisal. His torment must not have allowed him to think logically.

According to an official deposition, Bernini's servant returned to the house and discovered Costanza in bed. There, he carried out his master's orders.

After dispatching his servant, Bernini followed Luigi back home to his mother's house. He attempted to attack him again, this time with a sword, breaking down a locked door and frightening his mother, Angelica.

Luigi again managed to escape and fled next door to Santa Maria Maggiore, where he hoped to find sanctuary. Even an

enraged Bernini wouldn't kill in a church, his brother thought: He must curb his temper before the wrath of God.

Luigi was right. When Bernini arrived at the church, he had to satisfy himself, Avery says, "with kicking at the door."

Official penalties against Bernini were inevitable: Such a public disregard for civility and law demanded justice. Even in seventeenth-century Rome, attempted murder was frowned upon. Legal proceedings against Bernini were started, and charges were filed. The prospects for significant punishment were considerable.

Frightened and angered by her eldest son's scandalous behavior, Angelica Bernini asked the pope's nephew, Cardinal Francesco Barberini, chairman of the works at St. Peter's and nominally Bernini's supervisor, to "mitigate the penalties" and to talk some sense into her son, who was, she said, acting like the *padron del mondo*, the king of the world.

Bernini was eventually fined 3,000 scudi for his outrageous misbehavior—a large sum for the time, but no more than what a cardinal might pay for one of Bernini's sculptures. Once he was well enough to travel, Luigi escaped from Rome, settling in Bologna for a time, where he worked at San Paolo Maggiore on commissions that his brother had been given. On November 15 Pietro Paolo Drei replaced Luigi as *soprastante* at St. Peter's.

Writing years later, Domenico notes, "The Pope, apprised of the deed, ordered that the servant be exiled, and through his Chamberlain, he sent to the Cavalier an absolution of his crime written on parchment in which appeared a eulogy of his virtue worthy of being transmitted to posterity, because in it he was absolved for no other motive than that he was excellent in art."

Perhaps the pope considered Bernini's public humiliation penalty enough. In his declaration of the waiver, Urban proclaimed

Bernini "a rare man, sublime genius, and born by divine inspiration and for the glory of Rome to bring light to that century."

Costanza's role in this affair ends here; as far as Bernini is concerned, she disappears from his life. He cut her out of a joint portrait he had painted when he was "fiercely in love" and sent her bust into exile (it's now in Florence). There is also speculation that a later bust that Bernini carved of Medusa was modeled after her, which Bernini could have used, Avery said, "as a constant reminder and warning to himself."

Perhaps he didn't need to, as Bernini soon fell into a deep depression—his son called it "a mortal sickness"—which debilitated him. This "strange illness," Domenico reports, "forced him to bed with the most acute fever," and he stopped working completely. Urban had long urged Bernini to settle down: The pope, Baldinucci writes, "desired to make [Bernini], so to speak, immortal" by trying to convince the artist to father children. But Bernini told the pope that "the statues he carved would be his children and that they would keep his memory alive for centuries"—a statement of considerable bravado.

But further exhortations by the pope eventually convinced Bernini to marry. On May 15, 1639, Bernini, age forty, married twenty-two-year-old Caterina Tezio, the younger daughter of Paolo Tezio, a curial lawyer of modest means. Caterina was reputed to be the most beautiful girl in Rome, and Bernini told Urban that she was "faultlessly docile ... prudent and not at all tricky, beautiful but without affectation, and was such a perfect mixture of seriousness, pleasantness, generosity and hard work, that she might have been said to be a gift stored up in heaven for some great man." It was also rumored that Bernini put up his own money for her dowry.

If it were true as Bernini said of art that "harmony is the most beautiful thing in the world," he found it with Caterina. They moved to a spacious four-story house on the Via della Mercede, just south of the Piazza di Spagna, and lived by all accounts happily and fruitfully—they had eleven children, nine of whom outlived them.

SEVEN

An Ox and a Deer

❈

JUST AS BERNINI WAS GRAPPLING WITH HIS
greatest personal crisis (or at least his most pub-
licly personal one), he also found himself em-
broiled in the most potentially damaging dispute
of his career. Its timing was deplorable, coming
when Bernini was particularly vulnerable to criti-
cism about his architecture.

And at the center of the tumult was Borro-
mini.

The controversy could have ended Bernini's
career as an architect, and what Borromini said
and did gave every indication that he hoped it
would. And for a time Bernini was ousted from
the summit of Rome's artistic firmament and
was plunged into a professional purgatory.

The beginning of Bernini's problems can be
pinpointed to January 1637, when he was di-
rected by the Reverenda Fabbrica, at Urban's in-
struction, to begin building two campanili, or

bell towers, to stand at the northern and southern ends of Maderno's much-lambasted façade of St. Peter's. The bell towers were the first significant architectural commission at St. Peter's that Bernini attempted on his own, and he became the latest in a litany of architects who had been directed by papal enthusiasm but hindered by the fickleness of Mother Earth.

Maderno's initial plans in the early 1600s had called for lower, less obvious bell towers to be built above the chapels closest to the entrance of the church. But after Pope Paul V visited the construction site in September 1612, he revised the plans for the campanili. They would be built, according to a papal *avviso*, or bulletin, *una di qua et l'altra di la della facciata*—one at each end of the façade.

The pope's decision to frame the façade with bell towers was made without consulting Maderno. Paul hoped that by moving the bell towers forward and extending the length of the church front, the façade would appear larger and in proportion.

Work began soon after the edict, and almost immediately problems arose with the south tower (on the left side of the façade). Art historian Sarah McPhee explains that in late 1618 Maderno stumbled across subterranean springs below where the foundations were to be built "that were dangerously destabilizing." Giovanni Battista Costaguti, the pope's majordomo, told the diarist Marc Antonio Valena: "The ground was so sandy, it gave way if you as much as looked at it." It was particularly troublesome in the area where the south campanile was to be built.

In an attempt to ensure that the towers would stay where the pope wanted them, Maderno dug their foundations deeper than normal, more than 30 meters (almost 100 feet), and he ordered bricks and hay to be shoveled into the trenches to help bind the earth. Maderno also concocted a series of pilings in the ground,

which he hoped would keep the soil from moving. He even had a foundation of travertine placed in the shaft to use as a base. In his history of St. Peter's, Giovanni Battista Costaguti indicates that Maderno dug so deep that he ended up beneath the water level of the Tiber, "where a torrent of water revealed itself."

When Pope Paul V died in 1621, both the north and south towers were under construction, but even then it was known that there were structural problems with the south tower. The immense, arched supports of the campanili that were built aboveground, which look like elaborate pylons for a bridge over a river that was drained long ago, were begun at Paul's command and soon reached the height of the basilica's roof, but Maderno built no higher. Their presence at each end of the façade made St. Peter's look too wide. What the façade needed was something tall to dispel the sense that the church front was too broad.

Maderno had long been criticized for distorting the church's proportions as he turned a centralized church into a longitudinal one. (He had finished the façade before the rest of the basilica so that it towered over the Borgo like a backdrop to a play.) He was castigated for designing a church that made it impossible for anyone, pope or pilgrim, to see the full outline of the dome when standing directly in front of the basilica. This unexpected consequence of lengthening the nave was a blunder whose irony lingers today, like the brackish odor of the sluggish Tiber, given that Michelangelo's dome is visible from everywhere in Rome except in front of St. Peter's.

Almost two decades after Maderno began, Bernini was called upon to build his campanili upon the foundations laid by his predecessor.

These problems came upon the heels of a rumor that circulated

in April 1636 that Bernini's work on the crossing piers of the dome had been substandard. They had weakened the dome, the critics said, and made an old crack in the dome even larger. There was even speculation that the spiral staircases he had installed inside the dome's supports put the dome in such peril that they should be filled in immediately. "Bernini's competence as an engineer and architect was already under attack," McPhee notes.

Bernini had survived such ridicule before. He believed that it was only idle chitchat circulated by the jealous. He was so confident in the dome's stability, in fact, that he wrote and mounted a comic play about the hubbub—though one observer noted, "[I]t is believed . . . that Bernini will retreat to Naples if the dome threatens to become more dangerous." His was a cautious bravado.

Urban was committed to proceeding with the bell towers. By restarting construction of the campanili, the pope believed that Bernini's new designs would give St. Peter's a more majestic appearance and bring a new noble dignity to the basilica.

But even at the Vatican, miracles are in short supply.

Bernini understandably abandoned Maderno's plans for low towers topped by octagon-shaped tiers decorated by flags and crosses. He proposed (at the pope's request) his own design: grand, three-story towers that would cost nearly 70,000 scudi to build—a breathtaking price and a far cry from the 30,000 scudi that Maderno's towers would have cost. (Inflation was relatively low during the seventeenth century, so these numbers are roughly comparable.) Urban wanted—and Bernini obliged—an eye-catching addition to the skyline of St. Peter's that reflected a newer, bolder taste.

According to Filippo Baldinucci, "Bernini not only made the design for [the campanili] but also a fine model which gained the

approval of that learned pontiff [i.e., Urban] and the applause of the very eminent cardinals who were members of the Congregation of the Fabbrica of St. Peter's."

What is more, and perhaps part of the explanation for what happened later, "it was the Pope's custom, whenever buildings were to be erected in places where foundations of other buildings might exist, to take necessary precautions in order to ascertain if, in fact, there were any such foundations. He therefore issued a specified order to the Congregation to call in two of the best master builders then in the city of Rome, who, since the time of Paul, had been employed in laying foundations." These worthies, whom Baldinucci identifies as Giovanni Colarmeno and Pietro Paolo (he supplied no last name—perhaps it was Drei), "attested to the complete soundness and stability of the foundations so positively that the Pope and the Congregation were satisfied that it would be well to give new orders to Bernini to continue the construction of the bell towers."

In other words, if there were problems in the future, others— the master builders, the Reverenda Fabbrica, and even Urban— would bear the responsibility.

After having the master builders determine that the foundations were stable enough for further construction—even though, as Joseph Connors notes, "Borromini, who knew Maderno's façade and the capacity of its foundations from first-hand experience, warned that [Bernini's campanili] would be too heavy"— Bernini proceeded. He had every reason to be confident, Baldinucci argues. "The prudent artist had reason to turn to the enterprise with security, not to mention the probability of the great honor that the work would bring him."

On May 20, 1638, Bernini celebrated the laying of a new foundation stone for his dramatic and grandiose tower design. The

160 *muratori* (masons), *scarpellini* (stonecutters), and convicts who were to work on the project were treated to a special meal to mark the auspicious occasion.

The design Bernini settled on was an extravagant arrangement that used marble and travertine columns and deep recesses to contrast light and shadow as the eye moved 30 meters (about 100 feet) up the campanile. Baldinucci described the tower as "formed of two orders of columns and pilasters, the first order being Corinthian. . . . The second order was made up of a base . . . and in the middle of the archway opening ran a balustrade." Pedestals, columns, and pilasters were "gracefully set" around the tower. The attic tier was "formed of pilasters and two columns on either side of the open archway in the center." It was to be topped by what he called a "pyramidal finial" that was "made of the same stone as the other three orders."

Bernini kept Maderno's original bases, which had tall archways that allowed traffic to pass through them, and he placed above them a story of what Torgil Magnuson says were "no less than twenty-four columns, while above there were eight columns of *bigio antico* taken from Hadrian's Villa." Bernini used Ionic, Corinthian, and Composite columns and capitals arranged around three tiers decorated with the omnipresent Barberini bees that swarmed over Rome. Four statues of Victory were to be placed on each corner of the campanile; they were to hold the coat of arms of Urban VIII and were to be carved by an unexpected artist: the disgraced and lubricious Luigi Bernini. In October 1639, the Congregazione asked Luigi, still in exile in Bologna, to travel to the marble quarries of Carrara to personally select the most durable marble for the figures. Luigi agreed to go, on one condition: "only if his brother approved the request,"

McPhee says. Apparently the younger brother was willing to let bygones be bygones as long as his elder brother was, too. Bernini agreed, and Luigi left for Carrara. Upon his return from exile, Luigi was promoted to *soprastante* of the project.

Even during its construction, the bell tower was an impressive sight. During a trip to Rome in 1639, an English student known as Nicholas Stone the Younger saw the campanile and was struck by it enough to record a description, using somewhat erratic spelling. The pilasters, he wrote, were "cloath'd with white marble fluted, the little pillosters or pedestalls under the impost of the arches wrost and inlay'd with diverse coulours of marble. All the altars besydes the Maggior are made in one manner, each having 2 large collomes antique taken from Therma Dioclesiano [Baths of Diocletian], being in number 44; and to conclude absolutely it is the most marvelouse fabrike and best composed that is in the world of modern times." Not precisely poetry, but the enthusiasm is obvious.

The laborers worked quickly, for by June 1641 a third story— made in wood to Bernini's designs by Giovanni Battista Soria, a carpenter, and Guidobaldo Abbatini, a painter—was ready to be set in place in time for June 29, the Feast of Saints Peter and Paul. The tier measured 60 palmi, which is nearly 13 meters (43 feet) high, and it was fashioned to appear from the ground as close to the completed story as possible. It was decorated, Tod Marder says, with "festoons and dolphins, shells and bees, and crossed keys of St. Peter, and eight candelabra issued carved flames." The wood was painted to look like travertine, and the sculptural details were gilded. The tower rose 290 palmi in all, nearly 65 meters (more than 200 feet)—an extraordinary height.

When the pope inspected the progress just before the Feast of Saints Peter and Paul on June 28, 1641, to everyone's surprise,

including Bernini's, he didn't like what he saw. The bell tower wasn't grand enough. Marc Antonio Valena recorded that the top tier "appeared too small," while the diarist Giacinto Gigli wrote that it "did not give satisfaction." Urban ordered it torn down— a decision that cost the papal treasury some 25,000 scudi and Bernini considerable embarrassment.

Bernini had modified his plan for the bell towers, making the top story lighter to ease the weight on the weak foundations below, because troubling cracks had been discovered in the towers' foundations and inside St. Peter's. The pope thought this modification lessened the grandeur of the campanili, which irritated him. Gigli wrote that Urban chastised Bernini, who was said to have fallen "gravely ill," though he recovered when he later received the pope's blessing.

In a set of directions that Bernini sent to Soria, he demanded that the painter be careful, as the tower "grows in such a manner that it is necessary to take away some parts" (another translation uses "intervene"). But Bernini knew the importance of getting these bell towers right: "[I]t is very important to my reputation . . . it is a most pressing matter to me."

On the surface this seems logical enough: the careful, slightly querulous order of an obsessive artist. But it was more than that. This "pressing matter" Bernini spoke of takes on a new, darker meaning in September, when an *avviso* announces on the twenty-eighth: "The Cavaliere Bernini, who has undertaken to build a campanile at St. Peter's, has failed and the great weight of the tower will bring the façade down. This having come to the notice of the pope, he called Bernini to him and severely reprimanded him for not having wanted to take the advice of anyone."

Cracks had been found in the façade, and some feared that the

campanile and the southern front of the church were in danger of collapse. Even more worrying, at least to Bernini, was the pope's first public rebuke of his favored artist. Bernini's reputation was under siege.

Yet once the pope and the Congregazione vented their disapproval, concern seems to have subsided for a while. Work on the north tower began in earnest, more travertine was delivered to the building site, and the workers were paid in December 1641. In March 1642 a model of one of the Victories that Luigi was sculpting was hoisted into place to see how it looked from the ground.

But the confidence was as temporary as Luigi's statue. At a meeting of the Congregazione on July 28, 1642, a decree was signed that stopped all work on the towers above the roof.

For Bernini, the humiliation must have been profound. His reputation had been struck a severe blow and lay wounded for everyone to see.

He had blundered spectacularly. Whether it was his fault alone—after all, he had the initial support of Urban and the Congregazione, as well as the expertise of two *capomaestri*—the blame was placed squarely at his feet. Without Borromini's technical expertise, or even Luigi's pragmatism, Bernini had no one working for him who was reliable enough to tell him that the foundations were not strong enough to carry the weight of his ambitious upper stories; there was no one to point out, as someone had done during the design phase of the Baldacchino, that the ribbing wouldn't support his statue of Christ the Redeemer.

In both the Baldacchino and the bell-tower projects, Bernini had been more interested in the drama of the architecture than in engineering stability. Now he was paying the price for his carelessness.

Work on the south tower was halted immediately. In August 1641, the wooden model was removed from the top of the campanile and the tower was stabilized. Work continued on the north tower, however; but on July 28, 1642, the workmen were directed to build no higher than the first story without first getting permission from the Congregazione. When they sought it, they were told to stop working.

The issue of the bell towers was at an impasse. No one was quite sure how to proceed.

A contemporary engraving by Carlo Fontana, who worked for Bernini and who after his death became architect of St. Peter's, illustrates Bernini's plans for the campanili. The bottom story is square, with heavy stone supports set at a diagonal at each corner, which blunt the corners the way Borromini had at the cloister at San Carlino. But here they look heavy, stolid. On each side of the tower are two pairs of freestanding columns, which support a smaller story above with similar decoration, though an arch stands in the center of each side. At the top, where the actual bells were to be hung, Bernini placed smaller openings—some arched, some not—that were surmounted by the Barberini crest and, perhaps in tribute to the Baldacchino, dolphin-shaped volutes, whose tails came together at the very apex of the tower to support an orb. On top of this sphere, two papal keys support a large cross that towers over the city. It's a fussy combination of somber stone and restless ornament.

The bell towers were the talk of Rome. Nicholas Stone noted that "the upper part of the campanile or steple of St Peeters att Rome taken downe. In the same month the Cauellyer Bernine sicke to death and [at] once dead as itt was reported." Another Englishman, Richard Lassels, writes that Bernini's disgrace was

caused by "a crack in the roof of the Portch of St. Peter's" he had
built.

What happened next seems, to modern sensibilities at least, odd:
Nothing.

Work stopped on the south tower and further work on the north
tower slowed until June 1643, when it, too, stopped altogether.

The cause could well have been, as McPhee argues persua-
sively, that Urban was distracted by war. His attempts to wrest
control of the small but prosperous Duchy of Castro from the
Farnese family and place it in Barberini hands was ambitious, but
it ended in disaster. The pope's armies were routed, and hostilities
between the pope and Odoardo Farnese, the duke of Parma and
Piacenza, dragged on almost until Urban's death in July 1644.

The papacy paid a high price for Urban's ambition. The Cas-
tro war—*la guerra di Castro*—was incredibly expensive, draining
5 million scudi from the Vatican treasury. And it demanded as
much attention as money, leaving little of either to solve the dif-
ficulties of the bell towers.

So no one did.

ON JULY 29, 1644, Urban VIII died. And in Rome, the world
changed.

Urban's passing wasn't unexpected. In fact, Bernini had been
preparing for it. Avery notes that on July 16, 1644, less than
two weeks before the pope's death, Bernini wrote to the powerful
cardinal Jules Mazarin in France, whom he knew when Mazarin
lived in Rome, to see how open the French would be to receiving
him. It was, in essence, a request for asylum, and it's clear Bernini
thought that it was possible, even likely, that Urban's death could

topple him from his position as swiftly as it was expected to do for the Barberini.

Mazarin's reply was swift and generous. The French, the cardinal assured Bernini, would welcome him with enthusiasm. He offered Bernini a salary and the promise of the title of Architect to the King.

Six weeks after Urban's death, on September 15, Cardinal Giambattista Pamphili was elected pope. He chose the name Innocent X. A Roman by birth and a lawyer by training, Innocent wanted to rectify the excesses and ambitions of Urban's near-devastating extravagance, even going so far as to choose a conciliatory verse from the Book of Kings as his papal motto: "Give thy servant an understanding heart to judge thy people." He would need all the wisdom and understanding he could muster, because the papacy had a debt of 8 million scudi and its political influence in Italy and beyond was waning. For the first time in nearly a thousand years, the pope was no longer the most powerful man in Europe.

But Innocent had little time to contemplate the decline in papal power. More pressing problems demanded his attention, literally outside his window. He focused almost immediately on completing St. Peter's and the quandary of how to repair the cracks in its walls.

Innocent was blessed by a group of advisers who could help him with these challenges, particularly Father Virgilio Spada, the *preposito* of the Oratorians. This discriminating and conscientious priest, whom Innocent appointed his *elemosiniere segreto*, or secret almoner, a job that required Spada to manage and disburse papal money to charity, was much more than an accountant. As the pope's closest, most trusted architectural adviser, he also became

the man to whom Innocent, Borromini, and Bernini turned during the crisis of the bell towers.

Spada shunned the limelight, and at first he was reluctant to enter papal service. He was happy working with the Oratorians, content with a life of piety and service. But Innocent insisted, and after Spada's brother, Cardinal Bernardino Spada, another of Innocent's advisers, spoke to him, Spada gave in. By October 1644, he had left the comfortable confines Borromini had designed for the Oratorians and was living amid the papal retinue at the Vatican.

Spada did not have long to wait before Innocent called upon his building expertise. By early 1645, Innocent had chosen him to untangle the knotty problem of the bell towers. (There is even evidence to suggest that almost immediately after Innocent was elected, he asked Spada to write a report on the cracks in the façade.) For the next year, eight cardinals from the Reverenda Fabbrica met regularly to discuss, debate, and determine what—and perhaps even more important, who—caused the disturbing-looking cracks—McPhee calls them "fissures"—in the façade. They also addressed what Baldinucci describes as the "gilded stucco ornaments" of the vault in the benediction loggia, the long, arched mezzanine level above the main entrance of the church from which the pope issues his blessings to the multitudes who collect in St. Peter's Square. Spada served as the inquiry's facilitator, providing the cardinals with the documents and memoranda they needed to reach their conclusions and to determine the most prudent course of action. Such a strategy—meticulous and orderly, careful and attentive—suited Innocent's cautious, legalistic sensibility and, it could be argued, the basilica itself.

The pope gave Bernini the opportunity to explain the cracks. The artist's response was both honest and canny. The towers, he

said, had been built on the foundations laid by Carlo Maderno—
foundations, he reminded the pope, that the Congregazione had
approved after two *capomaestri* judged it safe to build. The crack-
ing, Bernini thought, was part of the basilica's natural and in-
evitable settling, and nothing more. But if there was a problem
with the campanile, it wasn't solely Bernini's fault; others were
just as culpable. Bernini asserted that his tower was still sound
and straight, but to placate the pope, notes McPhee, "Bernini
suggested that soundings be made of the foundations" of the
south tower as well as those of St. Peter's.

It was a shrewd suggestion. The sounding, or *tasto*, began in
early February 1645, and after a false start, a satisfactory vertical
shaft was dug in front of the basilica near the southernmost door.
Another shaft was dug perpendicular to the first one, McPhee
writes, "straight back to through the mass of Maderno's founda-
tion 'to find the crack and to identify the material surrounding it
on one side and the other.'" In small groups of one or two, a
number of clerics, architects, and builders descended the narrow
shaft to inspect Maderno's foundations, and several registered
their findings in drawings, including the *soprastante*, Pietro Paolo
Drei, and Francesco Borromini. At the end of March, the Con-
gregazione convened a meeting to hear what the architects had
concluded from their trips into the earth.

The cardinals met on March 27, 1645, at the residence of the
Congregazione's prefect, eighty-four-year-old Cardinal Marcello
Lante, who lived in a palazzo on the Piazza di Caprettari, near
Piazza San Eustachio.

The assembled cardinals heard from nine men, who in separate
meetings detailed the problems they had seen and outlined their
solutions. Several opinions were expressed, and two architects,

Martino Longhi and Cipriano Artusini, argued that Maderno's foundations were fundamentally flawed.

Borromini, who was one of the architects to give testimony, disagreed. If the foundations were as unsound as some claimed, he argued, St. Peter's would have moved more drastically than it had. He believed that the basilica's walls had cracked because of the extreme weight placed on them by Bernini's bell towers: They were too heavy for Maderno's foundation. Bernini had overbuilt.

Borromini drew a profile of the foundation near the *tasto*, which showed that a window on the western side of the base was leaning. On the other side of the sheet of paper he wrote: "The ruin of the campanile, which will drag the façade with it because they have been joined together, proceeds from nothing other than that the foundation of this campanile was made to support a single story above the façade, which was even rather narrow and open so as not to add a lot of weight." According to Borromini, the tower was three times higher and six times heavier than it should have been. "The prudent architect," he wrote, "does not first erect the building and then make a sounding to see if he finds a crack in the foundation."

Bernini, of course, wasn't present when Borromini spoke before the Congregazione, but it didn't take long for the news of Borromini's denunciation to reach him. The criticism by his former assistant must have been both professionally and personally galling, piercing his reputation as an architect at its weakest point—his lack of technical skill—and wounding his reputation as an artist known for always exceeding expectations.

In response, Bernini turned to the Spada brothers for help. When he heard that Cardinal Giambattista Pallotta, one of the Congregazione's members investigating the controversy, wanted another look at the basilica's foundations, he asked Bernardino

Spada to prevail on his brother Virgilio to accompany Pallotta, to ensure that Bernini's point of view was represented.

The Congregazione met again on June 8, 1645, and this time Innocent was present, as were several architects and engineers, including both Bernini and Borromini. It was an important meeting, because Spada had concluded that the façade of St. Peter's was in no danger of collapse. In a comprehensive and well-researched report, drawing from expert testimony, including that of Giacomo Grimaldi, a former canon and archivist at St. Peter's, Spada presented a lucid account of the façade's construction, pointing out that Maderno had been aware of the congenitally poor construction conditions at the basilica's southeastern end even before he began building the campanili. In fact, the Constantinian basilica had had problems in the same area. In addition, Grimaldi mentions that an ancient quarry may have been on the site and that clay could have been removed from the area to create bricks for buildings during the reigns of Nero and Gaius. The creation of Imperial Rome may have contributed to Bernini's ruin at St. Peter's.

Spada reminded the Congregazione that in 1618 Maderno had forty-two deep wells dug, which were then filled in with stones, flint, and lime. The hope was that this would help support the basilica's enormous weight. As a result, Maderno's façade, and later Bernini's south tower, were built on two different foundations, and Spada concluded that this was the cause of the current crisis.

While the report may be read as an indictment of Bernini's competence in building such a heavy bell tower on such flimsy foundations, Spada comes to the architect's defense in subtle, precise ways. McPhee describes how Spada employed a metaphor used by the architect Leon Battista Alberti: "When an ox and a deer run

across the same stretch of muddy land, the footsteps of the deer will be deeper and more visible, even though the ox may weigh six times as much as the deer. This occurs because of the concentration of the deer's weight on the small points of its hooves." Spada's point was that weight concentrated in one area pushes deeper into the ground than a greater weight on a broader area. His example of the ox's weight—six times that of the deer's—was not accidental. It was an artful rebuttal to Borromini's contention that the tower was six times heavier than it should be.

Bernini's mistake, Spada concluded, was building a heavy tower on top of two foundations that had settled at different rates. The flaw was in the tower's location, not its construction. His recommendation was to leave the towers alone. Let them settle, he advised, as they naturally will. Repair or replace the sections of the façade and tower when it's necessary, but neither is in any danger of collapse.

This advice was in complete disagreement with Borromini's conclusions. Though the two were friends and had actually worked together to collect data and information about the problem, they had reached diametric conclusions.

As Spada was the pope's architectural adviser, it would take either a fool or a zealot to contradict him before Innocent himself. Yet that is precisely what Borromini did.

At the meeting, Borromini presented four drawings, three of the south tower and one of the north. He used these to argue that the size and scope of Bernini's towers were indeed too big. He claimed they relied too heavily on the wall and supports of St. Peter's. In addition, he placed (on paper) a duplicate of the flawed south tower over the spot where its twin would be built to the north and pointed out that if it was constructed over the Cappella

Paolina, which is actually in the base of the north tower, the tower would devastate it.

It was a clever, audacious argument. Even if the Congregazione accepted Spada's contention that the south tower was fundamentally sound, the construction of the north tower as envisioned by Bernini posed another series of worries. Borromini attacked Bernini on two fronts: the instability of the south tower and the potential problems with the north.

Figuring out who to believe in this disagreement was a function of whom you listened to: Spada, Borromini, or Bernini. Domenico Bernini, as expected, claims that Borromini was driven by spite: "He declared publicly against Bernini in the pope's presence, with all of his heart and all his strength."

Baldinucci's position was equally sympathetic toward Bernini. He criticized Bernini's critics who, in his opinion, "quickly took up arms and said more against him than ever before. They reiterated constantly that the bell tower had shifted its position and that this had caused the cracks in the vault as in the outer façade. They said that these were the ruinous results visited on Rome by those popes who were pleased to give all the work to one man alone, although there was an abundance of meritorious men in the city." With Urban's death, the carping against Bernini grew bolder, fiercer. "People whom Pope Innocent X trusted and who, though he thought them very experienced, were on the contrary little informed concerning these arts, were made use of "—that is, Borromini and others like him. The iron grip Bernini had on Vatican patronage had been broken.

Cipriano Artusini, a Camaldolese monk and one of the men who had inspected the foundations by descending into the shaft, thought that Maderno had laid the south tower's foundations

improperly, but he also criticized Bernini for building on them in the first place: "If it were me, I would not have had the daring to erect such a heavy tower as one sees," he said.

Amid the turmoil and contention, Bernini remained curiously silent, his normally confident voice muted. Whether it was by intention or by happenstance, very little of what Bernini said about this very public problem was recorded. It is Borromini's voice that is heard above all—clear, penetrating, unequivocal. Borromini the technician, the confidant of Maderno, knew what he was talking about. Bernini, the well-connected protégé of a now-dead pope, was out of his element.

Instead of fighting back publicly, Bernini tried to save himself and his reputation quietly, behind the scenes.

He appealed to Virgilio Spada to entreat his brother not to leave town and to attend the next meeting of the Congregazione "to do him the favor of intervening" for him with the pope. Bernini was trying to use the time-tested ploy of relying on one's most powerful and well-placed allies to come to his aid. Apparently he feared that his arguments, like his foundation, needed further buttressing.

In a letter to his brother Virgilio, Bernardino writes that he had met with Bernini and "told him that Borromini is coming with me [to Tivoli] and that consequently there will be no competition" at the next meeting. It was obvious that Bernardino thought Bernini was worried that Borromini would sway Innocent.

Perhaps Bernini was right. But Innocent was a prudent man, inclined to take a cautious approach to resolving the problem of the towers. Despite Borromini's warnings about the instability of the south campanile, McPhee notes, "the pope did not wish to abandon the tower project. In fact, at this point, his objective seems to

have been deliberate perseverance and the pursuit of further information." At the conclusion of the June 8 meeting, the pope directed the architects to draw up their design solutions and present them at the next meeting, which was to be held on October 9, again at the palazzo of Cardinal Lante. The pope wanted to know what each man thought about keeping the bell towers as they were, and if so, how to repair them. If not, what did they propose instead?

It was, in essence, a competition.

The rivalry between Bernini and Borromini was about to intensify.

FOUR MONTHS LATER, on October 9, eight artists and architects, including Bernini, presented their solutions. As the official Architect of St. Peter's, Bernini also was expected to put forward his proposals for decorating the nave. According to a *discorso,* or official report, written about the contest, the Congregazione received campanile designs from Bernini, Andrea Bolgi, Pietro Paolo Drei, Martino Longhi, Giovanni Battista Mola, Santi Moschetti, and the father-and-son duo of Carlo and Girolamo Rainaldi.

The anonymous author of the *discorso,* who could have been Virgilio Spada, indicates that designs by Borromini and Paolo Maruscelli, the architect Borromini had replaced at the Oratory, had been expected by the Congregazione but did not appear, though Borromini is known to have at least mused on paper about an alternative to Bernini's towers. His proposed towers were lighter, less cumbersome-looking alternatives to Bernini's and were more in keeping with the towers Maderno originally had in mind. Instead of two rows of columns, Borromini envisioned one row, which he situated firmly above Maderno's foundations, answering

Longhi's stinging charge that Bernini's were *"situate in falso,"* placed over a void. McPhee believes that Borromini drew up these plans prior to the meeting of the Congregazione "but then thought better of it. . . . His sketches remained private thoughts"—a personal solution to a public problem.

Perhaps Borromini expected the Congregazione to turn to him in desperate appeal: Please fix the problem, please solve our dilemma. Perhaps he wasn't convinced that his designs were worthy to adorn the façade of St. Peter's. Perhaps he was simply too busy with other projects to turn his full attention to the problem. Or perhaps he just wasn't willing to let others have input on his own work—or receive credit for his brilliance. Whatever the reason, Borromini stood on the sidelines, ready to critique and to crucify.

Some of his detractors even believed that he had the ear of the pope and was whispering denunciations of Bernini's towers and the artist himself into it—a kind of Iago of architecture.

Once the drawings were presented to the Congregazione, they were shown to several architects for their opinion and input, including Borromini, Maruscelli, and Bernini. According to Martino Longhi, who was also shown the drawings—he was "given the right not to approve a single design"—there was no clear winner. However, Longhi did agree with Borromini's assertion that the south tower's weight must be lightened to ease the strain on the foundations (though Longhi also wanted the foundations reinforced). Borromini's point of view was gaining credence.

Four months passed until the next general meeting of the Congregazione on February 20, 1646, when the designs were formally presented to the pope at the Vatican (though there are indications that discussions had occurred in the interim). Bernini had revised his designs based on Carlo Rainaldi's radical notion

of lopping off the heavy attic tier of the façade and building the bell towers directly on their foundations, an idea that was greeted with enthusiasm by architect and cleric alike.

At the meeting, which was attended by six architects, Longhi again argued for keeping Bernini's existing towers if their foundations could be repaired and supported. One of Bernini's new designs was pronounced the most appropriate because, as the *discorso* notes, its elements were "most proportionate to the whole, and most natural, and is more solid and of greater magnificence." The pope agreed, Baldinucci said: "It seemed a good idea to him that the weight of the bell tower should be lightened by removing the attic story and that then the foundations could be strengthened." Consensus seemed about to blow through the Vatican like a warm spring breeze after a long, difficult winter.

Three days later, on February 23, the Congregazione met again and learned the pope's decision.

"A campanile that has recently been constructed above the façade of the Vatican basilica is to be totally demolished down to the level of the Apostles [i.e., the roofline] and the dismantled stone placed above the flanks of the church in order to be used in the construction of new towers on the same site, built according to a design currently being studied and considered."

Such an abrupt announcement was surprising enough, given the collective agreement that had been reached only a few days before and the general endorsement that Bernini's revised design had received. But when the south tower was dismantled, stone by stone over eleven months, ending in February 1647, the pieces, called *spolia*, were stored above the nave, like out-of-fashion furniture banished to the attic, and no new construction was begun. The denigration of Bernini and his reputation began anew.

Even more startling, some evidence suggests that Bernini's investments were seized by the Vatican to recoup the Congregazione's expenses. Carlo Cartari, one of the pope's advisers, wrote in a letter that "for the claims of damages for the campanile Pope Innocent sequestered about 30,000 *scudi*" that was due Bernini.

Innocent never declared his reasons for his abrupt about-face, and his silence on the topic prompted speculation to bubble forth, like foul-smelling water from a sulfur spring. According to Baldinucci, Innocent and his entourage left Rome to visit one of his estates "for repose," and during his time there "enemies of Bernini and the Barberini family, especially a certain person semi-skilled in art whom the Pope greatly trusted, were also present." Baldinucci explains that these people "knew how to use such opportunities to persuade the Pope by intensive arguments" to change his mind about the campanile and prevailed upon him to have it torn down instead of trying to save it.

Baldinucci's criticism of Borromini is even bolder than that of the shadowy figure in the pope's entourage. "It was the opinion of many that this war against Bernini was waged not so much because of dislike of the artist personally and of the memory of Urban VIII as because of the desire that, when it happened that the Pope for some reason would become displeased with Bernini, he would then appoint Borromini to succeed him in the office of architect of St. Peter's. Borromini had been Bernini's disciple, but, in truth, had little gratitude toward him." For evidence of this, Baldinucci points out that Borromini condemned Bernini's towers "without esteem or respect. He alone inveighed against Bernini with his whole heart and soul."

Domenico Bernini is more circumspect, alluding to the reality that "since from the unexpected novelty of hostile encounters not

even the innocent can escape, it easily happened that the Cavalier also remained exposed to the blows of that storm which for many years disturbed the court of Rome and Italy. . . . During all of those four years, which briefly gave scope to his rivals, he bore that fate, not with continual dissimulation, nor with useless laments—which are wont neither to offend nor defend—but by finding in his virtue the consolation and remedy for those misfortunes."

The historian Rudolf Wittkower also acknowledges that Borromini "came forward as Bernini's most dangerous critic and adversary" in the debate over the bell tower. "His guns were directed against technical inefficiency, the very point where—he knew—Bernini was most vulnerable."

Bernini fired back with money, the best weapon he had. In a 1646 letter to the Duke of Modena, his agent Francesco Mantovani writes from Rome that Bernini gave money to Donna Olimpia Pamphili, Innocent's powerful (and overpowering) sister-in-law, and a diamond given him by Henrietta Maria of England to Cardinal Camillo Pamphili, Innocent's nephew and perhaps the "certain person semiskilled in art whom the Pope greatly trusted" in order to "ensure that the campanile would not be removed."

It was money not particularly well spent.

EIGHT

Ecstasy and Wisdom

DOMENICO BERNINI COULD HAVE BEEN DE-
scribing both his father and Borromini when he
wrote, "When a man loses that which he is ac-
customed to having, or if he does not have that
which he desires, he often gives way to his feel-
ings, and like a city assailed by enemies, his
peace is destroyed, and he is kept in contin-
ual torment to a degree commensurate with his
longings." For the fortunes of both men were
about to change—in ways neither of them
could have expected or anticipated.

As the campanile crisis came to a head,
Bernini seemed confident that the Congrega-
zione and the pope would accept his revised
plans for the towers. While it is possible that he
harbored some private misgivings—after all,
Innocent was not a personal friend, as Urban
had been—Bernini continued to play the role
of *uomo universale,* giving the appearance of quiet

conviction that the controversy over the towers would be resolved satisfactorily in his favor.

Bernini even wrote and produced a play (for carnival in 1646) that had the cheek to lampoon both the pope and Camillo Pamphili, the pope's powerful nephew. "Even the great have been touched by the comedy of Bernini," Francesco Mantovani wrote at the time. It was an understatement. "There was depicted [in the play] a youth who had good will but who never did anything and an old man who could never make up his mind"—traits that Rome's gossips said were based on Camillo and Innocent.

The impertinence, the cheek, struck the Pamphili close to home, literally and figuratively, particularly because Bernini mounted the play at the residence of the pope's sister-in-law (and Camillo's mother), Donna Olimpia.

Producing the play (which has been lost) revealed more about Bernini's self-assurance than his foresight—the serious Innocent was not known as a man who enjoyed laughing at himself. Gone were the days of Urban's worldly acceptance of Bernini's precocity. This was a sterner, less forgiving era, and the city was titillated by the play's brazenness and audacity.

Cardinal Camillo Pamphili was enraged at the way Bernini portrayed him. Whether or not Bernini knew it, he had stumbled into a complicated and hostile tangle of family jealousies. Pamphili was particularly angered that the play had Donna Olimpia's "tacit approval and reinforced the caricature of the cardinal nephew circulating at court." He went to Innocent and railed against it, calling the play "foul."

The pope was swayed by his nephew's indignation and consulted Cardinal Giacomo Panziroli, his secretary of state, who managed to ease the pope's concerns about the play, but the memory of

it lingered. Mantovani could well have reflected the sentiments of many in Rome when he wrote reprovingly to the Duke of Modena, "It is a miracle that the Cavaliere [Bernini] has not been condemned to prison."

Bernini may have escaped jail, but he was never again treated by the Pamphili with the deference he had been showered with by the Barberini. His punishment was to be ignored.

This was one more sign, and a convincing one, that a new day had dawned over the Vatican.

Bernini should have known this already. He was aware that several members of the Barberini clan had fled Rome—quietly and at night—to evade the Pamphili family's wrath when the Pamphili discovered that the Holy See's coffers had been emptied during Urban's pontificate to pay for an ill-conceived war and to fill the pockets of the Barberini. Several of them, including Cardinal Antonio Barberini, ended up living comfortably, if perhaps unexpectedly, in Paris, under the protection of the French king. Taddeo Barberini died in Paris in 1647. But a year later, in a more forgiving climate, Cardinal Francesco returned to Rome, and the younger Cardinal Antonio returned five years later.

Bernini's play was the last enterprise he created for the Pamphili family for four years: between the dilemma of the campanili and his very firm association with the Barberini, Bernini was viewed by the Pamphili with a certain amount of suspicion. And when the pope decided, perhaps goaded by his nephew, to have the bell towers demolished—much to Bernini's surprise and embarrassment and to Borromini's satisfaction—it was more evidence that his dominance of artistic life—or at least of architectural life—in Rome was at an end.

Perhaps consciously, perhaps not, the crisis returned Bernini to his first love, sculpture. Almost immediately he began work on a large sculptural allegory he called *Truth Unveiled by Time*. He envisioned a nude woman, as voluptuous as a Rubens, who is discovered by, as Charles Avery characterizes him, "a hoary old man" hovering above her in midair, seemingly without support. As he uses his right hand to pull back the drapery that covers her nakedness, Father Time holds in his left hand a scythe, the symbol of his station.

Bernini completed only the figure of Truth, who sits on a base of rock—calling to mind the quote from Psalms that "Truth shall spring for thee from the earth." She reclines against a background of stone drapery, her naked body contorted as if startled by the marble's icy temperature. Her left leg, elongated and ungainly, is bent at the knee, allowing her large left foot to rest on a globe. In her right hand she holds a stylized image of the sun, a face in its center, which is similar to the suns Bernini used in the *Barcaccia* fountain in the Piazza di Spagna. (This fountain depicts a sunken, waterlogged ship—whose name translates roughly as "the rotten old tub"—and uses two small suns at either end of the ship as spouts.) She gazes up at her invisible discoverer, her face a study in simpering awe. It is as far from the vibrant, unblushing earthiness of the bust of Costanza Bonarelli as the Baldacchino is from the cloister of San Carlino.

Perhaps most unsettling are Truth's eyes. Unlike the eyes on most of his other sculptures, these are left unfinished. She has no pupils to give her face any expression or spark. Instead, they stare into the infinite, as blank and as empty as ignorance. She is, in essence, blind—as unseeing as her sister virtue Justice.

While the sculpture is not finished and its symbolism may seem obvious to modern eyes, Domenico writes warmly of it, describing her as "a most beautiful woman." This is fortunate, as the

figure remained in Bernini's studio for the rest of his life, prompting someone to suggest that Truth in Rome was to be found only in Bernini's house—a quip Bernini himself enjoyed repeating.

By contrast, Bernini's sculpture of Father Time remained forever trapped in a block of marble that sat on the street outside his home. "Whether dissuaded from the work by the ire of that same Time, who, inconstant by nature, refused to be eternalized by the hand of Bernini, or for some other serious occupation, it remained excavated in vain, a useless stone," Domenico notes, a hint of regret in his words. In his will, Bernini directed that *Truth* remain in the family home in perpetuity, bequeathing it to the firstborn son of succeeding generations to emphasize the artist's belief that "the most beautiful virtue in the world is truth, because in the end it is always revealed by time." (Since 1924 *Truth* has been at the Galleria Borghese and is now on display in the Room of the Gladiator.)

While there is a certain poetic propriety to *Truth* residing forever in Bernini's house, Bernini nevertheless was willing to explore a less altruistic alternative for the sculpture's destiny, by attempting to sell the entire completed group to the French. If he had succeeded, it would have been the second time that Bernini sent his work to France, and both instances were due to the efforts of Cardinal Mazarin.

Born Giulio Mazarini in Pescina, a town in the Abruzzi, on July 14, 1602, and brought up in Rome, Mazarini received his Jesuit education at the Collegio Romano and became a soldier in the papal army. He was appointed secretary to the papal legate in Valtellina and his efforts on behalf of the Holy See in France caught the attention of Cardinal Richelieu. In 1639 Mazarini left Urban VIII's service (with the pope's permission) to work for Richelieu and moved to Paris, where he became Jules Mazarin. In 1641, at

Richelieu's urging, Urban made Mazarin a cardinal (though he never took holy orders). After Richelieu's death in 1642 the forty-year-old cardinal became chief minister, first to Louis XIII and then to Anne of Austria during the regency of Louis XIV, ruling the most powerful nation in Europe in fact if not in name.

Familiar with Bernini's work in Rome, Mazarin had long wanted the sculptor to create for the French court. And thanks to canny negotiations on his part, he persuaded Bernini to do exactly that—though in Rome, not in Paris, and without the permission of either Urban or Cardinal Antonio Barberini, which further chilled already frosty relations between the Holy See and France. By January 1641 Bernini had completed a bust of Richelieu (which appeased the pope somewhat, since the original plan had been for Bernini to carve a life-size statue of Richelieu, an honor not normally bestowed on a mere French prelate). Rather than sculpting from life, Bernini probably used a triple portrait of the cardinal painted by Philippe de Champaigne, which had been brought to Rome by the French ambassador.

The bust Bernini carved, now in the Louvre, depicts a proud and disdainful man who looks slightly startled—discomfited, as if he had been discovered doing something he shouldn't be doing. It was considered a triumph in Rome, but in Paris it met a less enthusiastic reception. Richelieu didn't like it, complaining to Mazarin that it didn't look like him. Mazarin quietly agreed and told his brother that the bust was nothing like Richelieu.

But Mazarin persisted in his wooing of Bernini, and his patience seemed to be rewarded. Six years later, in July 1647, barely a year after the campanile ordeal, Bernini had crafted a model of *Truth Unveiled by Time* and asked the Duke of Bracciano to inquire of Mazarin how such a sculpture might be received in Paris.

"The figure of Time carrying and revealing Truth is not finished," Bernini said. "My idea is to show him carrying her through the air, and at the same time show the effects of time wasting and consuming everything in the end. In the model I have set columns, obelisks, and mausoleums, and these things, which are shown overwhelmed and destroyed by time, are the very things that support time in the air, without which he could not fly even if he had wings." In the duke's letter to Mazarin, he extolled the virtues of the piece, calling it "a jewel."

In a reply every bit as ingenious as Bernini hoped *Truth* would turn out to be, the sly Mazarin wrote that "if Bernini were to decide to let himself be seen" in Paris, the Cavaliere "would learn the high estimation in which both he and his works are held in France." In other words, Mazarin wanted both the art and the artist in France—*Truth* and the artist who had created it.

Bernini balked at such a demand. Even at this low point in his career, he was not really ready to leave Rome—nor would the pope allow it. After all, even during his disgrace he remained Architect of St. Peter's and was responsible for overseeing the dozens of sculptors carving marble busts of more than fifty former popes, from Peter to Benedict I, which would be set into the pillars of the nave, as well as supervising the fashioning of countless angels and larger-than-life-size doves that ornament the church. He had more than enough work to keep himself busy.

And there were still men in Rome ready to employ his talents, even if they weren't the Pamphili. One such man was Cardinal Federico Cornaro, the former cardinal patriarch of Venice, who commissioned Bernini to create what became his most famous fusion of architecture and sculpture, the Cappella Cornaro, the Cornaro Chapel, at the church of Santa Maria

della Vittoria, whose centerpiece is the astonishingly theatrical *Ecstasy of St. Teresa.*

In this dramatic, unrestrained work, which fills the entire shallow transept of this small and otherwise unexceptional church at the corner of the Via XX Settembre and the Largo di Santa Susanna, Bernini blurred the distinctions between architecture and sculpture and between sacred and physical love to form a new kind of devotional space, where the love of God—what Teresa called the *unión mistica*—becomes a palpable, physical thing.

The core of Bernini's chapel is Saint Teresa herself. In her autobiography she recounts the moment of her rapture in words that today would raise eyebrows:

> I saw beside me, on my left, an angel in bodily form. . . . He was not tall, but short, and very beautiful. . . . In his hands I saw a long golden spear and at the end of the iron tip I seemed to see a point of fire. With this he seemed to pierce my heart several times so that it penetrated to my entrails. When he drew it out, I thought he was drawing them out with it and he left me completely afire with a great love for God. The pain was so sharp that it made me utter several moans, and so excessive was the sweetness caused me by this intense pain that one can never wish to lose it.

In the chapel, Bernini illustrates this precise moment, calling upon his talents in sculpture, architecture, and theater. Suspended above the altar, an angel—young, empyreal, and otherworldly (the one leg Bernini carved is too long to be human)—holds in his right hand an iron-tipped arrow that he has just withdrawn from Teresa's breast. With his left hand, he delicately holds back a piece of her robe so that he may plunge the arrow in again. He

is smiling, his expression one of gentle understanding at the rapture she's experiencing.

Teresa herself lies back, away from the angel as if in a swoon, her eyes closed, her mouth open slightly in a half-gasp, as if her body cannot sustain the rapture her soul is experiencing. Her body is almost completely covered in drapery. Only her hands and feet are visible (her left hand lies limp against her side, and her bare left foot—the symbol of her order—extends off an escarpment of stone just behind the altar's tall central crucifix and candles). Behind Saint Teresa and the angel, gilded shafts of bronze, golden sunlight made tangible, rain down upon them, as does the natural light that enters through a hidden window and bathes the sculpture in radiance and illuminates the smooth, sleek surfaces of the two figures in this extraordinary tableau.

The statues of Saint Teresa and the angel are placed between two pairs of blue marble pillars topped by Corinthian capitals, which support a convex broken pediment of carved white marble that curves out into the church like the altar in Borromini's Filomarino Chapel—the first time since the Baldacchino that Bernini used such a curved form. Along the side walls of the chapel, in two arched enclosures that look like church transepts, Bernini placed stone silhouettes of Federigo Cornèr, his father the doge, and the family's six cardinals. Their position is for dramatic, even propagandistic effect, Avery explains. As a visitor walks down the aisle toward the church's main altar, "it is the gentlemen carved out of white marble in the right-hand balcony who first catch one's eye in the gloom." The eye falls first on Federigo, who stares down the nave as if in greeting. He seems to be standing at the end of a long, barrel-vaulted corridor or room, with Ionic columns along its sides and a putto sitting atop one corner of a

pediment in the background that looks very much like the one above Saint Teresa and the angel. These strangely fashioned openings look deeper than they actually are—their backgrounds of gray marble are carved in false perspective to give the illusion of depth and seem to give the men a splendid view of Saint Teresa's spiritual climax, though this isn't possible, because the convex, columned space of the altar extends too far out for them to see what is actually happening. Still, the men seem happy, reading, praying, and talking to one another as if they are witnessing the miracle unfolding here. The point is to commemorate the Cornèr family and Federigo's celebration of Saint Teresa's life and work, and Bernini succeeds at this—much more so than he had done with *Truth*.

The chapel's completion in 1652 was greeted with acclaim. "In the opinion of all, no marble made by hands was worked with greater tenderness and design than this one," Domenico wrote. "In that group the Cavalier has surpassed himself and vanquished art with a rare object of wonder." Even Bernini was willing to admit, "This is the least bad work that I have done." One of Bernini's other sons, Monsignor Pier Filippo Bernini, had a more spiritual reaction to it. He wrote of the chapel:

> *So fair a swoon*
> *Should be immortal;*
> *But since pain does not ascend*
> *To the Divine Presence*
> *In this stone Bernini made it eternal.*

But tastes change. Victor-L Tapié notes that when the French scholar and politician Charles des Brosses visited the chapel he

was reminded of a bedroom scene, commenting, "If this is Divine Love, I know all about it."

BORROMINI ALSO WANTED to capture the divine presence in his work, but his battleground was the University of Rome, La Sapienza, where he built his masterpiece and one of Rome's most remarkable churches, Sant'Ivo.

The seeds for this masterpiece had been planted years before by a most unlikely sower: Gianlorenzo Bernini.

In 1632, while Borromini was still working with Bernini at St. Peter's and the Palazzo Barberini, Urban VIII, at Bernini's instigation, selected Borromini to be the architect of the Archiginnasio—later the University—of Rome, one of the two public posts Borromini held during his lifetime.

A letter from the lawyer Montecatini recounts how Borromini came to get the job: "Cavalier Bernini has made known through the Cardinal Patron Barberini that, on behalf of the people of Rome, he has appointed as architect of the Sapienza, the most illustrious Francesco Borromini, nephew of Carlo Maderno, and that he desires that this post not remain an inactive one, but that he contribute his work for all that is necessary."

How active or inactive the position would be remained an open question, as the construction by Pirro Ligorio and Giacomo della Porta at the end of the sixteenth century severely limited Borromini's choices of where to build a church that would fit into the overall scheme of the Sapienza. In addition, work at the site had been halted since Paul V's pontificate. Borromini's task was to build a Chapel of Wisdom to balance the so-called Palazzo

della Sapienza, the Palace of Wisdom that stood just east of the Piazza Navona.

Nearly two decades after Borromini began Sant'Ivo, Fioravante Martinelli extolled the church's virtues in his unpublished guidebook. The pope chose Borromini, Martinelli said, "because of the liveliness of his talent, his familiarity with the Vitruvian rules, and his habit of imitating the work of the greatest ancient Greek and Roman practitioners of architecture." He wasn't bothered by a constrained site, Martinelli says. "Neither the mixture of corners, nor of straight and crooked lines, nor the lack of direct light posed a setback, knowing as he did that the trophy of excellence for an architect comes from the difficulties by which his talent has been challenged and exercised."

Borromini's goal was to design a church that fit satisfactorily in the unpromising space allotted it. That is precisely what he did.

In January 1643, only a year after the interior of San Carlino was finished, the foundation stone for Sant'Ivo was laid, and by 1648 the dome was covered with lead and the cross and globe that topped the lantern were gilded. Once again Borromini returned to the circle and the triangle for inspiration, but this time he used them to concoct a design that is at once more complex and less deceptive, more dramatic and less theatrical, than San Carlino.

Borromini understood that the church he was building at San Carlino was for a small group of the devoted; at La Sapienza, he was designing a public church that celebrates the mind and the spirit.

Situated at the end of a rectangular courtyard framed on three sides by two tiers of arcades, the church from the outside is a curious hybrid drum of convex and concave, of rational curves and surprising protrusions, like a mass of clouds floating across the Roman sky. Built of the flattened Roman brick that Borromini

favored and decorated with shallow pilasters, the façade looks like
an absurd, even contradictory medley of curves thrown together
on impulse. On every level the church advances toward the viewer
or recedes from him, as if it were expanding and contracting, like
a beating heart. Part snare drum, part beehive, part biblical ziggu-
rat, Sant'Ivo's exterior is as exotic-looking as anything Borromini
ever designed.

Inside, at its heart, Sant'Ivo is a triangle, the enduring symbol
of the Trinity. But Borromini wasn't satisfied with using just one
image—or one triangle. He placed two equilateral triangles (one
inverted) on top of each other. At each corner, Borromini carved
arcs into and out of the angles. The result is a jarring but potent col-
lision of concave and convex, filling the space with a staccato inten-
sity that even Borromini could scarcely contain. The church seems
to swell in surging waves, like the ebb and flow of a divine tide.

"Never perhaps did the Baroque ideal of movement attain
more complete and perfect expression" than at Sant'Ivo, Anthony
Blunt notes—an observation that rings as true today as it did
when the altar was consecrated by Cardinal Antonio Barberini on
November 14, 1660. It is a place that throbs with a passion that
can barely keep back the forces behind it: nature, man, or God. It is
every bit as dynamic as the intelligence and the faith that created it.

As Paolo Portoghesi and others noticed, "the stylized figure of a
bee" is at the heart of Sant'Ivo's design. It is both the symbol of
Charity and Prudence and of the Barberini family, which Borromini
may have done consciously. In an account preserved in the Archivio
di Stato, Monsignor Carlo Cartari seconds this conclusion. But it's
possible, even likely, that a deeper symbolism is involved, one that
according to Cartari was a true inspiration for the plan. Blunt ar-
gues that Borromini "must also have had in mind the idea that

the six-pointed star is the star of David, the accepted symbol of wisdom." Indeed, the motif of wisdom plays an important role in the design and layout of Sant'Ivo; it was at the heart of how Borromini approached the project.

On one of his early drawings for Sant'Ivo, he copied down three verses from the ninth chapter of Proverbs, which he indicated were to be carved above the church's altar, above its entrance door, and on a statue pedestal. The three lines from Proverbs are *Sapientia aedificavit sibi domum* (Wisdom has built herself a home), *Excidit columnas septem* (She has erected her seven pillars), and *Proposuit mensam suam* (She has set her table). The phrase *Excidit columnas septem* also served as inspiration: Borromini considered placing a semicircle of seven columns of yellow marble behind Sant'Ivo's main altar—an idea Andreo Palladio used to impressive effect in Il Redentore, his Church of the Redeemer on the Giudecca in Venice. (He seemed not to have been concerned that the odd number of columns would cause one pillar to be placed directly behind the altar—a violation of classic architectural design and a problem Palladio avoided in the Redentore by using only four columns in his church.) Though Borromini abandoned the idea in subsequent versions of the plan, that he considered it at all reveals the attention he brought to the design of Sant'Ivo, how he struggled to inform it with an intelligence, with *his* intelligence.

As Borromini matured as an architect, symbolism became an even more important aspect of his architecture. He wanted the parts of his buildings to mean something, to express emotions and ideas that are simultaneously universal and deeply personal. Much of Borromini's inspiration came from his faith, from his soul, from his intellect. In this he differed from Bernini, whose creativity, though deeply emotional and religious, was expressed theatrically. Bernini,

though a devout Catholic, wanted to impress the observer with the sentiments he expressed and the brilliance that produced it. He was a showman every bit as dazzling as Michelangelo or Raphael.

Borromini, by contrast, wanted to express his belief in God and his passion for his art by containing it in a rational, geometric form. Bernini astounded by letting his talent spring from his heart; Borromini by arranging and controlling the wonders of the infinite. Bernini, at heart, was a sculptor who manipulated space. Borromini was an architect who sculpted it.

And no other church in Rome has such a sense of sculpted space than Sant'Ivo. It's pure Borromini. Martinelli pointed out nearly four hundred years ago that it looks like a tent, which it does. But it is so much more subtle and ingenious than that.

The ingenuity begins literally with the floor and climbs up the straight walls into the dome, pulsing like a living organism as it curves up to the lantern. The movement is almost palpable: forceful and inexorable. It feels preordained. The decoration of the church is restrained—minimal when compared with other masterpieces of the Baroque. There are no magnificent frescoes or multicolored marble columns. Instead, Borromini had the walls painted in light tones—whites and grays—with gold embellishments of angels, stars, and papal coats of arms (though by the time Sant'Ivo was completed, the church honored Pope Alexander VII, not Urban; his crest was a pyramid of six crowned mountains). The result is a layout of intermingling triangles whose points bow into the church as the circles along each side push out, creating an undulating space that looks like a billowing parachute or that deceptively simple ice crystal, the snowflake. It is a restrained and sophisticated exercise in mathematics that uses—as Borromini often did—geometry to venerate God.

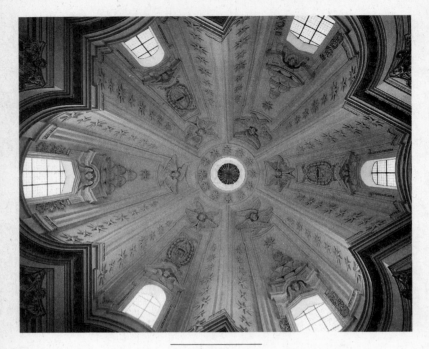

SANT'IVO DOME

Borromini extended this sensibility to the church's dome and lantern—or *tempietto*, as it was then called—which are unlike any others in Rome. Ribbed like the Pantheon, the dome of Sant'Ivo is low, but rises in twelve curving stages to the lantern, like steps to an altar. And an altar is what the lantern appears to be—or rather a tabernacle, the ceremonial resting place of the Host. Six sets of double Corinthian columns ring the lantern; between them Borromini placed narrow pedimented windows to admit light. Each set of columns is topped by stone sculptures of torches of fire, another symbol of knowledge, which resemble torches held by Olympic runners. At the center of the dome sits an extraordinary

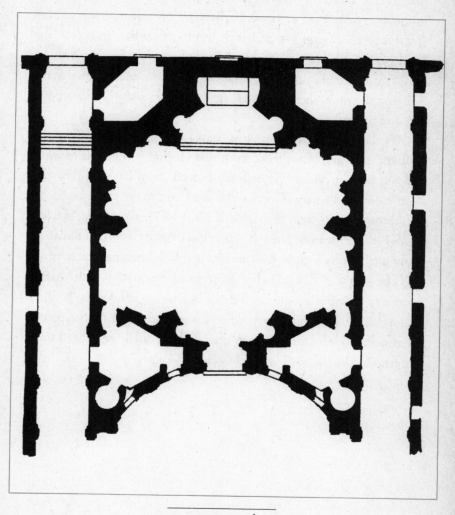

PLAN OF SANT'IVO

spiral cupola of carved stone that can be climbed, a tiny ziggurat that calls to mind the Tower of Babel, another ancient (if counter-intuitive) symbol of wisdom. Sacheverell Sitwell referred to this spiral as "the twisting spire which has been said to resemble 'the horn of a Sicilian goat,'" and it twists up to the very zenith of Sant'Ivo: four curving metal bars, forged into a metal flame sym-bolizing the unquenchable thirst for knowledge, support a golden orb and an ornate cross.

The lantern is, as the art historian Livia Velani points out, "a brilliant and free interpretation of the Gothic forms [Borromini] had studied in Milan Cathedral." Indeed, Sant'Ivo's lantern has been compared to the Tiburio, the dramatic tower that stands on the Duomo's roof and from which it's possible to see the Matter-horn. But Borromini's lantern, while less ornate than the Tiburio, is more intricate as it combines ancient symbols with natural forms.

The spiral is a form that Borromini resonated with. He is known to have collected conch shells during his life. When he died and an inventory of his possessions was taken, one of the pieces identified, Joseph Connors notes, was a large shell "mounted on a pedestal in the shape of an eagle's claw."

NINE

A Pope's Renovations

BORROMINI'S INVOLVEMENT WITH SANT'IVO lasted through three pontificates. He was given the post by Urban VIII, and he completed the church's decoration under Alexander VII, but it was during the papacy of Innocent X that he enjoyed his greatest favor and greatest disappointments.

The Pamphili was a family with ambition—both for themselves and for Rome. Even before Giambattista Pamphili became Pope Innocent X, the family had aspirations for refashioning the city on their own terms—or at least the part that they lived in. It began with the family's front yard, the Piazza Navona.

If the Piazza San Marco in Venice is, in Napoleon's glib but accurate phrase, the drawing room of Europe, then the Piazza Navona is Rome's *gran salone*, its most popular secular assembly room. It has been so for generations.

Built on the spot where in A.D. 86 Emperor Domitian had constructed (out of brick, travertine, and concrete) a U-shaped stadium with a grandstand that seated fifteen thousand spectators, the long, nearly oval piazza has been the site of diversions of all kinds, from *naumachias*—mock sea battles—to medieval jousts to the more social but no less competitive amusement of parading in public wearing the finest that Rome's dressmakers and tailors could supply. During the summer, when the heat of Rome can feel as oppressive and as everlasting as the fires of hell, the etiolated Piazza Navona—more than 300 yards long but less than 60 yards wide—was often flooded so the city's nobility could find relief by riding their carriages through the knee-deep water that was known as the Lago di Piazza Navona. It was such a popular pastime that the Roman scene painter Giovanni Paolo Pannini portrayed the amusement in his 1756 painting *The Piazza Navona Flooded*.

The Pamphili had been a presence in Rome for centuries. The family had moved to Rome from Gubbio, one of the ancient towns of Umbria, in the 1400s. Over the years, its members began to buy property around the Piazza Navona and its neighboring square, the Piazza Pasquino. In 1501 an ancient stone statue was uncovered nearby, on which the Romans used to hang satiric, mocking commentary (often in verse) about the city's great and powerful—a practice that irritated pope and prince alike and gave rise to the word "pasquinade." When Innocent became pope, Pasquino was decked out as Neptune, the Roman god of the seas, holding a trident and riding in his chariot, an image culled from the *Aeneid* in which Neptune quiets the turbulent waves and winds and reestablishes peace and equilibrium—precisely what Innocent hoped to do after the turbulent Barberini years.

Even before Innocent became pope, the Pamphili began to

consolidate their property holdings. In the autumn of 1644 Cardinal Giambattista Pamphili's nephew Camillo Pamphili and his mother, Donna Olimpia, bought land next to the cardinal's house with the idea of combining their properties in the *sestiere* into one large palace that fronted onto the Piazza Navona. They envisioned a magnificent showplace that would house one of Rome's leading families in what was then the largest civic space in the city.

Perhaps the family member most interested in the structure was Donna Olimpia Maidalchini Pamphili, Innocent's sister-in-law. This determined, formidable woman—whose first husband, Pamphilio (or Panfilo), Innocent's older brother, had the good taste (and perhaps the good fortune) to die in 1639—became the palazzo's most notorious resident, though not for her piety or her charitable works. Born in 1591 in Viterbo, she came from a relatively simple background and was known for being intelligent if not particularly refined. By the standards of the day she was thought somewhat mannish: One of her favorite diversions was hunting. Acquisitive, even ruthless, she was known for being *di nauseante ingordigia*, disgustingly greedy, and for craving wealth and power. And through the force of her personality and an advantageous marriage, she managed to achieve both, perhaps prompting Giovanni Giustiniani, the Venetian ambassador, who hated her, to call her a "latter-day Agrippina."

Perhaps most important to the million and a half souls who lived in the Papal States, her influence over her brother-in-law was alarming and unpredictable. It was said that no one could get to the pope without first getting through her. A bust of Donna Olimpia, carved by Alessandro Algardi and now in the Doria-Pamphili collection in Rome, depicts her as a plain, unsmiling creature. Her round, jowled face is fleshy and dominated by a

large, broad nose; her widely spaced eyes stare out at the world with resolution. Her headdress is carved to billow back from her head, giving her the appearance of a Venus flytrap ready to spring shut at any moment.

Many of the pope's colleagues in the College of Cardinals knew of the dangers that Donna Olimpia's presence in Innocent's sphere raised. They knew that she had loaned money to her brother-in-law from her personal fortune earlier in his career as a papal diplomat, and they warned him about his sister-in-law. But Innocent paid no attention. Upon his election, Donna Olimpia instantly became one of the most powerful people in Rome, certainly the city's most powerful woman.

Some believed that she was the true controlling power behind the Throne of Saint Peter, a conviction that triggered some to refer to her as *la popessa,* the lady pope, or *la* Dominante, or even *la* Pimpaccia di Piazza Navona. Others were convinced that she was Innocent's mistress. Her reputation was not helped by the inconvenient fact that her first name could be bastardized easily to *"olim pia,"* a phrase that translates as "once pious."

For many in Rome, Donna Olimpia Pamphili was simply a new stanza added to an old aria: She was the Pamphili version of the sins of greed and self-interest that Innocent had punished the Barberini for. The new pope and his family were not, many thought, very different from the popes (and their families) who had come before them.

The Pamphili had high hopes for their new palazzo. To design and build it, the family selected Girolamo Rainaldi and his son Carlo, known for their cautious and correct approach to design. The family also appointed a commission to work with the Rainaldis to oversee the project.

Borromini was one of those selected to sit on the committee. Bernini was not.

The pope and his family chose a long and narrow site that ran along the southwestern side of the piazza, combining several smaller houses that the Pamphili owned. For the palazzo's main façade facing the piazza, the Rainaldis designed a lugubrious, four-story structure with a belvedere that sits atop the center section of the building above the roofline, giving the whole front a vertiginous appearance. It looks as if it's about to topple over into the piazza. Dozens of windows in a variety of sizes and shapes—rectangles, squares, and ovals; some wide; some narrow, some tucked under cornices like pigeons seeking shelter from the rain—march across the front of the building in straight lines, like army regiments in search of their commanding officers. Ornament is understated, even dull; other than the carved papal coat of arms, which hangs above the central window on the *piano nobile,* the only other decorative elements that draw the eye are the four columns supporting the palazzo's central balcony above the main door, which are said to have been taken from St. Peter's.

In 1646, perhaps because he was unhappy with how the palazzo was progressing, Innocent, probably on the advice of Virgilio Spada, called in Borromini. Every Thursday between April and June 1646 a committee consisting of Girolamo and Carlo Rainaldi, Borromini, a master mason named Ludovico, and Donna Olimpia's representative met to discuss the details of the palazzo's design and construction and how they were to be carried out. Whether he was asked to by the pope or his family, or whether he simply couldn't help himself, Borromini designed several versions of the new palazzo. One of his ideas, Anthony Blunt says, was to arrange the palace around "a long court with apsed ends"—essentially an

extended oval, which called to mind the shape of Piazza Navona. Such a concept, if it had been built, would also have drawn comparisons with the Sapienza, whose courtyard—just one street away from the Piazza Navona—also has an inviting, curving end, which Borromini had used as the façade for Sant'Ivo.

In the end, the pope opted for the Rainaldis' more conventional approach to the palazzo. But Innocent's prudence didn't keep Borromini from having some influence in the interior. Innocent let him design the *sala grande*, the gallery, the palazzo's most impressive room.

The gallery is a room of superlatives, of grandeur and invention. It is long, running from the front of the palazzo, and takes up much of the north wing's *piano nobile*. It shares its outer wall with the southern edge of the complex of the church of Sant'Agnese, which the Pamphili also had built. Its decoration is splendid: strikingly opulent and gracefully elegant in equal measure. By the standards of other Roman palaces, the walls are austere, even plain: Painted a uniform color (at one time they were a rich crimson), they stand in serene contrast to the ornate, highly distinctive door casings of white and gold that frame the doors and statuary niches along the walls. At the far end of the gallery, underneath the barrel vaulting and looking out onto the piazza, Borromini placed a huge Serlian window. It is a tall arched center window flanked by two narrower, flat-topped windows half as wide as the center one. (Such a window was named after Sebastiano Serlio, the sixteenth-century Italian architect and theorist, and was popularized by the Venetian architect Andrea Palladio, which is why today they are also called Palladian windows.) Framing the windows are four small twisting stone columns on low bases, and topping the entire arrangement is an elaborate border

with the pope's crest perched above the central window, like an eagle waiting to pounce on an unsuspecting prey.

Above the doors are astonishing inventions—fantastic confections of sculpture and decor, panache and swagger. Curved, scroll-like pediments, painted and gilded, press up toward the ceiling like parachutes waiting for a breeze. Just below them are round recesses painted a luminous Byzantine gold. Standing in each niche is a white marble bust, which stares down reproachfully at anyone with the temerity to stroll the richly polished, honey-colored parquet floor below.

Such embellishments aren't typical of Borromini; they look fussier than his other work. It's possible that he may have incorporated into the design for the gallery's door frames some of the flavor of the magnificent fresco on the ceiling of *The Apotheosis of Aeneas* by Pietro da Cortona, which is the room's triumph and its treasure. Painted by the same artist whose fresco of *The Triumph of Divine Providence* draws the eye upward at the Palazzo Barberini, this huge painting is a stunning display of virtuoso technique and dynastic propaganda. At the emotional center of the fresco is Innocent himself, depicted as the god Neptune, who is, in the words of one historian, "quelling the tumult of the winds with consummate stillness of attitude and gesture, restoring calm, order and peace in his empire solely by the power of his speech." If only that had been true.

Shortly after Innocent became pope, Borromini designed a suburban villa for Camillo Pamphili to house his impressive collection of antiques. Though many details about this project aren't known, Borromini did include a letter with his plan in which he puts forth his ideas for the villa, which he calls "a study in practical mathematics." His idea was for a rectangular villa "with four towers, or bastions, at the four corners, and . . . 32 windows in the

whole circuit of the building ... [which] would be positioned so that the observer, placing himself in certain doors of the rooms ... would have a view terminated at the horizon in the 32 divisions of the winds." The center window of the two main façades "would be terminated at the beginning and end by the Tropic of Cancer on one side, and by the Tropic of Capricorn on the other." A statue of Innocent would be placed in the villa so "that on the 15th of September the sun would kiss his feet with a ray in the hour in which he was created pope."

With the Pamphili wielding so much power, Borromini saw his fortunes improve—so much so that during the early years of Innocent's pontificate, he considered his decade-long rivalry with Bernini to be over, what Paolo Portoghesi described as "closed in his favor." He had won.

Bernini, after all, was in disgrace, the catastrophe of the campanile's razing was as public a rebuke as Rome had ever seen. And it was evident that Innocent wanted little to do with Bernini. With the Barberini out of power, everything associated with them was, too; in many ways Bernini was tainted by his association with Urban.

Although he did not lose his post as architect of St. Peter's, Bernini nonetheless found himself no longer the pope's preferred artist, either in architecture or in sculpture. Urban may have insisted that Bernini was the Michelangelo of his age, but Innocent found several other artists who looked the part.

Borromini was one of them.

Thanks in part to Virgilio Spada, who had become Innocent's closest architectural adviser, and despite Innocent's continued use of the Rainaldis, Borromini became the architect of choice for several of the major projects that the pope undertook. Perhaps Borromini's greatest commission, at least in terms of its importance to

the church and to Rome, was his selection as architect for the restoration of the church of San Giovanni in Laterano in time for the Holy Year of 1650. This job, second only in prestige to the reconstruction of St. Peter's, was Borromini's greatest public appointment.

The official seat of the pope as the bishop of Rome—*omnium urbis et orbis ecclesiarum mater et caput*—San Giovanni in Laterano is one of the traditional seven pilgrimage churches in the city. It stands at the eastern edge of the medieval city, just east of the Colosseum, and was for a thousand years the city's preeminent church. Its history is as colorful as Rome's. Sacked by invading barbarians, scorched in two separate fires, and battered by bad taste, through it all San Giovanni has maintained its connection to the papacy, a link that goes back further than that of St. Peter's. Emperor Constantine gave the Lateran Palace to Pope Miltiades after he triumphed over Maxentius at the Milvian Bridge in A.D. 312, and he directed that a church dedicated to Saint John be built next door. It is said that within San Giovanni's main altar are the remains of the original table that Saint Peter used as an altar. It now stands under a square, Gothic-inspired baldachino—as different from St. Peter's Baldacchino as it's possible to be.

For centuries the Lateran was both the pope's church and the church's administrative home, and when the Roman Empire fell and the pope became the temporal head of Rome, the Lateran became the political and administrative center of Rome as well.

Though its history extends back to the very beginnings of the church, San Giovanni was not left in splendid isolation. Over the centuries the church has been refurbished and decorated to repair acts of God and reflect the change in taste. Two earthquakes—one in 896, the other in 1349—destroyed parts of the church,

which were rebuilt. A fire in 1361 destroyed the original roof, which was replaced; between 1564 and 1566 Daniele da Volterra replaced it with a deeply coffered wooden ceiling that still covers the nave. In the early fourteenth century, when the papacy bowed to political pressure and decamped to Avignon, the Lateran fell into a gradual state of decline.

When the papacy returned to Rome—thanks in large part to the exhortations of Saint Catherine of Siena—Pope Gregory XI opted to move to the Vatican rather than the Lateran Palace, because he felt that St. Peter's was better protected than the Lateran, Leo IV having constructed towering, sturdy walls. Though Popes Martin V and Eugene IV had parts of San Giovanni restored early in the fifteenth century, retiling the floor in the medieval style and adding Gothic tracery to the windows, the church went through no other major renovation. Which was just as well: It is perhaps one of the few churches in Rome that still has a faint Gothic flavor to it.

With the pope now ensconced in the Vatican, San Giovanni began to be eclipsed in papal attention by the building of the new St. Peter's, which consumed the papacy's attention and pocketbook for the next century. San Giovanni seemed to wither, and by the 1640s the church was in shocking disrepair.

Some of San Giovanni's troubles were purely structural. The church's upper walls, for example, were 2 feet out of plumb and were dangerously close to toppling over. It also had its share of aesthetic problems, including the ancient columns that extended the length of the nave, which weren't strong enough to support the walls. They had been shored up by brick casings, which was expedient but unsightly.

Innocent was determined to change that and to return San Giovanni to its past glories in time for the Holy Year of 1650,

when tens of thousands of pilgrims from all over Europe would descend upon Rome to be enriched spiritually by praying at the city's important churches and shrines (and in turn enriching the church's coffers with their alms and offerings). On April 15, 1646, the pope appointed Spada to oversee the renovation of San Giovanni, and he selected Borromini as the project's architect.

But Innocent was nothing like Julius, who had ordered that the old St. Peter's be dismantled to make way for a new, more magnificent church, thereby severing a tangible link to the church's past. For some, this was an unforgivable sin. Innocent was determined not to discard the past in order to forge a new, more dynamic future.

He was not alone in this. Since the demolition of St. Peter's, there had been a revival of interest in the roots of the ancient church, in early Christian art, and in archaeological finds from that era, all of which sparked a resurgence of interest in, and enthusiasm for, church tradition and history.

Beyond the artistic concerns at San Giovanni, Innocent needed an architect who could manage the technical issues of renovating an old, nearly decrepit building. The job called for more than just an artist or a theorist; it demanded a technician, an engineer, a problem solver—a realist, not a dreamer, someone who understood the secrets of stone and wood, the limits of travertine and tile; someone who could refurbish the pope's church the way the pope wanted.

Innocent and Spada had seen firsthand how ably Borromini had presented his point of view during the crisis of the campanili, and though Borromini's recommendations weren't adopted, Innocent was impressed enough by the architect's abilities—or was willing to be convinced of them by Spada—to offer him this papal prize. He was also surely aware of Borromini's work at Sant'Ivo, of his having to design and build a church within the narrow

confines of the courtyard that Giacomo della Porta had built in the 1560s. (Though it had been designed and built during Urban's pontificate, Sant'Ivo's lantern and spiral weren't complete by the time Innocent became pope, prompting Borromini to ask Innocent in 1651 to fund their construction.)

Although Borromini got the job, Innocent did not give him free rein. Borromini would have to work with San Giovanni as it existed; he would not be allowed to alter the structure of the building. He could repair and restore, but he could not rebuild.

In a letter dated March 16, 1647, Innocent indicated that he wanted to *mantenerla quanto sarà possibile nella sua primitiva forma e abbellirla* (preserve as much of the old church as possible and embellish it).

This was not precisely what Borromini had in mind. His friend Fra Juan de San Bonaventura wrote that such restrictions ran counter to how Borromini worked best and contradicted his ideas for reimagining San Giovanni. Though Borromini's work "gave great satisfaction to the Pope and to everyone in general," in the end "the whole work did not give him satisfaction, even if it did so generally to everyone else."

Still, the architect abided by the restrictions Innocent placed on the project, despite his opposition.

Spada and Borromini began work immediately—in fact, they started so soon after their appointments that it's possible that Borromini had already worked up designs for San Giovanni before he was given the post.

What Borromini did at San Giovanni is to rethink a Constantinian church on his own terms. His approach at first seems straightforward, even obvious, but in its own way it was revolutionary. Carefully, painstakingly thought through, the renovation shows how Borromini could fuse his own ideas with an existing building, creating something entirely original. Using the lessons

he had learned at St. Peter's and drawing from his work at San
Carlo, the Oratory, and Sant'Ivo, he turned San Giovanni into an
ingeniously arranged space that now celebrates the founders of
the church, the Apostles. The result is a very personal statement
in a very public church.

The original San Giovanni was much like the original St. Pe-
ter's, with a tall, rectangular nave and two lower aisles on each side
of it—similar, in fact, to other public buildings in Rome during
the time of Constantine, from civil courts to pagan shrines. A
chain of columns plodded dully down the nave like prisoners
marching to their fate. A series of nondescript windows along the
outer walls admitted some light, but sunshine made it to the nave
itself only intermittently; the low, dark aisles seemed to consume it,
as if hungry for illumination. (Even today, despite Borromini's im-
provements, the church can seem dark and unwelcoming.) This, ap-
parently, was the way Innocent wanted it to remain.

Borromini focused most of his attention on the nave, which
over the years had become a disorganized muddle. To replace the
monotonous sequence of columns, Borromini combined them,
fusing two columns into one support. This innovation served
both to simplify the lines of San Giovanni's interior and to
strengthen the columns. It also allowed Borromini the chance to
broaden the open spaces between the columns; in them, he placed
tall, wide archways, five along each side of the nave. Above the
arches he placed high, clear windows, also arched, which allow
light to cascade down into the church. Next to each arch he placed
soaring, square pilasters of white marble, their bases light gray,
which begin at the floor and stretch to the very top of the wall.
They seem to grow out of the floor like thick trees, just as the pi-
lasters do at Sant'Ivo. Between these towering pilasters, Borromini
placed twelve rectangular statuary niches, called tabernacles, which

now display statues of the Apostles who are memorialized in white marble carved in the eighteenth century and are a noteworthy decorative detail of what Henry James called "that cold clean temple" of San Giovanni. Framing each statue and supporting a stone pediment that bows out into the nave as if it were too big for the space it was designed for are two *verde antico,* green marble columns about 3.5 meters (11.5 feet) high, which had stood originally between the two outer aisles (and which Borromini moved to decorate the niches) and now stand upon bases of dark gray marble with the name of the saint carved into each one, surrounded by crisply rendered laurels and palm fronds.

The sequence of taller, rounded arch and lower, rectangular openings—combined with the two outside corners of the nave curving *into* the church—calls to mind details from Borromini's other works: the Serlian window at the Palazzo Pamphili and the lively, logical cloister at San Carlino.

Perhaps Borromini's greatest disappointment at San Giovanni was the ceiling. He had wanted to vault it, probably using either a barrel or a coved vault (his surviving papers aren't clear about this) with diagonal ribbing that would reach out across the ceiling from one side of the nave to the other at angles, linking the different parts of the church by weaving a meticulous matrix over them. But Innocent couldn't bring himself to tear down the remarkable (if gloomy) carved wooden ceiling that Pius IV had had installed in the sixteenth century. When work on San Giovanni reached the top of the pilasters, the pope told Spada and Borromini that he would not allow them to proceed with the vaulting. Though Borromini may have been more comfortable with the huge arched ceiling Michelangelo had designed for St. Peter's, the pope, Joseph Connors explains, had been schooled in

"the teachings of Baronius and the Oratorians, who promoted the cult of early Christian antiquity, and his slogan of conservation with embellishment (*et vetustas servareter, et venustas addereter*) was incompatible" with Borromini's ideas.

Borromini had greater success with the side aisles, where he had a freer hand and a better chance of seeing his inventiveness take shape. He both simplified and enlivened these long, constricted passages, giving them physical and spiritual illumination they hadn't had before. Because the inner and outer aisles were of different heights, Borromini was able to insert windows *between* the aisles, which gave him the opportunity to play with light and shadow. He also took every opportunity to use cherubs' and angels' heads as decoration, motifs he had used liberally at San Carlino and Sant'Ivo. He placed them above arches and along support beams, their tranquil faces and graceful wings (either folded in repose or spread wide as if ready for flight) a soothing detail in a church bursting with embellishment.

At San Giovanni, Borromini elaborated on the architectural ideas he began at San Carlo and expanded them on a grander scale for the pope's home church, turning what had been an overlooked place of worship into a rival of St. Peter's.

Innocent had set aside 70,000 scudi for the renovations, and the work proceeded quickly. By the end of 1647, the major structural work was finished; by the next year, the roof was done; by October 1649, the interior stucco decoration was complete—two months before the Holy Year was to begin.

One of the reasons the renovations proceeded so rapidly— beyond the need to complete them before the Holy Year began— was Innocent's keen personal interest in the project. Torgil Magnuson indicates that the Venetian nobleman Alvise Contarini

SAN GIOVANNI IN LATERANO

wrote the Venetian senate that the pope had his agents visit San Giovanni every day. The pope would even "look in personally to see what stage had been reached and to urge the workers on to greater efforts."

Innocent's interference turned out to be a blessing for Borromini—in fact, it saved his reputation and possibly even his life.

As with many things about Borromini's life, the details of the tragedy at San Giovanni are sketchy and contradictory. What is known is that on December 6, 1649, just a few weeks before the Holy Year was to begin, the body of a young man, Marco Antonio

Bussone (or Bussoni), was discovered at San Giovanni (either in a room or in the building yard; sources differ on this detail). He appeared to have been bound and severely, even ruthlessly, beaten—and had died from his injuries.

An official investigation began, and it was determined that the youth had been caught by workmen in the basilica's building yard trying to damage some of the marble that was being prepared for the basilica. On instructions from their supervisor, the laborers gave him a brutal beating.

Their supervisor was Francesco Borromini.

There is no evidence that Borromini wanted the youth killed, but it is clear that events, once they began, quickly spun out of control. The workmen, at Borromini's prompting, vented their anger at the young vandal, and Borromini either couldn't or wouldn't restrain them.

Even more damning was the discovery, according to Connors, that the men had tried to dispose of Bussone's body by burying it in the porch itself at San Giovanni—a shocking tactic. Either they failed or they thought better of it, because the body was discovered elsewhere.

Despite efforts to hush up the crime, the news got out. Even in seventeenth-century Rome, a murder is a murder. The matter went before the Roman courts, and it appeared that the laborers and Borromini were in serious trouble. The situation was so severe, the circumstances so damning, that the pope himself was required to intervene personally in the case to save Borromini from substantial punishment.

Because of Innocent's intervention, Borromini was given a relatively light sentence. "He was remanded to temporary banishment at the pope's pleasure," Connors explains, with the disconcerting

prospect of a three-year expulsion from Rome to Orvieto, a hill town some seventy miles northwest of the city, if he misbehaved further. (Another version of the story places Borromini's banishment in Viterbo, some fifty miles from Rome.) However, nothing indicates that Borromini was ever forced to leave Rome, though he may have been.

Despite the scandal, Borromini completed the renovations of San Giovanni in Laterano to Innocent's satisfaction. The pope was pleased with Borromini's ingenuity, though by then he had grown tired of the demanding, difficult architect. Innocent awarded Borromini a knighthood, the *croce di Cristo*, in July 1652—an honor Bernini had received three decades (and three popes) earlier. Finally, there was official public recognition of Borromini's work.

Yet even at this moment of triumph, the apex of his career, neither the pope nor his closest aides could bear being in the presence of the wearisome Borromini long enough to confer this great honor on him. So they arranged for the traditional symbols given to a *cavaliere*, a cross and heavy chain, to be delivered to him by an intermediary, the only papal courtier who seemed to be able to stand Borromini, Virgilio Spada.

The pope's interest in renovating and restoring Rome extended beyond San Giovanni and the sacred. Even after he commissioned the work on the Palazzo Pamphili, he and his family continued to work at turning the Piazza Navona into the family's personal courtyard. At about the same time Innocent commissioned Borromini to renovate the Lateran, the pope directed that an ancient damaged obelisk—discovered in pieces originally on the Via Appia and now in the Circus Maxentius—would be moved to the Piazza Navona, where it would be reassembled to stand at the center of a fountain.

It was a task that Borromini would begin but someone else would complete—much to his aggravation.

TEN

Water and Disappointment

✳

BERNINI REESTABLISHED HIS REPUTATION AS
the greatest artist in Rome on the slipperiest of
foundations: water. The opportunity—which
came from the most unlikely source, the pope—
presented itself unexpectedly but not without
some effort on his part.

As the Palazzo Pamphili began to take shape
on the Piazza Navona, Innocent realized that
the character of the piazza was changing. It was
no longer just a jumbled open-air vegetable
market or the site of haphazard neighborhood
celebrations. It must look like what it was: one
of the city's most important squares and the
home to the first family of Rome. As the build-
ings around the piazza were being built and
refurbished—Innocent would soon commission
the church of Sant'Agnese in Agone for the site
north of the Palazzo Pamphili, making it the
de facto family chapel—it became obvious that
the piazza itself needed a unifying focal point.

Over the years the piazza had been improved somewhat arbitrarily and for utilitarian reasons rather than for artistic ones. During the late sixteenth century, Pope Gregory XIII had commissioned Giacomo della Porta to design a fountain at the southern end of the piazza, which would use water from the Acqua Vergine, the ancient Roman aqueduct that drew water from the outskirts of Rome into the city. Della Porta designed a foundation where the Fontana del Moro now stands, while at the center of the piazza he placed a rectangular stone trough that horses and donkeys could drink from.

By 1647, Innocent had decided that the center of his family's piazza merited something more distinguished than a drinking trough. He wanted a glorious fountain in the center of the piazza and commanded that most of the water from the Acqua Vergine be diverted to the Piazza Navona instead of the Fontana di Trevi, a project that Urban VIII had championed when he was pope. Innocent appointed Borromini as overseer of the project to extend the aqueduct so that it could convey the greater amount of water to the piazza. He also made tin, lead, and other building materials available for the project, as well as money from the *Camera apostolica*—in other words, from the church, not from the Pamphili family fortune. Innocent was using both church resources and Borromini to finance the exaltation of the Pamphili, just as Urban had used Bernini to celebrate the Barberini.

Borromini suggested to Innocent that this new fountain should commemorate the four great rivers of the known world—the Nile, the Danube, the Ganges, and the Plata—which would in turn represent the four known continents of Africa, Europe, Asia, and the Americas. The idea intrigued Innocent, as did an obelisk carved in Egypt, which Filippo Baldinucci indicates had

been brought to Rome by the emperor Antoninus Caracalla and which recently had been rediscovered lying in several salvageable pieces in the Circus Maxentius (also known as the Circo di Massenzio) on the Appian Way. On April 27, 1647, Innocent inspected the obelisk and then directed that it be reassembled and incorporated into the new fountain in the piazza.

Innocent asked Borromini and several other artists to come up with a design for the fountain. Bernini, the self-styled *amico delle acque,* friend of water, was not asked. This was a particularly public reproof, given that Bernini had already created several extraordinary fountains in Rome, including the Triton Fountain at the Piazza Barberini. This remarkable piece of sculpture, which literally effervesces with movement, depicts the muscular sea god Triton, his scaly tail-like legs curving back on either side of him from his waist, kneeling atop a large open shell that is supported by four angry-looking dolphins. Triton's head is thrown back and he holds in two hands a massive conch shell, which he blows into and which throws a single jet of water into the air. It is, in Howard Hibbard's memorable phrase, "an apotheosis of water, myth come to life." Bernini has captured in stone the scene from Ovid's *Metamorphoses* in which Triton calls back the waters that have flooded the land: "He lifts his hollow shell . . . and sounded forth the retreat which had been ordered . . . and all the waters by which 'twas heard it held in check. . . . The world was indeed restored."

That such a master manipulator of water wasn't asked to submit a design for the new fountain at the Piazza Navona reveals more about the Pamphili's capacity for holding a grudge than it does Bernini's lack of skill as a designer.

Because of Borromini's close association with the fountain—he designed the conduit for the water to reach it, and it was his

idea to celebrate the four rivers—it was assumed along the corridors of the Vatican that he would win the commission. Yet the design that is thought to be Borromini's (it is not signed) is remarkable for how uninspiring it is. (There are those experts who don't believe it was his.) It is a far cry from the other, more ingenious designs he was working on at the time and from the extraordinary fountain that was eventually built. In this design, the repaired and reassembled obelisk stands atop a high base that is decorated with the pope's coat of arms and inscription. Beneath that, on its four rectangular sides, shell-like apertures with grotesque, lionlike faces serve as spouts from which the water pours into a low stone basin.

It is a dutiful design, as correct and as careful as the pope himself, and it undoubtedly accomplishes precisely what Innocent had asked, by incorporating the obelisk into the fountain's design. But it does nothing more. In fact, it is so pedestrian a design, so perfunctory and humdrum, that some believe that it isn't Borromini's design at all.

Others had been asked to submit designs—"Every artist worth the name was invited," Howard Hibbard writes—including Alessandro Algardi, a sculptor whom Innocent preferred over Bernini early in his pontificate. Algardi proposed several ideas, one of which, Tod Marder writes, "features an allegorical figure, Roma, on a tall, squared base with four river gods perched on the corners"—a proposal that could well have influenced the design that was eventually chosen.

There was considerable consensus in the Vatican that Innocent would select Borromini to oversee the design for the Fountain of the Four Rivers. Even if Borromini had submitted the uninspired design, Innocent could have asked him for another.

And he undoubtedly would have provided one. From such certainty the greatest surprises spring.

Several stories have circulated over the centuries explaining how Bernini managed to secure the commission for the Fountain of the Four Rivers and how he returned to papal favor. Perhaps the likeliest of the tales—or at least the one that relies on Bernini's talents as an architect and a sculptor rather than on his skills as a courtier—is the one that both Baldinucci and Domenico Bernini recount. According to both, it is Nicolò (or Niccolò) Ludovisi, Prince of Piombino, who engineered the commission.

According to Domenico, the prince, a friend of Bernini's who had recently married the pope's niece, Donna Costanza Pamphili, decided that it was time for Innocent to forgive Bernini for his inauspicious association with the Barberini. "Attributing the aversion of the Pope more to the liabilities of those times than to any fault of the Cavalier," Domenico writes, Ludovisi "made up his mind, for the good of Rome, to promote [Bernini] in every way."

Such high-minded sentiments, however, didn't alter the fact that Ludovisi's "knowledge of the tenacious and steadfast nature of the Pope made him doubtful of a favorable outcome." Still, he was willing to take a chance.

Domenico writes that Ludovisi persuaded Bernini to design and build a model for the fountain project, even though the pope hadn't asked him for one. "Making up in ingenuity what he lacked in strength, [Ludovisi] sent for Bernini and, as if for an entirely different purpose than to show to the Pope, but, as he said, for his own enjoyment, he secretly asked him to make a design" for the fountain.

Bernini agreed, because he "could not deny to so praiseworthy a Prince a gratification which he believed to be private and which

should not otherwise be made public," Domenico writes. Perhaps. But since Bernini was also currently the architect of Ludovisi's own palazzo, Bernini could well have wanted to keep his powerful patron happy; perhaps his interest in Bernini's other work might help the architect capture Innocent's goodwill.

Whatever the reason, when the model was finished, Bernini sent it to Ludovisi, who "received it with . . . much pleasure since the idea of it seemed beautiful and the design grand," Domenico says. Ludovisi had the model taken to the Palazzo Pamphili, where his artistic ambush, using Bernini's model as ammunition, was to take place. The prince was convinced that when the pope saw the model he "would at least demand to know by whom it had been done."

On August 15, 1647, the Feast of the Assumption of the Virgin, Innocent dined with his sister-in-law Donna Olimpia and his nephew Camillo Pamphili at the Palazzo Pamphili. According to Domenico, Ludovisi "deliberately placed the model on a little table in a room through which the Pope had to pass after the meal." According to Baldinucci, "Upon seeing such a noble creation and a design for such a vast monument," the pope "was nearly ecstatic" with enthusiasm. He spent half an hour studying the model, "continuously admiring and praising it," until at last he exclaimed: "This design cannot be by any other than Bernini, and this is a trick of Prince Ludovisi so that in spite of those who do not wish it, we will be forced to make use of Bernini, because whoever would not have his things executed must not see them." That day, according to Domenico's account, the pope summoned Bernini.

Baldinucci says that Innocent showered Bernini "with a thousand signs of esteem and love and with a majestic manner, almost apologizing, he explained to him the motives and various reasons

for not having made use of him before, and he gave him the commission to make the fountain after his model."

Another version of Bernini's redemption comes from a letter by Francesco Mantovani, the Duke of Modena's emissary in Rome. He wrote to his patron, Francesco d'Este, that Bernini won over the pope by presenting to Innocent's grasping sister-in-law Donna Olimpia a model of the fountain cast in silver. The pope saw this miraculous piece of silversmithing and was suitably impressed—so awed, in fact, that he engaged Bernini to oversee the fountain.

The trouble with this story is that there is no record of the Pamphili ever owning such a remarkable object. According to Charles Avery, Cardinal Mazarin did own a version of this Fountain of the Four Rivers that was possibly presented to him by Bernini; however, the model is now lost.

Whatever method was used, Bernini was back in the good graces of the pontiff. The mortifying exile from papal favor was over. The prodigal architect had returned.

Domenico's view on his father's redemption was that it was inevitable: Genius cannot be ignored forever, particularly by the mighty.

Such enthusiasm wasn't shared by everyone. On July 10, 1648, when the commission was formally awarded to Bernini, "Borromini stormed through a series of angry interviews with the pope, so agitated that to some observers he looked as though he might throw himself into the Tiber." Incensed, he stalked off the construction site at San Giovanni in Laterano. He was furious that his rival had returned to such public—and papal—prominence at his expense. After all, the idea of using the fountain to celebrate the world's four great rivers had been his, and at the pope's command he had engineered the means to get the water to the piazza

to make the fountain possible in the first place. To have the commission snatched from him—or at least the expectation of the commission—and given to Bernini was infuriating.

Though Borromini's anger was genuine, his fit of pique was calculated, a self-indulgent tantrum to drive home what a blow to his honor Bernini's selection was. He refused to return to San Giovanni, but Joseph Connors notes that he "allowed work to continue under the direction of his friend Pietro da Cortona." After all, work on the basilica had to be completed before the Holy Year began. The efficient Virgilio Spada knew this better than Borromini, and while hurrying along the work he enraged Borromini further by engaging another band of stuccoists under a supervisor Borromini didn't like. Such a misstep prompted a game of architectural brinkmanship, with potentially disastrous consequences: "Borromini called a general walkout, and the two rival *capomaestri stuccatori* stalked the work site wearing swords," Connors explains. Violence seemed likely, perhaps inevitable.

But in the end, Borromini's ruffled feathers were soothed, the replacement laborers were dismissed, and work continued.

None of this, of course, changed the pope's mind about who should design the fountain. Nor should it have, for it is impossible to criticize Bernini on artistic grounds. The Fountain of the Four Rivers is a marvel, as impressive today as it must have been when he completed it in 1651. The graceful tapering obelisk— slender and elegant and topped by a dove, the symbol of the Pamphili, an olive branch in its beak—stands on an outcropping of travertine carved to look like the quarry from which the stone for the obelisk was taken. But to make this base even more dramatic and startling, and to astonish visitors even today, Bernini carved out a grotto-like space beneath the obelisk, so that one

can see through the fountain's base to the opposite side of the piazza, all the while wondering how the obelisk is supported at all.

Sitting at the corners of the obelisk, balanced precariously on the rocky outcrops of the base, are four colossal nude figures, each representing a different river. At the southwest corner, closest to the Palazzo Pamphili, Bernini placed the bearded Danube, who gestures with his right arm to the east, toward the figure representing the Ganges, whose head faces south as he straddles a large oar pitched into the water below.

In the northwest corner of the fountain is the figure representing the Rio de la Plata. It is the least suitable rendering of South America and reveals how little was known of the New World in the seventeenth century: A bald and bearded, Moorish-looking man, with a jeweled band circling his leg just above his right ankle, leans back on his right arm (so that, some think, he can see the dove on top of the obelisk), his left arm above his head, as if he might suddenly roll off the fountain to escape being crushed by an unseen avalanche.

In the northeast corner, his head covered by a shroud of stone (to represent that its source was still unknown), sits the Nile, another beaded leg band circling his left thigh just above his knee. Surrounding these figures are symbols of the continents that the rivers flow through: the papal arms and a horse for Christian Europe; the oar for Asia (the Ganges is navigable across India); a snake, an armadillo (a creature unknown in seventeenth-century Rome but seen as native to South America), and scattered gold coins for the riches of the New World; a palm tree and lion for Africa.

Work on the fountain began soon after Bernini received official word of the commission. According to the diarist Giacinto Gigli, the obelisk was moved to the site at phenomenal cost:

12,000 scudi—a sum so high that Romans began to complain about Innocent's expensive whims (though some scholars doubt this figure). While the pope was spending money to move broken pieces of old stone, they said, the city's residents were going hungry. Such a state of affairs prompted an unknown and no doubt hungry wag to quip in rhyme:

Noi volemo altro che guglie e fontane;
pane volemo, pane, pane, pane.

We want more than just obelisks and fountains;
It's bread we want; bread, bread, bread.

Despite these complaints, the work continued, using Bernini's successful and long-established practice of overseeing a group of talented workmen. The stonemason G. M. Fracchi carved much of the travertine base, Bernini adding the finishing touches before the obelisk was placed in August 1649. During 1650–51, Bernini's assistants carved the four river figures to Bernini's designs. The accounts indicate that Antonio Raggi carved the Danube, Claude Poussin the Ganges, Francesco Baratta the Rio de la Plata, and Jacopo Antonio Fancelli the Nile. Nicolò Sale worked on the escutcheons and on the Pamphili dove, which was cast in bronze, and Guidantonio Abbatini was hired to paint the rock and detailing, which has long since faded.

In addition to completing the finishing touches of the rock, Bernini is credited with carving the palm tree, the lion, and the horse, which needed to be done on site—an impressive achievement, given the abundance of detail Bernini managed to incorporate and how constrained the working quarters must have been.

And while the three-dimensional qualities of the fountain are appealing—by turns witty and surprising—the proportions of some of Bernini's work seem off. The horse in particular, which seems to be about to spring from the cleft in the rock between the Rio de la Plata and the Danube, appears incongruously long: Given the size of its head and front legs, the horse's hindquarters shouldn't be visible from any of the other arches in the base. Yet the rear legs and tail are visible between the Danube and the Ganges. Such a long creature seems to serve art more than nature. Or perhaps there is another horse hidden in the grotto, waiting to break out of its soggy stall.

Whatever the reason for the elongated equine, Bernini seemed more interested in the drama he could create than in preserving the details of natural proportions. And his instincts certainly proved correct, because the fountain has received almost universal praise. Even the fastidious Englishman Tobias Smollett in his 1766 guidebook, *Travels Through France and Italy*, described the Fountain of the Four Rivers as "perhaps the most magnificent in Europe," though he complained that the Piazza Navona itself "is almost as dirty as West Smithfield, where the cattle are sold in London."

Innocent was inordinately pleased with the result, particularly when he arrived a few days before the official unveiling on June 14, 1651 (the scaffolding was still up) as Bernini and his workmen were putting the final touches on the fountain.

The pontiff arrived with his entourage, including Cardinal Giovanni Giacomo Panziroli, the papal secretary of state. According to Baldinucci, the pope spent more than an hour inspecting the fountain and its details, delighting in what he saw.

After a while he asked Bernini when he could see the water flow through the fountain.

Bernini, Baldinucci writes, "replied that he could not say on such short notice, since some time was required to put everything in order."

The pope, no doubt disappointed at such an answer, nevertheless gave his benediction and prepared to leave.

It was then that Bernini, who had been preparing for such a visit, gave the signal to turn on the water.

As Innocent was leaving, he heard a rush and turned toward the fountain to see water "gush forth on all sides in great abundance."

The pope was enchanted.

Bernini understood, Baldinucci wrote, "that the more unexpected it was, the more pleasing it would be to the pope." It was precisely the ploy he had used decades before when showing Cardinal Scipione Borghese his original, flawed bust. And it was as successful in the middle of the Piazza Navona as it had been in his sculpture studio.

If the pope was pleased with the fountain before, he was doubly so now. Innocent exclaimed to Bernini, "In giving us this unexpected joy, you have added ten years to our life." To show his enthusiasm and gratitude, Baldinucci says, the pope dispatched a servant to the Palazzo Pamphili to retrieve one hundred doubloons, which Innocent distributed to the grateful workmen. Bernini was more substantially rewarded: He received 3,000 scudi, nearly a tenth of the fountain's entire 29,000 scudi cost, as his fee.

Despite the pope's public approval of the fountain, there were lingering whispers about its construction and the sculptor's technical proficiency. Bernini, the stories said, hadn't constructed the obelisk properly. The tall arches weren't strong enough to support such a heavy piece of stone. Bernini had again surrendered safety for spectacle; it was going to fall over.

As they had with the *campanili* at St. Peter's, Bernini's critics focused on his weakness as an architect. After a particularly strong thunderstorm, the speculation grew louder that the obelisk was in danger of toppling down at any moment.

To counter such criticism, Bernini decided to meet his critics head-on. According to Domenico, his father made a special trip to the fountain several days after the storm. A crowd had gathered. After making a show of painstakingly inspecting the fountain, Bernini took four pieces of twine that had previously been strung from nails hammered into the walls around the perimeter of the piazza and attached them carefully to the top of the obelisk. When he was finished, he gazed with approval at his handiwork and, satisfied, got back into his carriage and rode away—"amidst general hilarity" from the onlookers. Bernini's elaborate pretense of giving the obelisk more support was a clever (if theatrical) public rebuke to those detractors who claimed the fountain was too weak to stand on its own without additional support. Bernini knew that the obelisk was in no danger of falling down. More than 350 years later, it still stands exactly where Bernini had placed it.

Such grandstanding doesn't mean that Bernini didn't take criticism to heart, even self-criticism. Domenico admits that as his father aged, he thought less and less of the Fountain of the Four Rivers, once even pulling the curtains of his carriage closed as he was driven through the Piazza Navona and exclaiming, *"O come mi vergogno di haver operato così male."* How ashamed I am to have done so poorly.

This was not a sentiment Borromini was ever known to have expressed. If he did have regrets about how his architectural ideas turned out, they were more likely to be directed at the patrons or bureaucrats whose lack of imagination forced him to restrain his

ingenuity than at himself for not being creative or resourceful enough. Such a situation arose at the church of Sant'Agnese in Agone, the Pamphili family chapel just north of the Palazzo Pamphili, whose splendid façade and dome dominate the Piazza Navona. Borromini's work on this church, one of the most beautiful in Rome, is both brilliant and tragic, sparkling and sad. His involvement with it is, Anthony Blunt says, "the saddest in the whole of Borromini's career."

It could have ended so much more satisfactorily than it did. In 1652, after both the renovation of San Giovanni in Laterano and the Fountain of the Four Rivers had been completed, Innocent decided to pull down the small church of Sant'Agnese in Agone and rebuild it on a more sumptuous scale, turning the entrance toward the Piazza Navona. Though neither of them knew it, it would be Innocent's last major building project and the beginning of the end of Borromini's career as a papal architect.

The original Sant'Agnese was a tiny ninth-century church that fit snugly into the arcades of Domitian's stadium and commemorated the refusal of Agnese, a young Christian, to succumb to the advances of a Roman. Her chastity angered her pursuer, who had her brought to a house of prostitution amid the stadium's ruins, where she was to be stripped naked. Such was Agnese's piety, however, that the Almighty protected her modesty by causing her hair to grow, thus concealing her nakedness from public view.

Unfortunately, such a display of the power of the Almighty did not keep the young Agnese from being tortured and killed. The original church was said to be built on the site of her martyrdom. Little else about the original church is recorded until the twelfth century, when Pope Calixtus II ordered a larger church constructed on the site.

In December 1651 the architect Giovanni Battista Mola measured the old church of Sant'Agnese—perhaps as a sign of what the pope had in mind for it. But the ever-cautious Innocent waited several months before resolving to rebuild the church. By February 1652 he had consulted other architects, eventually settling once again on the Rainaldis, the *architetti di casa* and the preferred architects of his nephew Camillo. It was a mistake he would regret.

The team of father and son went to work immediately on the project. They designed a centralized church that was an uneasy combination of an octagon and a Greek cross. The central space was dominated by a heavy, low dome. Four squat arms—one containing the entrance, one the main altar (directly across from the front door), the other two side chapels—extended out from it and were connected visually by four low, shallow niches, which faced the central space and cut off the angles of the arms, creating an octagon. Outside were two short bell towers at either end of a high, flat façade, which looked very much like Maderno's at St. Peter's and added little lightness to the lackluster design. What the Rainaldis envisioned seemed to employ all of the mistakes Maderno committed at St. Peter's with none of his scope or vision.

In the spring of 1652 the Pamphili purchased the nearby Palazzo Mellini, the last obstacle to construction. The family now had enough land for the Rainaldis to begin to build. Work on the new Sant'Agnese began over the medieval church on August 14, 1652, when its foundation stone was laid by the five-year-old son of Don Camillo, the pope's nephew, and Donna Olimpia Aldobrandini, the princess of Romano. (The pope had allowed his nephew, whom he had made a cardinal, to leave the church in

order to marry.) It was a family celebration with a point: Innocent wanted his family and the people of Rome to consider the new Sant'Agnese as the Pamphili family chapel.

Though the church was not large—it is wide but not deep, like the piazza it stands in—it must be opulent enough, and important-looking enough, to house the tomb of a pope.

Though work on the church proceeded for nearly a year, there were problems almost immediately. Water in the subsoil made it impractical to use the old church as a family crypt, so that idea was abandoned. However, this did allow the Rainaldis to lower the floor of the new church, making it closer to the level of the piazza.

The entrance staircase proved to be a particularly trying problem, and it possibly contributed to the Rainaldis' dismissal from the commission. The stairs that Girolamo designed and built were deemed too intrusive; they jutted out too far into the narrow piazza. They were eventually demolished, and Carlo Rainaldi offered a revised plan for the façade, which introduced the idea of a concave entrance front. It would be some time before this idea was adopted, and it would not be Carlo whose work would be built.

By the spring of 1653 it became clear that the aging Girolamo was not up to the task of designing and overseeing Sant'Agnese. Carlo was put in sole charge of the project, probably at the suggestion of Virgilio Spada.

By July 1653 problems with the church became public. They were less structural than aesthetic. The diarist Gigli notes that the architect Martino Longhi had openly criticized the church's design and construction, condemning "a certain staircase that took up part of the piazza and hid Palazzo Pamphili"—in all probability Girolamo's unfortunate entrance stairway. Perhaps because of this, or perhaps "because the pope was greatly enraged at having

heard the design was not worthy of praise," construction on the church halted.

The pope found himself in a quandary. He certainly must have approved the initial designs for the church, but Longhi's loud condemnation of the designs and construction upset him. In addition, Innocent was now involved in the latest in a long line of squabbles that bubbled up from the Pamphili family. He had quarreled with Donna Olimpia and had turned to her son, Camillo, for support. But when Innocent reconciled with his cantankerous sister-in-law, Camillo found his influence with the pope waning. And when influence is taken away from a patron it usually is also taken away from the artist.

The Rainaldis' designs for Sant'Agnese certainly would not generate much enthusiasm without a powerful advocate like Camillo Pamphili to advance them. Paolo Portoghesi calls the designs "absurd and unjustifiable," and it's clear why. The design's most obvious flaw, then and now, seems to be that the tall, square front of the church hid a substantial part of the dome. It's the same problem that Maderno had at St. Peter's. But Maderno's excuse was that he had to complete a church that was longer than it was supposed to be. At Sant'Agnese, the Rainaldis had had a free hand and the support of the pope's nephew Camillo. And they botched it.

Now that Donna Olimpia was back as a papal favorite and once again had Innocent's ear, it's possible that she, together with Virgilio Spada, convinced the pope that the Rainaldis were not the architects for Sant'Agnese.

However he reached such a conclusion, Innocent dismissed Carlo Rainaldi, and even though Bernini had been rehabilitated in the pope's eyes, Borromini was called in to take charge of Sant'Agnese's design and construction.

The pope had become, if not favorably disposed toward Borromini, at least confident in his abilities and talents as an architect. After all, the architect had satisfactorily completed San Giovanni in time for the Holy Year (though the pope had to intervene personally to keep Borromini from going to jail) and had proven himself to be both creative and willing to work to fulfill the pope's wishes. In addition, Borromini had the support of both Donna Olimpia and Virgilio Spada, two powerful allies. According to Spada, "Even though the pope was fed up with him, because he abandoned [San Giovanni] at its peak, and lamented having given execution of the marvelous Piazza Navona fountain to others after he had piped in the water, nonetheless the pope reckoned that the façade of Sant'Agnese was distorted— it seemed too tall from the ground—he handed it over for correction to him, and he created that beautiful façade, which cannot be criticized except by [here Spada canceled "hatred"] envy."

At Sant'Agnese, Borromini took over a complicated commission. He inherited a half-finished church: The façade was about 3 meters (10 feet) high and the interior walls had been completed to the tops of the tall niches that decorate the church along the sides of the octagon. And any changes he wanted to make in the church's plan or design had to be approved by the family member in charge of the building project: first Camillo Pamphili, then Donna Olimpia, and then after her death Camillo again.

Despite this, the pope wanted the church completed and was reluctant to modify much of it. Despite having Spada's support— and Spada knew how to influence Donna Olimpia as well— Borromini had little actual opportunity to change the church. Instead of rethinking what should be built on the site, Borromini

attempted to repeat the trick he had mastered at San Giovanni: to please the pope by making the church *look* better.

Borromini began overseeing work at Sant'Agnese on August 7, 1653. He had drawn up new plans (possibly before he even took over the commission) that maintained the church's size and scope as the Rainaldis had envisioned it, but he proposed modifying the angled sides of the central space to make them convex, so that they curved into the church—a technique he also used at Sant'Ivo—which would have given Sant'Agnese a greater sense of movement, of drama and momentum, instead of the austere, unadventurous dignity the Rainaldis envisioned and Camillo preferred. He also proposed reconfiguring the courtyard behind the northern chapel, turning it into an arcaded square with rounded corners—an intimate quadrangle similar to the large courtyard he had designed at the Oratory.

Most of his attention, however, was expended on the façade, where the family gave him a free hand. One of the jabs that had been leveled against the Rainaldis' front for Sant'Agnese was that the original set of stairs that led to the main doors protruded too far into the piazza. They were considered awkward and inconvenient. Borromini ordered the original façade torn down and began to build a new one.

His new design was both imaginative and vigorous. He continued to use the motif of a concave front—which Carlo Rainaldi had suggested when the initial charges against the steps were aired—to subtly embrace a visitor. Eight tall, sturdy columns framed three large doorways, the center one taller. Above the columns Borromini placed a striking pediment whose outline is reminiscent of the complex overdoors in the gallery at Palazzo Pamphili; this time, however, the outline frames not a statuary

niche but a large, nearly semicircular window that had it been built would have allowed the morning sun to suffuse the church with light. The pediment would also have drawn the viewer's eye up to the dome, which Borromini framed with two low but dramatic bell towers, one at each end of the church, which were to be topped by intricate groupings of columns and embellishments (stone lilies, another emblem of the Pamphili family, were to stand above the columns as if they had sprung from fertile ground beneath). A set of low, curved steps ended at an oval landing that was high enough to perhaps prompt a visitor to try to catch the eye of the statue of Rio de la Plata in Bernini's Fountain of the Four Rivers, which stood a few yards away.

In his design, Borromini managed to do what many thought was impossible: to provide a harmonious architectural counterpoint to the sculptural melody that had been played first by Bernini in the Piazza Navona. Borromini, Portoghesi said, was "generous enough to make his façade suggest an embracing movement in relation to the fountain," which produced "an accentuated dynamic rapport" between the work of these two artists.

Work on Sant'Agnese progressed quickly. The dome's drum was complete by the summer of 1654, even though Borromini insisted that only the best brick would do. Such haste didn't come without a price: Supervision and safety measures got lax, and an accident—what Torgil Magnuson calls "a collapse"—occurred, causing considerable injuries and finger-pointing, some of it at Borromini. It was the second recorded instance that an accident had happened on a building site overseen by Borromini.

Yet Innocent didn't seem to care. He made monthly visits to the site, exhorting the laborers to work faster and clashing with Borromini over building details and the speed with which the

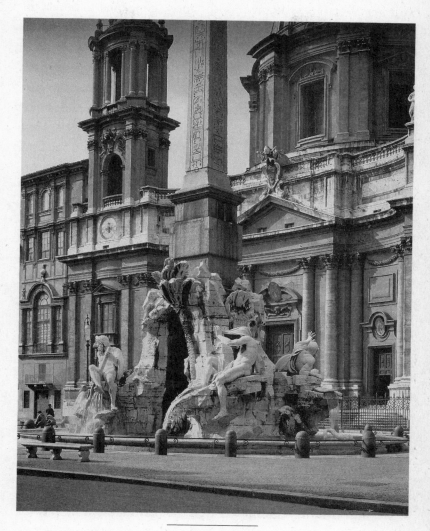

PIAZZA NAVONA

work was progressing; the pope was not the most patient of men. Nor was Borromini known as the most congenial architect in Rome. So their arguments could have been caused by either man. As he aged, the pope was becoming more querulous and ill-tempered. By the autumn of 1654 Innocent fell ill, and it became apparent that he was sinking.

"The senile decay that accompanies arteriosclerosis seems to have become more marked, and he grew increasingly restive and irritable," Magnuson notes. The pope became more argumentative and even dismissed his physician Gabriele Fonseca from his service. The concern for the octogenarian pope's health consumed Rome; at any moment, the Throne of Peter could fall vacant, throwing the future into doubt.

Such turmoil prompted nearly everyone to take precautions. Gigli notes that the rich began to bar their doors and posted armed guards at them. Humbler Romans resorted to carrying weapons to defend themselves if they were attacked.

In such a state of heightened uneasiness, it was hardly surprising that some of life's details were overlooked, which is exactly what happened at Sant'Agnese. Someone forgot to pay the workers. And, not unexpectedly, they quit.

Such behavior further angered the Pamphili family, particularly Camillo, who thought that Borromini should be attending to his duties and details like paying his workmen. He had had enough, he said, of the architect's *capricci inutili e modellature triangolari*, his useless caprices and triangular ornaments. A quarrel was inevitable.

From Borromini's point of view, he had much to be pleased about. As Innocent lay dying in early January 1655, the church of Sant'Agnese was nearing completion. The façade was nearly finished, the dome was waiting for its lantern, and much of the work

inside the church had been finished. Borromini had done exemplary work in a very short period. The church now dominated the piazza, as it has done ever since.

But the pope who commissioned it wouldn't live to see it completed. While the bedridden pope edged toward death—and while Donna Olimpia snuck away from the pope's room to rifle through her brother-in-law's apartments, stealing as much plunder as she could—Innocent asked Father Gian Paolo Oliva, his confessor, to support him as he begged the assembled company's forgiveness for his sins.

When Cardinal Fabio Chigi, the papal secretary of state, arrived, he banished Donna Olimpia from the room, which did little but push her away from the bed itself. "She still continued to hover in the doorway," Magnuson says, until "Father Oliva told her curtly that this was no place for a woman and she would do better to mind her own business." On January 7, 1655, Innocent died.

With Innocent's passing, Donna Olimpia's power vanished. But the ill feeling that his personality and policies fostered did not. Such was the bitterness and acrimony among the members of the Pamphili family that no one was willing to pay for the traditional papal coffins of lead and wood. Donna Olimpia pleaded poverty—a shocking lie, given that at her death two years later, she left an estate worth 2 million scudi—and neither Camillo nor his sister's husband (and Bernini's friend), Prince Nicolò Ludovisi, expressed any willingness to be generous to the memory of the man who had enriched the family so handsomely.

As the family bickered for weeks, the pope's body lay ignominiously in a masons' storage shed behind the sacristy at St. Peter's. The masons themselves proved more attentive to Innocent's memory than was his family: One placed a lighted candle in the

shed; another stood vigil at night to keep the rats from nibbling at the dead pope's decomposing body.

Finally, Gigli says, in an act of charity, a canon at St. Peter's—a Pamphili relation—agreed to pay for the funeral and burial at Sant'Agnese.

When Camillo took over as head of the Pamphili, Borromini found himself without allies in the family. With Donna Olimpia gone and Spada (at least for the moment) out of power, Camillo had complete authority over all of the family's holdings. And he was not one who would forgive Borromini for his past actions.

It was the beginning of the end of Borromini's career.

ELEVEN

Affection and Caprices

ONCE AGAIN THE COLLEGE OF CARDINALS convened in Rome to choose a new pope. On January 20, 1655, the conclave met, with sixty-six cardinals attending—an impressive number, given the difficulties inherent in traveling in winter.

A number of cardinals jockeyed for position while the king of Spain and Cardinal Mazarin of France used their influence (and agents) to manipulate the voting. Neither faction had enough support to secure the papacy for its candidate, in part because several cardinals who had been appointed by Innocent publicly declared that they were in neither the French nor the Spanish camp. This faction, led by Cardinal Decio Azzolino, was dubbed the *squadrone volante*, the flying squadron. These men brought a refreshing, if inefficient, integrity to the process of selecting a new pope.

Deadlock was certain to occur, and it did—for months. By early April there still wasn't a new pope, and the cardinals' impatience was growing. Because of the crowded quarters and fetid air—the Sistine Chapel, where the conclave meets and votes, is not known for the charms of its cross-ventilation—a number of cardinals had fallen ill and left, while Cardinal Pier Luigi Carafa, one of the early contenders to be pope, died on February 17. Electing a pope was not, it seemed, for the faint of heart or body.

Finally, after weeks of discussion, negotiation, and even an occasional prayer, Mazarin agreed—by letter from Paris, where he had been banned by Innocent from returning to Rome without papal permission—not to block the selection of Cardinal Fabio Chigi of Siena, Innocent's secretary of state, as pope. On April 7, Chigi was selected by a near-unanimous vote. Only Chigi cast his vote for another cardinal, Giulio Sacchetti.

Chigi chose the name Alexander VII in honor of Alexander V, whose papacy began in 1254 and who was called by his biographer Sforza Pallavicino "the defender of the papal dignity against the great of the world."

Small and fine-boned, with intelligent eyes, elegant manners, and a well-known wit, Alexander was a conscientious if occasionally weak-willed pope who developed a reputation for looking too often to others for counsel and advice. Learned if not necessarily intellectual, and pious though not particularly humble, he was for his time a good example of priestly virtue and had a wide array of interests in religion, history, and the arts, particularly architecture. "Architecture . . . on a large scale was what Alexander passionately cared for," the art historian Richard Krautheimer notes in a history of Alexander's pontificate.

He was known to be vain and could be susceptible to flattery.

Abate Francesco Buti told the Frenchman Paul Fréart de Chantelou that Alexander was "like a child who is won over with candy and apples; that is the way to achieve one's aim—big things for small ones." His health was always delicate and teetered on the precarious—even before he was elected pope he suffered from painful kidney stones—but he was known for his religious devotion and sincerity. As pope, he actually said his own masses and when he donned the papal robes for the first time after his election, his colleagues noted with some surprise that he wore a hair shirt next to his skin.

Alexander and Bernini had been friends for several years before his election, having become acquainted when Cardinal Chigi returned to Rome in 1651 from Cologne, where he had been papal nuncio. Chigi and Bernini were both men of accomplishment, and it was inevitable that Bernini would continue his friendship with a man as powerful as Chigi.

Alexander appreciated Bernini's amusing intelligence, and according to Domenico Bernini, "The sun had not yet set on that happy day which saw the creation of a new Pontiff, when the Cavalier was summoned by the Pope and treated by him with demonstrations at once appropriate to his new dignity and to their old reciprocal affection."

Filippo Baldinucci recounts a similar story, explaining that Alexander "encouraged Bernini to embark upon great things in order to carry out the vast plans that he had conceived for the greater embellishment of God's temple, the glorification of the papacy, and the decoration of Rome." What Alexander envisioned was nothing less than the completion of the final architectural chapter in the saga of St. Peter's.

Alexander kept Bernini as architect of St. Peter's, but the pope

made him his personal architect as well as architect of the *Camera*—
an unmatched sign of papal favor. According to Baldinucci, Alexan-
der paid Bernini "a monthly provision of two hundred and sixty
scudi." Once again, Bernini became the undisputed artistic arbiter in
Rome, and Borromini was effectively dismissed from papal service.

Although Borromini would continue to be involved in the com-
missions he had been given before Innocent's death, he would never
again enjoy the favor and attention he had received from the papal
court. He had never been an intimate of Innocent's the way Bernini
had been for Urban and would be for Alexander; his provoking
personality made such familiarity difficult, if not impossible. And
while the breach wasn't abrupt—Borromini still had friends in
Alexander's court—the tide that brought Bernini back to preemi-
nence certainly was. And Bernini was impossible to hold back.

The year 1655 would be the first one in a decade of disappoint-
ment and decline for Borromini as his professional fortunes
waned. It was as inescapable as it must have been heartbreaking to
witness, because he now entered a period in which he did precisely
the opposite of what he should have done to return to favor.

Several projects were left unfinished at Innocent's death, includ-
ing Sant'Agnese, and the bickering over how they were to be com-
pleted only increased. Given the Pamphili's disdain for Innocent's
memory—what the art historian Francesca Bottari calls "the se-
quence of envy, rancour, and rivalry that followed between his heirs
and the artists involved in complying with their fancy"—it was
hardly surprising. Camillo in particular had strong opinions, espe-
cially about the completion of Sant'Agnese. He had no love for Bor-
romini or for his plans for the church, particularly when a section of
the church being built collapsed, prompting a renewed round of
finger-pointing and recrimination. His involvement in determining

how Sant'Agnese should be finished—participation Borromini no doubt found meddlesome and in questionable taste—prompted Borromini to stomp off the work yard in a huff, vowing never to return—or at least not until an apology was offered. To irritate Camillo further and to make the prospect of Borromini's return even more remote, the architect allowed himself to be seen wandering among the *librerie*, the bookstalls, in the Piazza Navona, literally under the noses of the church's laborers and the Pamphili family.

On July 2, 1657, Borromini was dismissed from Sant'Agnese—or quit, depending on whose story one believes. But it wasn't all conflict, Connors notes. "After Innocent X's death Camillo Pamphili had expected to return the commission to old Rainaldi and his son Carlo, the family architects and his personal favorites. But against all expectation he was so satisfied with Borromini that he kept him on. . . . In the end it was Borromini's desire to press on hard with work, 'the way the late pope wanted and the present one, too,' that came into conflict with Camillo Pamphili's tendency to go slow." Given the antagonism that flared on both sides, it was a wonder that Borromini lasted in the position for as long as he did after Innocent's death. To replace him, Camillo selected a commission of six architects to oversee the church's completion. The architects represented a more traditional, conservative approach to architecture and design, and the group included Carlo Rainaldi.

It was the second dismissal Borromini had to endure that year. Earlier, in April, the Oratorians disregarded Spada's petition to engage Borromini to complete the final phase of the Casa dei Filippini, giving the job instead to Camillo Arcucci. Spada wrote at the time, "When I returned on the occasion of the death of His Majesty Innocent X to my nest at the Chiesa Nuova, I quickly noted what great esteem the architect Arcucci enjoyed, one might

say, with everyone, and the disfavor surrounding the Cavaliere Borromini, but as this was something that mattered nothing to me I expended not a word in approval or disapproval of these thoughts." Yet Spada couldn't convince his fellow Oratorians to change their opinion of the difficult architect. "I discovered opinions that were so contrary to my own," Spada admitted, "that I felt obliged to clarify this matter." Despite his efforts, Spada was outvoted. On May 17, 1657, by a vote of twelve to four, the Oratorians determined to reject Borromini as their architect.

After the debacle at the hands of the Oratorians and on the heels of Borromini's departure from Sant'Agnese came potentially more disturbing news, involving his masterpiece, Sant'Ivo. It was perhaps no surprise that stories began to circulate that Borromini suffered from a *malattia*, sickness. Cracks had begun to appear in the church's vaulting, probably, Portoghesi suggests, "the result of uneven settling caused by the suspension of work" that had occurred after Urban's death in 1644 and before Innocent X allowed construction to resume in 1651. This neglect had left the church *in rustica*, without proper support, and the consequences were now all too obvious.

With the cracks in Sant'Ivo came the criticism from Borromini's enemies. To counteract the damaging gossip that skittered about Rome, the rector of Sant'Ivo, Monsignor Vizzani, asked Borromini to respond to the taunts about his incompetence, which must have rankled the architect's touchy sense of honor.

Borromini rose to the challenge by issuing a challenge of his own:

> I the undersigned, adhering to the obligation that architects
> have by law of maintaining for fifteen years the buildings made

by them, and not intending to avoid this responsibility, but rather to add law to law, make liable my heirs and estate for all damages that may occur in the fabric of the chapel and cupola of the Sapienza, or that may be occasioned by such damages, in the said span of 15 years, desiring however, that the Sapienza on its part proceed to complete, through the height of the second storey, the loggia on the left hand side, that flanks the said chapel on the part toward the Dogana, up to the opening of the piazza of the Dogana.

In other words, Borromini guaranteed his work, publicly and with more than a hint of bluster, if the building was completed according to his design. It was a daring, self-important pledge, and it had about it a hint of injured desperation.

It succeeded. Alexander, though no admirer of Borromini, agreed to allow Sant'Ivo to be finished after he saw a scale model of the chapel that Vizzani had brought to the papal apartments. (It's possible that Spada could have been consulted on this.)

As a result, the work proceeded quickly, with Alexander allotting money to finish the floor (Borromini installed rhomboid-shaped gray and white marble tiles throughout the church, creating a honeycomb of hexagons over the star-shaped space), the altarpiece (Alexander commanded that there be one altar, not three, as Borromini had originally planned), and the stuccowork inside and outside the church (including the Chigi emblem of six crowned mountains topped by an eight-pointed star, winged cherubs, and belts of alternating six- and eight-pointed stars that garnish the ribs of the dome).

On November 13, 1660, the church was consecrated, and the next day Cardinal Antonio Barberini celebrated the consecration

of the altar, so that Alexander himself could say Mass there on November 15 to commemorate the university's official opening.

AS BORROMINI STRUGGLED to complete commissions that he had begun years before, fighting to maintain his patrons' interest and open purse, Bernini was embarking on his last, and perhaps his greatest, creative period. Even before Alexander became pope, Bernini had been working on the Chigi family chapel in Santa Maria del Popolo, the first church that pilgrims encounter when they entered the Porta del Popolo, the traditional northern gate of Rome. In the early months of Alexander's reign, Bernini returned to sculpture, carving two statues, *Daniel* and *Habbakuk*, for the chapel he had been engaged to finish. The statues stand in two of the four niches in the chapel across the circular shrine from each other, and they are linked visually by Bernini because of the story they tell.

According to an apocryphal book of the Bible called "Bel and the Dragon," as Daniel prayed for deliverance from the lions, into whose den he had been thrown by the Babylonians, an angel appeared to the prophet Habbakuk in Judea. Habbakuk was delivering bread to workers in the fields when God called to him and said, "Carry the dinner which thou has into Babylon to Daniel, who is in the lions' den."

Habbakuk naturally replied that he knew neither Daniel nor the den. It was then, according to the story, that an angel took matters into his own hands, grabbing Habbakuk "by the top of his head and carried him by the forelock and set him in Babylon."

With these two statues, Bernini attempts to capture these events at the moment of their highest drama. In one niche to the right of the altar, the angel has Habbakuk by the hair and leans out into the

chapel toward the viewer while he points across the chapel to the statue of Daniel, whose blank, featureless eyes gaze heavenward, his clasped hands extended in submission and thanks to the Lord who saved him, as indicated by the enormous head of a lion peering out from behind his right leg, gently licking his foot.

Infinitely more impressive, and vastly more important, than either *Daniel* or *Habbakuk* are the architectural sculptures Bernini began during this period—the monumental colonnade of St. Peter's Square and the *Cathedra Petri*, the Throne of Peter. Taken together, these two works by Bernini represent the alpha and omega of St. Peter's, its eye-catching overture, thrilling in its scope and spectacle, and its dramatic finale, a profoundly moving blending of art, history, and drama that fortifies man's connection to God.

When Alexander became pope, the space in front of St. Peter's was much the same as it had been for decades: a disorganized open area hemmed in on three sides by cramped little houses and dirty, tangled streets. Innocent had asked Carlo Rainaldi to propose a plan for reorganizing the piazza, with arcades and church offices built along its perimeter.

According to Baldinucci, Rainaldi proposed four different shapes—a hexagon, a square, a circle, and an oval—for the piazza. Nothing was done with the proposals, however, during Innocent's pontificate. But it clearly was a priority for Alexander, because just three months after he became pope, he convened a meeting of the Congregazione on July 31, 1656, at which its members agreed with the pope that a piazza should be built in front of St. Peter's and that Bernini, as Architect of St. Peter's, should offer suggestions on how the Congregazione should proceed. A month later, on August 19, Bernini did precisely that.

Bernini first envisioned the piazza as a large trapezoid (a

four-sided figure with only one set of parallel sides) bounded by long, straight arcades that included buildings behind them. The *avviso* for August 19 described it as "covered loggias with offices and dwellings for the Canons and penitentiaries." The trapezoid may seem an odd choice for such a public space, but its pedigree was impeccable: Michelangelo had used it for the Piazza del Campidoglio atop the Capitoline Hill, which has been hailed as a brilliant piece of urban planning ever since. Bernini was attempting to do for sacred Roman life what Michelangelo had done for political Rome.

Though "Bernini's trapezoidal piazza was conspicuously modest," the art historian Timothy Kitao notes in his study of the design and construction of the piazza, "it was nevertheless a very efficient solution."

From the outset there was concern about the enormous expense that such a large project would demand. One critic, Cardinal Giambattista Pallotta, submitted a written critique of the proposal (he wasn't at the meeting of the Reverenda Fabbrica), arguing that the piazza was too large and too expensive for a church in such dire financial straits to tackle at present. But Alexander disagreed. He wanted the piazza built, despite the cost, which some estimates placed at 1 million scudi, an enormous sum at the time. (Angelo Correr, the Venetian ambassador to Rome, wrote in 1660 that the Reverenda Fabbrica would bear all of the building costs for the colonnades, though Torgil Magnuson posits that "it seems likely that the pope must have obtained additional funds elsewhere.")

Such an astronomical expense worried the pope's aides, including Spada. But Alexander countered Pallotta's and others' criticism by arguing that the piazza's construction would benefit the city's poor by employing them; the money would circulate through the city's economy and would benefit more people than

just the workers who were paid. It was a seventeenth-century fore-runner to the trickle-down theory of economics.

With what must have been profound reluctance, the Reverenda Fabbrica acceded to the pope's wishes and voted in favor of having a wooden model of the piazza built based on Bernini's designs, and a temporary wooden section of the design constructed along the northern side of the piazza to see what it would look like—much as Urban had directed with Bernini's bell towers. One of the questions a temporary structure would answer was whether Bernini's design would obscure or hide completely the view of the pope's window in the Vatican Palace from which he blessed the assembled crowds on feast days and other special occasions.

According to Bernini, when a full-scale model was built, Alexander "immediately . . . saw the drawbacks in giving the portico a square plan, in that the height of the portico would block the view of the Palace from the people and from the Palace the prospect of the piazza."

Clearing the site began on September 29, 1656, even though the exact shape and dimensions of the piazza had yet to be decided. According to Bernini's *giustificazione,* or official summary, the pope proposed an oval piazza, though some historians believe that Bernini may have planted the idea in the pope's mind and used the pontiff's pronounced preference for an oval piazza to silence criticism against his own inclination.

Bernini continued to work on revising his ideas, and toward the end of 1656 he proposed a new plan for the piazza, this time an oval. It was actually two semicircles on either side of a square with a short, straight arcade between the outer ends of the curves, what became known as the *terzo braccio,* the third arm. Such a departure took some members of the Reverenda Fabbrica by surprise when Bernini

presented this idea on March 17, 1657, and there was considerable criticism surrounding Bernini's new proposal—so much, in fact, that Carlo Rainaldi submitted a counterproposal for the piazza.

Eventually Bernini proposed an elegant alternative to his more prosaic oval, the *ovato tondo*. It was more of an ellipsis than an oval and was based on the geometric relationship between two overlapping circles—a system akin to what Borromini used when finalizing the shape of San Carlino. By August 1657 Bernini replaced his proposed arcades with simple colonnades. The result was a plan that spreads out from St. Peter's more gracefully than his previous proposals had done. It is this scheme that in large part was adopted (though without the *terzo braccio*) and became the Piazza San Pietro that exists today.

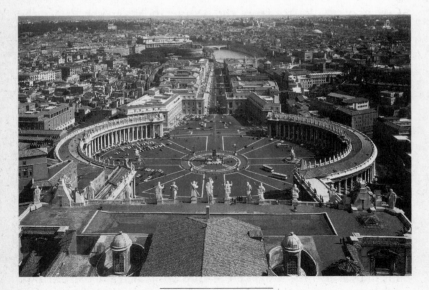

ST. PETER'S SQUARE

It is a magnificent, monumental space, at once spectacular and welcoming, elegant and surprisingly functional—what one historian called "the most successful piece of architecture on earth." The graceful sweep of three hundred massive Doric columns of travertine, which Émile Zola once described as "a forest of gigantic stone trunks," and the ninety-six colossal statues of saints that adorn the colonnade's roofline (overseen, though not carved, by Bernini) enclose an arena (really an amphitheater; Alexander himself referred to it in his diaries as a *teatro*) nearly 200 meters (650 feet) across at its widest point. It can hold three hundred thousand souls in its embrace at one time.

In fact, that is precisely the image Bernini was thinking of when he designed the piazza: the welcoming, maternal arms of Holy Mother Church. According to Howard Hibbard, "The image of the piazza was likened by Bernini to the outstretched arms of the Church welcoming the faithful, so that even this seemingly pure architectural creation has an anthropomorphic, and even quite sculptural, connotation and function. Paul Fréart de Chantelou wrote in his diary that Bernini compared the piazza to a head and arms because "architecture consisted in proportions drawn from the human body."

Though there were critics of the elliptical plan and the cost concerned everyone but Alexander, there is no question that the piazza is one of the world's great man-made open spaces, It's a place, George Eliot wrote, "where all small and shabby things were unknown." Charles Dickens found that "nothing can exaggerate" the piazza's splendor, "with its clusters of exquisite columns and its gushing fountains—so fresh, so broad, and free, and beautiful."

The colonnade provided a subtle but deliberate improvement to the space in front of St. Peter's by adding an equilibrium to the

façade of St. Peter's that it lacked. The colonnades are relatively low, and they narrow as they extend away from the church, which persuades the viewer that the church front is actually taller and not as wide as it appears—a flaw in the façade's design that Maderno's critics complained about for more than a century. By keeping the colonnades relatively low and pulling them toward each other (rather than keeping them parallel), Bernini solved (or at least diminished) the problem of an ill-proportioned church front.

Construction on the colonnades proceeded soon after the pope had agreed on the elliptical design in 1657. The foundations for the mammoth project were laid on August 28, 1657, in a small ceremony attended by both the pope and Bernini, and the architect was kept busy, Magnuson says, "with the exacting preparations and the technical difficulties of laying the foundations in the marshy terrain"—Bernini didn't want to make the same mistake he had made earlier with the campanili. By the next summer, forty-seven columns were standing, and by 1662 the northern side of the colonnade was complete.

As Bernini was working on the largest public works project Rome had ever seen, Borromini was struggling through his last important commission, one that he had held for the better part of a decade and which truly got under way only when Alexander became pope: architect of the Collegio di Propaganda Fide. The post was an important one, since the Propaganda Fide enjoyed a long, auspicious association with the papacy.

Gregory XV created the Congregazione di Propaganda Fide on June 22, 1622, as the administrative center for Christian missionaries that the church was sending out into the world to combat the rise of Protestantism. This was also the era of exploration, and the church wanted to make sure that the new civilizations that were being conquered embraced Catholicism.

On August 1, 1627, Urban VIII founded the Collegium Urbanum, a seminary dedicated to educating young missionaries and turning them into devoted soldiers for God and church. What became the Collegio di Propaganda Fide was housed in the congregation's headquarters, which were in a small palazzo at the southern end of the Piazza di Spagna originally called the Palazzo Ferratini (or Farratini), which sits in the wedge between the Via di Propaganda Fide and the Via Due Macelli. The building had been given to the group by Juan Bautista Vives, a Spanish priest, and such was the attention Urban showered on the congregation that in 1634 Bernini was commissioned to build a chapel for it.

Bernini envisioned a small oval chapel, which he placed along the western wall of the congregation building, just across the narrow Via di Propaganda Fide from the house he would eventually buy and live in until his death. The chapel was dedicated to the Three Kings and became known as the Re Magi.

By 1646 the congregation owned all of the land in its triangular-shaped block, and it was decided that befitting its growing influence within the church and the increasing number of missionaries, its headquarters should be expanded. After the death of Urban's brother Cardinal Antonio Barberini in September 1646—Urban's apolitical brother didn't flee to Paris as Urban's nephews Antonio and Taddeo had—Pope Innocent nominated Borromini as architect of the congregation.

But Borromini didn't begin work immediately. A litany of false starts, a rethinking of what should be done and where the money should come from to build it, dragged work on well into Innocent's papacy. Finally, in 1654, Innocent decided to allow the expansion of the congregation's home to go forward and gave Borromini the time to turn his thoughts seriously to a design.

"Very likely it was at this time that the chapel of the Re Magi

built by Bernini was torn down," Portoghesi notes, which must have given Borromini a certain satisfaction. Having been nudged out of the commission for the Fountain of the Four Rivers by Bernini, he may have felt that the scales had been balanced somewhat by the pope's allowing him the chance to demolish one of Bernini's creations.

But before he turned his attention to rebuilding the chapel, Borromini designed the façade for the new construction along the Via di Propaganda Fide. It's a long expanse of wall and its very size and setting make it a knotty design problem. The street is narrow, so it was impossible to engineer a façade that could be appreciated head-on. A visitor must approach it obliquely, from an angle, as if sneaking into the building unnoticed.

Borromini managed to turn an indirect prospect to advantage, creating a silent, graceful undulation stone. From its outer beveled corner, the façade pulls the eye across it. As with his façades for the Oratory and Sant'Ivo, the outer wall of the Propaganda Fide moves logically but in contradiction: wherever one expects to see, Borromini presents precisely the opposite.

Even the entrance portal is a surprise. Instead of being a traditional doorjamb, two square pilasters flank the door. They are narrower at the bottom than they are at the top and look like two pairs of striped stirrup pants stretched out to dry. Borromini placed them at 45-degree angles to the wall so that each one's outer corner projects from its center, as if they are turning on a hidden winch. Above the door, nestled into its own convex, altarlike space, Borromini placed a large window between two sets of Doric columns that support a nearly elliptical stone roof. Under the roof, barely visible from the street but no doubt plain to someone looking out the window, Borromini placed his ever-present

cherub's head, with four wings folded around it. It is a detail he used extensively throughout the latter part of his career, and its presence at the Propaganda Fide illustrates how involved he was with all of the details of the design.

By 1656 the façade of the Propaganda Fide was complete. It stood in marked contrast to the somber buildings around it, particularly across the Via di Propaganda Fide—including the west wall of Bernini's own house, a large, drab-looking square building. Over the next two years, Borromini turned his attention to the Cappella dei Re Magi (the Chapel of the Three Kings), giving it a distinct, poignant character all its own and in the process creating his last sacred masterpiece.

Unlike Bernini's oval chapel, Borromini's Re Magi is a rectangle with rounded corners, though as is typical with Borromini, it's much subtler and more complicated than that. It is small—there are only two diminutive altar niches on each long side—but Borromini has managed to instill in the space a sense of contemplation missing in San Carlo or even Sant'Ivo; here the spirit can catch its breath. It knows how difficult, and how wearing, the world can be.

The Re Magi is the most soothing of Borromini's churches because of the harmony of its proportions. The chapel's height, depth, and width are all in balance, giving it a sense of equilibrium that Borromini's other works don't have. This is a place of poise and controlled grandeur.

There is relatively little color in the chapel itself, but the effect is far from austere. The walls are a soft off-white with twelve monumental pilasters ringing the space—four on the long sides of the rectangle and two each framing the main altar and the entrance. Bands of gray marble are inlaid along the insides of the

niches' openings and black and white marble are arranged in bands that connect the bases of the pilasters to each other.

Embedded in each of the twelve pilasters just above eye level is an eight-pointed star, the symbol of the Jesuits, who founded the Propaganda Fide College, its Greek cross and sunburst outlined in colors of white, gold, red, and green. Between the pilasters halfway up the wall are niches of white and gray marble that display busts of past congregation members. The busts stand atop oval bases of smooth black marble, which seem to mimic the shape of the oval windows high above.

The windows are the very heart of what makes the chapel extraordinary, because they are, like the windows in the refectory at San Carlo, the wellsprings from which originates the ceiling's cross ribbing. The windows are arranged at the very top of the chapel and alternate between oval and square windows with shallow arched tops. Some of the windows are real, some are false, but their ability to let in light is almost beside the point: The eye is drawn to all of them, and they become the origins for the ceiling's complex ribbing, which is arranged on the diagonal.

The ribs are complex but logical, as meticulous and as rational as a proof by Newton. The ribbing flows across the ceiling at acute angles. One rib begins at the side of one window and streams across the ceiling like a comet, ending its journey at the center point of the top edge of another window. The pattern works its way around the room, creating a series of diamond-shaped figures and cross-hatching that produces a hexagon in the center of the ceiling. In the middle of this central form is a dove, the symbol of the Holy Spirit, which rains its rays of golden light—its blessings—down upon us all.

The Chapel of the Three Kings is a kind of hushed triumph,

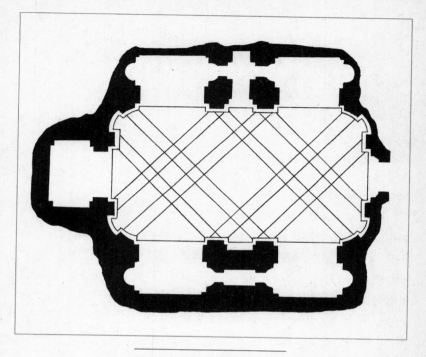

PLAN OF RE MAGI CHAPEL

a model of Borromini's unmatched ability to synthesize the ancient and modern into a building that is completely new and wholly his own.

. But Borromini couldn't rest on the triumph of the Three Kings for very long—if he ever did. Even though the façade for the Propaganda Fide was essentially complete by 1662 and the interior of the chapel by 1665 (though the stuccoing wasn't finished until after Borromini's death), Bernini had embarked on his own great small church—one that has the audacity to stand right next door to Borromini's own masterpiece, San Carlino.

TWELVE

Training the Eye to See

THE CHURCH OF SANT'ANDREA AL QUIRI-
nale is a brilliant piece of theater—"a master-
piece," according to Sacheverell Sitwell. It's not a
large church, but its theatricality makes it seem
as grand as a trumpet flourish. It's perhaps the
most innately dramatic building Bernini ever
designed by himself; it's certainly the structure
he was most happy with, though it took a dozen
years to complete. It's also one of the few com-
missions for which Bernini refused payment. In-
stead, he asked that he receive a loaf of bread
from the novitiate's bakery every day—a request
that was readily granted. Perhaps he knew that
building the church would feed his soul so that he
would need little enough to fill his belly.

But Domenico Bernini recounts a telling an-
ecdote that reveals how the aging lion of Italian
art—Bernini was by now nearing sixty—was
learning the satisfactions of a job well done.

Domenico came across his father unexpectedly one day at Sant'Andrea.

"What are you doing here, all alone and silent?" he asked Bernini.

His father's reply was unexpected—surprising for an artist known for being perpetually dissatisfied with his own creations.

"Son, I feel a special satisfaction at the bottom of my heart for this one work of architecture," Bernini said. "I often come here as a relief from my duties to console myself with my work."

Bernini's approval of Sant'Andrea is understandable, springing as it does from the clever interplay of surprise and spectacle that he instilled in this church of modest dimensions on the Quirinale. This is a church of consequence, of great deeds memorialized, of great faith rewarded.

Sant'Andrea was begun in 1658, having been commissioned by the Society of Jesus—the Jesuits—to replace an old chapel attached to its novitiate across the street from the papal palace. Bernini had a long association with, and sympathy for, the Jesuits. He practiced the *Spiritual Exercises* of Saint Ignatius, and was known to have owned a copy of Thomas à Kempis's *Imitation of Christ.* He attended *la divozione della buona morte,* the devotion of the good death, at the church of the Gesù, every Friday for four decades and took communion once a week.

As Bernini aged, his early years of passionate self-indulgence gave way to a life of devotion and unshakable faith. So his involvement with Sant'Andrea is natural, particularly as he was appointed to the post at the suggestion—some might say the command—of Pope Alexander VII. His selection was one more snub to Borromini, because under Innocent X, Cardinal Francesco Adriano Ceva, the order's protector, had commissioned

Borromini to draw up plans for what Torgil Magnuson calls "a large and sumptuous church" to be built on the site. But Innocent soon changed his mind. He decided that he did not want such an imposing church near the papal palace. And so the proposal was tabled.

Alexander, however, had no such concerns. He also saw the opportunity to use a nearby church to accommodate his papal household, because the papal chapel in the Quirinale Palace was too small to hold the growing number of courtiers and attendants. But his aversion to Borromini and preference for Bernini ensured that the pope would choose another architect to build the Jesuits' church dedicated to Saint Andrew.

In addition, Camillo Pamphili, at the pope's request and his own ambition, had agreed to be the church's patron and to pay 15,000 scudi to finance the interior decoration of the church. If anyone in Rome had a greater distaste for Borromini than Alexander, it was Camillo Pamphili.

And so, to no one's surprise, the commission for Sant'Andrea was settled on Bernini. Borromini never had a chance.

Whether or not Bernini intended it to be, his design for Sant'Andrea—an ellipsis—is to a great extent reminiscent of his doomed oval chapel at the Propaganda Fide, which Borromini had unceremoniously torn down to make way for his own master-work (though, to be fair, he had initially tried to preserve it). While one of Bernini's first ideas for Sant'Andrea was a pentagon—the Jesuits required five altars—he also submitted a proposal for an oval church whose main altar was on the short axis, just as he had built at the Propaganda Fide.

This was the proposal that Alexander approved—a small ellip-tical church with a main altar and two chapels on either side—and

which the Jesuits commissioned. The pope noted in his diary entry for September 2, 1658, that Bernini had shown him the plan for Sant'Andrea, and he had directed him to move the church farther back from the Via Pia, "making it less visible from the Quirinale garden," Magnuson says. The initial aim was to build an intimate chapel for the order to use, with occasional visits by papal courtiers.

Two weeks later, Bernini showed Alexander a model of the building, and shortly after workmen began digging the foundations. The pope formally approved the plans at the end of October, and on November 3, the foundations were laid. A year later, the dome was complete (though it was modified to its present form in the 1660s and 1670s, as were other aspects of the church).

The exterior is unexpectedly grave, even sober—a startling change for Bernini. It's his most controlled façade since his designs for Santa Bibiana nearly three decades before. No windows are visible from the street. Instead, the major decorations are a simple semicircular portico festooned with the coat of arms of Camillo Pamphili (complete with crown—after all, he was a prince) and supported by two columns, which stand atop a cresting wave of stone steps, longer than what Bernini envisioned, but Sitwell still finds poetry in them, calling them "rings of water that seem to enlarge themselves as we look at them." Two high curved walls, graceful if unwelcoming, spread out from either side of the narrow entrance like a theater's curtain barring a glimpse of the mystery that lies behind.

While the exterior is restrained, the interior is not. Built to impress rather than to welcome, it's an attention-grabbing celebration of bravado and audacity in marble, stucco, and gilt, an

ecclesiastical stage set unparalleled in Rome. Camillo Pamphili's ambition for a lavish church was met—thanks in large part to the work of Giovanni Maria Baratta, the prince's *scarpellino*. The church far exceeds expectations; indeed, it dazzles, like a series of carefully timed fireworks.

Arranged under a low elliptical dome of lavishly gilded florets set in hexagons of white and gold (which like the decorations in the dome at San Carlino diminish in size as they rise to the lantern) are four chapels and a main altar—two chapels on each side of the short axis between the entrance and the main altar. Two rings of figures—putti at the base of the lantern and fishermen (because Andrew was one) sitting on ledges just above the windows at the base of the dome—populate the upper part of the church between ten vividly decorated ribs, which flow down from the lantern's oculus like rays of sunlight. The fishermen hold undulating rings of gilded garland while the putti peer down at the goings-on below.

Ringing the church's walls are eight colossal square pilasters, which Bernini placed in an orderly rhythm around the church to nudge the eye inexorably toward the main altar, which stands in a high narrow niche behind four massive Corinthian columns. Between the pilasters, just below the beginning of the dome, are eight nearly square windows (they have a slight arch), which allow the church to be bathed in light.

The deeply colored reddish marble—in hues of rose, rust, and even dried blood, depending on the time of day—saturates the church, suffusing it with a feeling of overpowering, almost merciless splendor: It's difficult to find a spot here that doesn't overwhelm. The opulence is deliberate, as Camillo Pamphili was determined to finance a church that was *rica e bella*, rich and beautiful. It is both—and more.

SANT'ANDREA AL QUIRINALE

Marble is everywhere in the church, from the tiles of white and gray *bardiglio* that cover the floor, to the white Carrara marble capitals of the chapel's pilasters, to the four massive, marvelously veined pillars that mark out the main altar and frame the striking painting of the *Crucifixion of St. Andrew* by Guglielmo Cortese, who was known as Il Borgognone. It hangs above the altar and is set in a border of red *breccia* marble, which seems to be pulled up by a flurry of finely wrought (by Giovanni Rinaldi) angels and cherubs that flutter about the top of the painting in conscientious attendance.

One of Jesus's first disciples, Andrew was, like his brother Peter, a fisherman. He, too, was crucified—in his case, on a saltire cross, essentially two pieces of wood arranged in a large X, to set his death apart from the crucifixion of Jesus. (According to the New Testament, it was Andrew who brought Peter, then called Simon, to meet Jesus. Andrew became known as one of the four Doctors of the Church and was, in the words of Saint John Chrysostom, "the Peter before Peter.")

In Il Borgognone's painting, Andrew is shown just before his death, looking heavenward, toward the paradise that the carpenter from Nazareth had promised him. If the visitor's gaze follows Andrew's, it rises up to the focal point of the church, Bernini's enormous figure of Saint Andrew, which sits on a stucco cloud atop the center of the heavy semicircular pediment that caps the altar. This statue of an old man, his lanky arms outstretched in surrender, his knobby left knee bent out into the church as if he were about to stumble from his amorphous aerie, his simple face and euphoric gaze lifted toward the bliss of heaven, is full of emotion, almost quivering with the thrill of his ascent into paradise. It's a study in rapture that is more accentuated and extroverted than Bernini's Saint Teresa, which he had carved a decade

earlier. Perhaps by his sixties, Bernini had begun to have a more pronounced sense of the joys of heaven.

Despite the pleasure that Bernini eventually derived from Sant'Andrea, there was considerable debate about whether it should be built at all. Some in the Jesuit community were concerned that the church Bernini envisioned was too grand, too ostentatious. Such sumptuousness, they believed, was at odds with the principles of poverty and simplicity the Jesuits were supposed to live by. In the end, since Camillo Pamphili, not the order, was paying for the church's decoration, the majority decided that such splendor could be seen as the physical manifestation of the Jesuits' motto, *ad majorem Dei gloriam,* for the greater glory of God. Such glory was Bernini's glory, too.

As it was elsewhere. While Sant'Andrea was being constructed, Bernini was called upon by Alexander to return to St. Peter's. This time the pope wanted a new entrance for the Vatican Palace, which until Alexander's pontificate had been an unimpressive series of staircases and courtyards—Howard Hibbard describes the stairs as "rickety"—that had led up to the Sala Regia, the ceremonial entrance hall of the palace.

One of the reasons Alexander wanted a new entrance was that the route from palace to basilica was circuitous at best. It could be a difficult trip, particularly during official processions when the popes, who were often elderly and not always in the best of health, were carried in the *sedia gestatoria,* the portable throne that twelve footmen bear on their shoulders, from the Vatican Palace to St. Peter's. Previous popes had wanted a safer, more direct and impressive entrance to the Vatican Palace and a link between the palace and St. Peter's.

Decades before, Maderno had tried—and failed—to devise a

better route. But it wasn't until Bernini further renovated the Vatican Palace, tearing down one tower and realigning the Portone di Bronzo, the official ceremonial entrance to the Vatican from the Piazza San Pietro, that he finally had enough space to create the mesmerizing cascade of stairs that is the Scala Regia.

Still, Bernini had enormous design and construction challenges: He was literally boxed in. He had to fit the stairway into a narrow, tapering triangle tucked in between the northern wall of St. Peter's and the southern wall of the Sistine Chapel. The walls between the two buildings aren't parallel, which made Bernini's job trickier. In addition, he was further hampered by the limits imposed on the project by the stairway's height. The stairway couldn't be too tall because it began directly under the southern section of the Sala Regia.

Everywhere Bernini turned, he was confronted by restrictions and technical challenges that would flummox any architect. But instead of giving up, he used these limitations to his advantage, brilliantly overcoming them to create a remarkable fusion of architecture and art, drama and utility.

The Scala Regia is actually a tall, barrel-vaulted tunnel that rises from a square landing adjoining the porch of St. Peter's and (via an impressive corridor of marble) the Portone di Bronzo. It begins with a massive triumphal opening—really a Serlian arch—supported by two huge stone columns and bracketed by smaller rectangular openings between the columns and the staircase walls. It looks like a larger, grander version of the window Borromini designed for the gallery of the Palazzo Pamphili. Alexander's coat of arms hangs above the arch, and two stone angels trumpet his magnificence from both sides.

As the stairway ascends, it narrows—a deficiency in the site that Bernini used to canny advantage. He actually lowered the heights

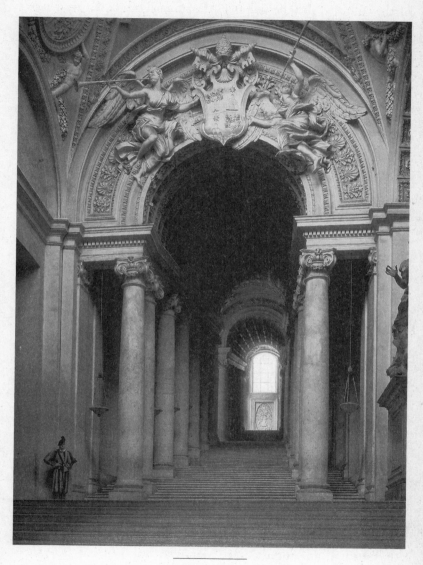

SCALA REGIA

of the columns and the ceiling as the stairs climb to the *piano nobile*, which creates a false, but dramatic, perspective looking up the stairs. He also used light (from a hidden window along the way) to soften the stairway's darkness, and placed on the main landing, visible from the bottom, a window that acts as a beacon, beckoning visitors higher. (To complete the spectacle, Alexander later commissioned from Bernini a huge equestrian statue of Constantine, who sits on horseback and gazes in stunned wonder at the vision of the cross that appeared to him on the eve of battle, to stand at the landing between St. Peter's and the entrance to the Vatican Palace.)

Bernini told admirers that the Scala Regia "was the most daring operation" he had ever attempted, and that if he had heard that another artist had completed it, "he would not have believed it possible." But it certainly was a magnificent example of his turning what others saw as limitations into advantages. What appears to be a stately, majestic staircase is in fact a cunning trick of the eye.

It's a very similar kind of optical trick that Borromini helped to create at the Palazzo Spada, the Roman palazzo that Cardinal Bernardino Spada had purchased in 1632. The scale of the Scala Regia is grander, but the intent is the same.

As a diversion for Cardinal Bernardino's garden, Borromini designed and built in 1652–53 a short colonnade visible from the palazzo's main room. Though only 8.82 meters (less then 30 feet) long, it appears much longer and more impressive—due to the intentional deceptions inherent in the plan. Basing his designs on mathematical calculations made by Fra Giovanni Maria da Bitonto (or Bitonti), an Augustinian friar who was fascinated by perspective, Borromini constructed a barrel-vaulted corridor lined by two rows of Doric columns that are purposely shortened the

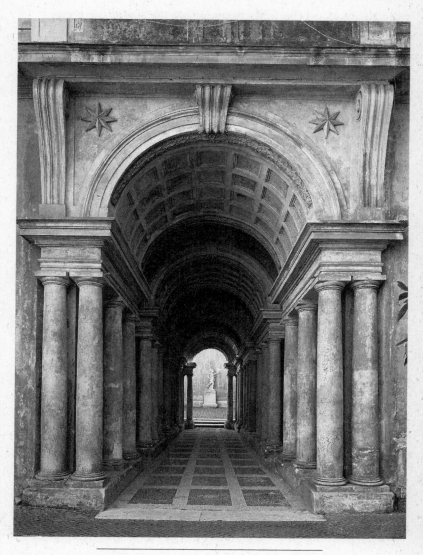

PERSPECTIVE GALLERY, PALAZZO SPADA

farther away they are from the corridor's opening. The entire ef-
fect calls to mind the Scala Regia. Only the size is different.

Bernini probably was familiar with Borromini's colonnade at
Palazzo Spada. Given that both of the Spada brothers were part
of Alexander's inner circle and that Bernini was always ready to
modify good ideas to suit his own creativity, it's possible that
Borromini's witty entertainment in Cardinal Bernardino's garden
might have inspired, even in a small way, the imposing and im-
pressive Scala Regia. But Bernini had used similar scenic illusions
for his own plays, this sort of perspective trick is certainly some-
thing Bernini knew how to use to advantage.

Borromini never complained that his ideas for the Spada
Colonnade had been used by Bernini—at least not to anyone who
recorded such grievances. By then, few people would have listened.

✳

THIRTEEN

No Greater Favor, No Sadder End

⚉

THREE OF ROME'S GREAT COMMISSIONS FROM
the 1660s—the colonnades at the Piazza San
Pietro, the Scala Regia, and the Cathedra Petri (a
grand bronze reliquary housing the chair believed
to have been the original Throne of Peter, which
was placed at the center of a sophisticated sculp-
tural group that stands on a huge altar along the
western wall of St. Peter's)—were Bernini's. And
he was in demand all over Europe. So highly re-
garded were his abilities and his reputation that
Bernini was as popular during Alexander's pon-
tificate as he had been during Urban's.

These were some of the busiest, most cre-
ative years of Bernini's life. Now in his early
sixties and still in robust health, he was the
undisputed elder statesman of European art,
able to draw upon decades of experience and a
still-nimble creativity to rise to the challenge of
any commission that intrigued him.

He was still young enough to live well, having amassed a sizable fortune—at his death in 1680 it was estimated at 400,000 scudi—and he had the resources to finance both his necessities and his fancies. He also had the satisfaction of seeing his children grown and settled satisfactorily. Some worked for their father, others joined the church. In short, he had been given the greatest of all gifts, the capacity to enjoy life.

Borromini's later life wasn't as agreeable. Although he continued to work during the 1660s, at places like the church of Sant'-Andrea delle Fratte (with its fascinating and still-unfinished brick dome, whose drumlike profile calls to mind an ancient Roman tomb near Capua known as the Conocchia, and its campanile, a tall, tapering tower that looks like an emaciated and overdecorated bowling pin) and at San Carlino (on his magnificent heraldic façade for the church), requests for his plans grew fewer and praise for his gifts fainter.

Alexander wanted little to do with him. Though he respected Borromini's abilities—due in part to Virgilio Spada's persistent cheerleading—the pope wanted him at arm's length. It wasn't an accident that during the eleven years he was pope, Alexander met with Borromini only twenty-seven times. By contrast, Alexander met with Bernini more than four hundred.

Most of Borromini's work during this time came from the few friends he still had. Orazio Falconieri was one. His commissions to design and build the Falconieri chapel at San Giovanni dei Fiorentini and to add on to the Palazzo Falconieri, his rambling palace near the Tiber, offered Borromini the chance to continue to find expression for his inventiveness. The Lombard architect may have been out of favor, but he wasn't out of ideas.

He worked on them slowly, painstakingly, perhaps because he knew that such commissions wouldn't last forever.

During the years of 1664–65, as Borromini was beginning work on the façade of San Carlo, Rome heard the astonishing news that Bernini had been invited to Paris by Louis XIV to provide plans for adding on to the Louvre.

In March 1664 Louis's minister Jean-Baptiste Colbert had written to Bernini, requesting that he present plans for finishing the medieval royal palace along the Seine. (Colbert could not find a French architect capable of the job.) He wrote similar letters to Carlo Rainaldi and Pietro da Cortona. After considerable back-and-forth between Bernini and Colbert, Bernini was selected because, Filippo Baldinucci writes, the French king "could only be satisfied with that which would be admired by all eyes."

Louis was so intrigued by Bernini's ideas for the Louvre that he wrote to the artist directly. In a letter dated April 11, 1665, Louis said: "I have a great desire to see and to know more closely a personage so illustrious. . . . My desire moves me to dispatch this special courier to Rome to ask you to give me the gratification of undertaking the journey to France" to confer about the plans in more detail.

Such a request was unprecedented—an unheard-of honor. It was also a political nightmare for Alexander.

Bernini was a national treasure, one of the few the Papal States possessed during this period. As the kingdoms of Spain and France grew in power and influence throughout the seventeenth century—they were the dominant nations in Europe at the time—the secular authority of the papacy fell into decline. Never again would the pope play a pivotal role on Europe's political stage. The limelight had shifted, shining on others.

Still, Alexander would not be shunted off into the shadows

without a fight. The papacy still held an unquestioned supremacy in the arts, and Rome was still the hub of European sculpture and architecture—due in large part to Bernini. Alexander had no intention of allowing this advantage, however slight, to be co-opted by Louis—and he didn't want to allow Bernini to go to Paris.

But Louis insisted. Writing to Alexander himself, the king put pressure on the pope. "[I] entreat you then, if [Bernini's] duty to you permits it, to command the Cavalier to come here in order to finish his work. Your Holiness could not grant me a greater favor in the present set of circumstances."

The pope tried to resist, but in the end, he had no choice. France was too mighty a nation, and Louis was too formidable a king, to defy. With great reluctance, Alexander agreed to Louis's request. The pope allowed Bernini to go to Paris for six months.

Baldinucci says that on April 25, 1665—Domenico Bernini says it was the twenty-ninth—sixty-six-year-old Gianlorenzo Bernini, together with his retinue, which included his eighteen-year-old son Paolo and his longtime assistant Mattia de' Rossi, left for Paris.

The trip north to Paris lasted about a month. This was typical of the time and took into account the comfort and strength of the elderly dignitary. Bernini's entourage traveled through Florence, Bologna, Siena, Milan, Turin, and several cities in France; at each city he was met by local dignitaries, and the townspeople lined the streets to catch a glimpse of the famous *cavaliere* from Rome. Bernini is said to have joked that the curious crowds were acting "as though he were a traveling elephant." In early June, after a month of travel, Bernini arrived at the outskirts of Paris and was met by Paul Fréart de Chantelou, a courtier who would serve as Bernini's attendant and guide during the artist's sojourn in France.

Chantelou, chosen because he had spent several years in Rome and spoke Italian—Bernini could speak no other language—kept a meticulous diary of the great man's visit, which gives a fascinating insight into the life and opinions of the greatest artist of his time.

Chantelou described Bernini as "a man of medium height but well-proportioned and rather thin. His temperament is all fire. His face resembles an eagle's, particularly the eyes.... He is rather bald, but what hair he has is white and frizzy.... I consider his character to be one of the finest formed by nature, for without having studied he has nearly all the advantages with which learning can endow a man."

Knowledgeable though he may have been about artistic matters, Bernini proved to be tone-deaf to the social niceties of visiting a foreign country. He suffered from the malady that often plagues neophyte travelers who believe that their ways and their lifestyles are far superior to foreign ones. It was not long before Bernini's pronouncements and opinions began to irritate his French hosts. He loathed the now-gone Tuileries Palace, calling it *una grande picciola cosa*, "a big little thing." He criticized the dome of the Val-de-Grâce, the church started by François Mansart and completed by Gabriel Le Duc, observing that "a little cap had been placed on a very large head," and he commented that "Paris seemed nothing but a mass of chimneys, standing up like teeth of a carding comb." Bernini further annoyed the French by declaring that "art should be disguised with an appearance of naturalness; in France, just the opposite generally happened." Such a point of view was unlikely to endear the speaker to his hosts. Nor was his proclamation that he uttered in his first speech to Louis: "Let no one speak to me of little things."

But Louis was captivated by Bernini, as he was by the madrigal that Abbé Buti wrote (in Italian) for Bernini's visit: "The

question hangs in doubt whether it is a more fortunate destiny for Bernini to have found Louis or Louis, Bernini."

Despite his opinions, Bernini's time in Paris was fruitful. In the end, he designed four different plans and elevations for the Louvre, each time in response to critiques—or criticisms—from his hosts, particularly by Colbert, who wanted rooms for his king that were both convenient and handsome. The two men, the architect and physician Claude Perrault wrote, were polar opposites: "The Cavaliere never went into detail. He was only concerned with planning huge rooms for theatricals and fêtes, and would not bother himself over practical considerations. . . . Monsieur Colbert, on the other hand, wanted precision. He thought, rightly, that it was not merely a question of housing the persons of the King and the royal family well, but also of providing convenient lodgings for all the officials." Bernini, Perrault said, thought "it was beneath the dignity of a great architect such as himself to have to bother about such details."

While in France, Bernini agreed to carve a bust of Louis; the king, Baldinucci says, "was often happy to serve as a living model." Such regal generosity had its price, however. Louis never went anywhere without a considerable entourage of courtiers, ladies, and hangers-on, some of whom felt compelled to offer comments to Bernini on his handling of the marble and the progress of the bust.

During one modeling session, in which the king was still for an hour, Bernini threw down his chisel "in admiration and loudly exclaimed, 'Miracle, miracle that a king so meritorious, youthful and French should remain immobile for an hour.'" During another sitting, as the king was arranging himself, Bernini, according to Baldinucci, "gently parted the locks of hair which were arranged, as was the fashion, over the brow. He exposed the forehead somewhat and in an almost authoritative manner said, 'Your

Majesty is a king who must show his forehead to one and all.' " This surprise prompted a new hairstyle at the French court that became known as "the Bernini modification."

The finished bust of Louis is a dignified and stately study of the authority of monarchy. Bernini portrayed Louis as proud, imperial, completely in command. When critics told Bernini that he erred in some of the details of Louis's face—the king had rather smaller eyes and a lower forehead than Bernini portrayed—Bernini replied astutely, "My king will last longer than yours." He understood that what he had carved could be both art and propaganda.

By autumn, Bernini's time in France drew to a close. "I must return to Rome," Bernini told his hosts. "Some of my children that I cannot bring here, the Cathedra Petri and the Piazza, are pressing me to go back." According to Chantelou, "no one dared to write to him about [them] and thinking of [them] brought tears to his eyes." He thought about them incessantly, pondering their details and how they were progressing in his absence.

It was just as well: Bernini was as eager to return to Rome as the French were for him to leave. Though the foundation stone to the new Louvre had been laid amid suitable ceremony in the king's presence on October 17, Colbert had no intention of allowing an Italian palazzo, in all of its inconvenient splendor, to be built along the Seine. So when Bernini departed—after receiving from Louis 20,000 scudi and a life pension of another 2,000—it was with negligible regret on either side. (What Colbert and his architects did build at the Louvre—the east front, the so-called Grand Colonnade—is a masterpiece of French classical architecture, completely at odds with Bernini's Baroque.)

Bernini left Paris on October 20, 1665, arriving back in Rome in early December—no doubt relieved to have returned to a place

that understood and appreciated him. Alexander, too, was pleased to have him back. There was always the concern that the allures of the French court might draw Bernini to it permanently. After all, Leonardo da Vinci had lived at Francis I's court for several years, eventually dying in his service of the first of the great French kings of the Renaissance. Alexander wanted to avoid that at all costs, and fortunately, Bernini remained in Rome and in papal service until the pope's death on May 22, 1667.

Less than three months after Alexander died, Borromini did, too.

AFTER BORROMINI HAD thrown himself on his sword, a surgeon from the Ospedale di San Spirito, which was nearby, was sent for, though hopes for the architect's recovery were slim. But to everyone's surprise, Borromini did not die at once. He lingered for almost a day, lucid enough to give a detailed account of what he had done and to dictate another will in the presence of seven witnesses.

He also had a change of heart about his burial place. He asked to be placed not in the crypt at San Carlino, which he had designed and for which he had obtained permission from the Trinitarians a year before, but instead at San Giovanni next door, in the tomb of Carlo Maderno, "in return for a generous recompense to the architect's daughter Giovanna," Joseph Connors notes.

His request was granted, and Borromini was buried next to his kinsman and master, close to the third column on the left of the nave, without ceremony and without a grave marker. All that indicates the spot today is a small plaque.

Borromini's estate was much smaller than Bernini's: approximately 10,000 scudi. But though he had lived simply in the same house for decades, he nevertheless managed to acquire an impressive

array of hundreds of books and nearly 150 paintings, including portraits of Virgilio Spada and Innocent X. He owned at least two stucco busts—of Michelangelo and Seneca—several swords, a dozen compasses and even more ancient medals, and a variety of specimens from the natural world: snakes' heads, frogs, and shells. It was, in short, the collection of a connoisseur, a man captivated by the life of the mind and the lives of the world around him.

Today San Giovanni is not visited by many tourists, having neither impressive size nor sublime art nor dramatic history to place it on most itineraries. It is better known as the only church in Rome that welcomes parishioners' pets than as the burial place of Maderno and Borromini.

Yet almost four centuries after the sword plunged into Borromini's side, perhaps the greatest irony of his chosen resting place is that across the nave from his grave marker, high on a dimly lighted space on the right side of the church near the entrance to the sacristy, is a memorial portrait bust of Antonio Coppola, the surgeon and benefactor of the hospital of San Giovanni. The bust is small and severe. The strong nose and deeply set eyes, while impressive, cannot draw the viewer's attention away from the sunken cheeks and the high, tight cheekbones.

The bust was discovered in the basement of the church in 1966 by the American art historian Irving Lavin, and it was not long after that he determined it had been carved in 1612 by a young artist whose fame and success eclipsed both of the architects who are buried at San Giovanni: Gianlorenzo Bernini.

FOR THE REST of his life, Bernini—who would live another thirteen years after both Alexander and Borromini—devoted his attention to sculpture. From overseeing the work on the massive

angels that adorn the Ponte Sant'Angelo to completing the colossal statue of Constantine, which was so large that a wall needed to be taken out of his studio to remove it, Bernini was intent on leaving his stamp on Rome through the glories of his sculpture.

But scandal continued to plague him, even into his seventies. One of the worst occurred during the papacy of Clement X Altieri, who became pope in 1670. That same year, Bernini found himself once again having to save his brother Luigi from his own excesses.

As Bernini was completing his statue of Constantine on the landing of the Scala Regia at the Vatican, Luigi was caught brutally sodomizing a young boy behind it. Such a desecration was scandal enough, but the fact that the perpetrator was Bernini's own brother and assistant was a further stain on the family honor. Bernini was forced to pay a substantial fine, and Luigi was once again banished from Rome. Perhaps as a way of clearing his family's reputation, Bernini agreed to design for free the Altieri Chapel at San Francesco a Ripa and to carve the magnificent and mysterious reclining statue of the Blessed Ludovica Albertoni that is the chapel's centerpiece.

In 1680 Bernini fell ill with what Domenico calls "a slow fever, to which was added at the end an attack of apoplexy." It was more likely a stroke, as he soon lost the use of his right arm. He was remarkably accepting about it; he wasn't bothered that his arm, the tool that he had used for decades to create, was now useless. "It is only right that even before death that arm rest a little which worked so much in life," he said philosophically.

Over the next two weeks, he grew progressively worse. During one of his visits, Bernini's nephew, an Oratorian priest, Father Filippo (Domenico says Francesco) Marchese, asked him about

the state of his soul and whether he was afraid to die. Baldinucci indicates that Bernini replied, "Father, I must render account to a Lord who in his goodness does not count in farthings."

Eventually, as he faded, Bernini lost the ability to speak. However, he had planned for such a likelihood, having figured out with Father Marchese ways to make himself understood if he couldn't speak. "It astonished everyone how well he made himself understood with only the movement of his left hand and eyes— a clear sign of that great vivacity of spirits, which did not yield even though life withdrew," Domenico writes.

Bernini received the pope's blessing—by now, the pope was Innocent XI; he had lived through ten pontificates—and on November 28, 1680, he died at his home.

He was buried at Santa Maria Maggiore, across the street from the house he grew up in. The crowds attending the body were "so numerous," Baldinucci reports, "that it was necessary to postpone somewhat the time for the interment of the body." Eulogies were heaped on him, praising his talents and his qualities. But Bernini himself was right when he told Chantelou during his time in France that he owed his success "to a lucky star that made his contemporaries admire him, but when he was no longer alive that influence would have no further effect and therefore his reputation would be diminished or decline altogether."

It was a perceptive comment, as both Bernini and Borromini fell out of fashion as new, more classical tastes took hold. It would be generations before the world learned to appreciate again the work of these two men.

FOURTEEN

A Legacy in Stone

IT TOOK A PAINTER, NOT AN ARCHITECT OR a sculptor, to properly illustrate how profoundly Bernini and Borromini changed Rome. In his famous (and famously impressive) painting of eighteenth-century Rome, *Picture Gallery with Views of Modern Rome* (2.5 meters [more than 8 feet] long and nearly 1.75 meters [5.5 feet] tall), Giovanni Paolo Pannini depicts the city's myriad glories—the remarkable churches, palazzi, fountains, and sculptures known all over Europe for their beauty and inventiveness. At the center of the painting (one of four that the duc de Choiseul commissioned) Pannini placed several well-dressed connoisseurs, who are inspecting some of the canvases in an enormous and fanciful gallery or artist's studio. Perhaps the men (there are no women in the painting) are wealthy tourists on their Grand Tour who have stopped in Rome to acquire the

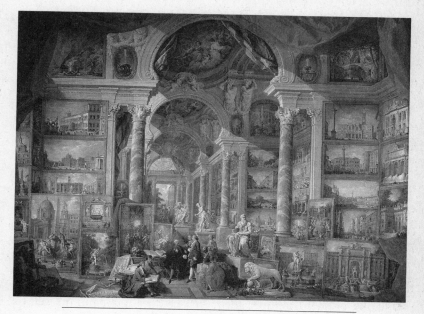

PICTURE GALLERY WITH VIEWS OF MODERN ROME
by Giovanni Pannini

requisite number of paintings and sculpture to take back with them.

But the men aren't really the point of the painting. They are simply artistic details dwarfed by the beauty that surrounds them. What draws the eye past the high archways supported by pink marble columns and decorated by elaborate ceiling frescoes are the dozens of paintings and statues that line the cool white walls of the gallery.

Rome's usual tourist attractions are commemorated here: the Spanish Steps, the Castel Sant'Angelo, even Michelangelo's *Moses.* But most of the other works of art illustrated are of more recent creation. The Fountain of the Four Rivers and the church of

Sant'Agnese in Agone. La Sapienza and the dome of Sant'Ivo. St. Peter's Square with its colonnade. San Giovanni in Laterano. *Apollo and Daphne. David.* Sant'Andrea al Quirinale. The Propaganda Fide.

It's clear to Pannini, and to anyone who sees this painting— or to anyone who has ever walked the twisting streets of Rome and stumbled across one of these marvels—that the city Pannini knew in 1757 when he painted *Picture Gallery* and the city today both bear the indelible stamps of Gianlorenzo Bernini and Francesco Borromini.

Despite their differences—in their work, their characters, and their behavior—they shared a deep love of their adopted city that never waned. Urban VIII once told Bernini, "You are made for Rome and Rome for you." The same could be said of Borromini. Even Virgilio Spada's insight into Borromini's personality—"He is by nature of such a temperament that he does not stand up well to the wrongs that others do him and for that reason he has broken with many, but where he has been treated with that respect that his love and loyalty deserve, he is like a puppy"—has parallels to Bernini's own character. "He [Bernini] could not bear to be laughed at . . . as the pupils at the Collegio Clementino learnt to their cost when they dared to make fun of the papal favourite," Magnuson notes. "Bernini used his influence to have their play stopped."

They both also shared a lifelong passion for creativity, for the new, and they reached heights that few artists have achieved since. Even the American architect Frank Gehry, whose own work has been praised and lambasted for its rule-breaking individuality, told a television interviewer that the greatest building ever designed is Borromini's San Carlino. "It's got all the moves in it that I've made," he said. "I've done nothing new since then."

It's the individual approach to their work that truly distin-

guishes these men, through the way they lived and the way they worked. Bernini succeeded by surpassing expectations; Borromini startled by defying them. Bernini's artistic vision was persuasive, impressive, precocious, and emotional. Borromini's sensibility was personal, intuitive, logical, and incorruptible. Together and apart, they worked to the best of their abilities to produce art that would last. They succeeded. And in the process they became immortal.

Sebastiano Serlio, the great Italian architect and historian, wrote in 1537, *"Bella cosa è ne l'architetto l'esser abbondante d'inventioni."* It is a good thing in an architect to abound in invention. Both Bernini and Borromini understood this, and each in his own way lived by that principle. Their legacy is a city that is an infinitely more beautiful place because of them.

NOTES

ONE: *The Beginning and the End*

2 *Some speculate that he was gay:* This question is raised in the essay "The Final Problem: Borromini's Failed Publication Project and His Suicide," by Martin Raspe, in *Annali di Architettura: Rivista del Centro Internazionale di Studi di Architettura Andrea Palladio* (Vicenza, Italy, 2001), p. 134.

 The place where Borromini was buried: For more details about San Giovanni dei Fiorentini, see Howard Hibbard, *Carlo Maderno and Roman Architecture 1580–1630* (University Park: Pennsylvania State University Press, 1971). A briefer chronology of San Giovanni can be found in Chris Nyborg, *Churches of Rome* (2000), which is available online at http://www.roma.katolsk.no.

3 *"so large a church along so terrifying a river":* Joseph Connors, "Poussin detrattore di Borromini," in *Atti del Convegno Internazionale su Borromini*, proceedings of conference held at the Bibliotheca Hertziana and Palazzo Barberini in January 2000. This quote is taken from the online version of the essay, which is available at http://www.columbia.edu/~jc65/cvlinks/poussin.html.

7 *"his opinion without esteem":* See Filippo Baldinucci, *The Life of Bernini*, trans. Catherine Enggass (University Park: Pennsylvania State University Press, 1966), p. 34.

8 *The style of Cavaliere Borromini:* See Rudolf Wittkower, *Gothic vs. Classic: Architectural Projects in Seventeenth-Century Italy* (New York: George Braziller, 1974), pp. 88–89.

"discussed Borromini, a man of extravagant ideas": See Paul Fréart de Chantelou, *Diary of the Cavaliere Bernini's Visit to France*, trans. Margery Corbett (Princeton, NJ: Princeton University Press, 1985), p. 326.

"feverish melancholia": See Joseph Connors, "Francesco Borromini: La vita 1599–1667," in Richard Bösel and Christoph Frommel, eds., *Borromini e l'universo barocco* (Milan, 1999), which accompanied an exhibition held at the Palazzo delle Esposizioni in Rome. The material quoted here is from the online version of the essay, which is available at http://www.columbia.edu/ ~jc65/cvlinks/vita.html.

"had another attack, even more violent": See Anthony Blunt, *Borromini* (Cambridge, MA: Belknap Press of Harvard University Press, 1979), p. 208.

9 *"His nephew [and heir, Bernardo]"*: Ibid.

10 *"Signor Cavaliere, you ought"*: Ibid., pp. 208–9. This quote and the several that follow are taken from Borromini's account, dictated to a notary, as he lay dying from his injury on August 2, 1667.

TWO: *Talent and Ambition*

14 *"For a while a poet"*: See Sir Nikolaus Pevsner, *An Outline of European Architecture* (New York: Penguin Books, 1977). Pevsner is referring specifically to artistic trends during the Victorian era, but this is a predicament that has afflicted architects since ancient times.

15 *"Not even the ancients"*: Avery, *Bernini: Genius of the Baroque*, p. 265.

"he devoured marble": Baldinucci, *Life of Bernini*, p. 13. Domenico Bernini writes something similar in his biography of his father; see *The Life of the Cavalier Gian Lorenzo Bernini*, in George C. Bauer, ed., *Bernini in Perspective* (Englewood Cliffs, NJ: Prentice-Hall, 1976), p. 27.

16 *"aspro di natura"*: This phrase, which is included in, and first popularized by, Domenico Bernini's biography, is often quoted when describing Bernini. This reference comes from Robert Wallace and the editors of Time-Life Books, *The World of Bernini: 1598–1680* (Alexandria, VA: Time-Life Books, 1970), p. 13.

17 *He was the eldest son:* Although Bernini's family was not from Florence proper and Bernini was born in Naples and grew up in Rome, he was still called "the Florentine," and there were Romans who referred to him, according to Tod Marder in his book *Bernini and the Art of Architecture* (New York: Abbeville Press, 1998, p. 12), as a *forestiero,* an out-of-towner. Marder also notes that "a later, hostile critic who happened to be a partisan of Borromini described Bernini as 'Florentine or Neapolitan depending on his fancy' " (p. 14).

18 *"by divine plan":* Baldinucci, *Life of Bernini,* p. 8.

21 *For a decade the church:* For more information about the construction of the Pauline Chapel, see Torgil Magnuson, *Rome in the Age of Bernini,* vol. 1 (Stockholm: Almqvist & Wiksell International, 1982), pp. 151–55.

22 *"the hand of the young Gianlorenzo":* In *Bernini: Genius of the Baroque* (London: Thames & Hudson, 1997), his monograph on Bernini's career as a sculptor, Charles Avery posits this in a note (p. 16), though his actual text is more speculative: "Could the young Gianlorenzo possibly have lent his juvenile talent to some of these putti, or is this spectacularly enhanced level of quality simply Pietro at his very best?"

 "at the age of eight": Bernini, *Life of the Cavalier Gian Lorenzo Bernini,* p. 24, and Baldinucci, *Life of Bernini,* p. 8.

24 *"Bernini's early portraits":* Marder, *Bernini and the Art of Architecture,* p. 14.

 Late one night in 1608: For a brief biography of Cardinal Scipione Borghese, see Robert Wallace, *The World of Bernini* (Alexandria, VA: Time-Life Books, 1970), pp. 14–15.

25 *"carried himself with such":* Bernini, *Life of the Cavalier Gian Lorenzo Bernini,* pp. 25–26. This anecdote is told in a slightly different version in Chantelou, *Diary,* p. 102.

27 *"spent three continuous years":* Baldinucci, *Life of Bernini,* p. 9.

 "the delineation of noble figures": See Howard Hibbard, *Bernini* (New York: Penguin Books, 1965), p. 25.

 "Watch out": This famous anecdote is retold frequently, including

by Maurizio Fagiolo and Angela Cipriani in their book *Bernini* (Rome: Scala, 1981), p. 9, and by Charles Scribner III in *Gianlorenzo Bernini* (New York: Harry N. Abrams, 1991), p. 9.

28 *"expressed both admiration and disparagement"*: Baldinucci, *Life of Bernini*, p. 10.

30 *"savage spite"*: Scribner, *Gianlorenzo Bernini*, p. 64.

"Change and destroy": Ibid.

According to Ovid's version: Guide to the Borghese Gallery, the museum's official guidebook edited by Kristina Herrmann Fiore, has an informative essay on this piece (Rome: Ministero per i Beni Culturali e Ambientali, Soprintendenza per i Beni Artistici e Storici di Roma, 1997), p. 37.

32 *"of having been modeled"*: Magnuson, *Rome in the Age of Bernini*, vol. 1, p. 210.

"only the eye": Baldinucci, *Life of Bernini*, p. 13.

"metamorphosis of the block of marble": Avery, *Bernini*, pp. 63–65.

33 *"The figure of a lovely naked girl"*: Chantelou, *Diary*, p. 30.

"Quisquis amans sequitur": This translation, one of many published over the years, is from Avery, *Bernini*, p. 55.

The story has circulated: See Baldinucci, *Life of Bernini*, p. 13, and Magnuson, *Rome in the Age of Bernini*, vol. 1, p. 211.

35 *"had Bernini not made one mistake"*: Norton's hypothesis comes from "An Estimate of Bernini," an essay in *Bernini and Other Studies in the History of Art* (New York: Macmillan, 1914), p. 17. While this suggestion has been either dismissed or ignored by other Bernini experts, the sculpture certainly appeared to be backward to me when I saw *David* for the first time (and it was months before I came across this essay). If it's true that Barberini held a mirror for Bernini to sculpt the face of David, perhaps this could also explain why he's holding the sling backward.

36 *"the jagged and illogical boundary"*: Connors, "Francesco Borromini," p. 7.

38 *"maestra di tutte le cose"*: Ibid.

"structures that are durable": Ibid.

39 *Before he became an architect:* Ibid.

"was already so enamored": See Paolo Portoghesi, *The Rome of Borromini: Architecture as Language*, trans. Barbara Luigia la Penta (New York: George Braziller, 1968), p. 27.

40 *Borromini began his career:* Connors, "Francesco Borromini." Connors's descriptions of Borromini's youth, family, and early days in Rome throughout the essay are insightful.

THREE: *The Perpetual and the Beautiful*

43 *St. Peter's is a church of superlatives:* The details of St. Peter's can be found in the English versions of *Guide to the Vatican Museums and City*, published by the Vatican through its Pontifical Monuments, Museums and Galleries Administration (Città del Vaticano: Gestione Vendita Pubblicazioni Musei Vaticani, 1986), pp. 171–81; and Sonia Gallico, *Vatican* (Rome: Edizioni Musei Vaticani Ars Italia Editrice, 1999), pp. 17–22.

44 *Soon after Peter's burial:* For background on the early years of St. Peter's, see Laure Raffaëlli-Fournel, ed., *The Knopf Guide: Rome*, trans. Louis Marcelin-Rice and Kate Newton (New York: Alfred A. Knopf, 1994), pp. 209–15; Riccardo Cigola, *Geography: Cities: Rome* (1999–2004), which is available online at http://www.italycyber guide.com/Geography/cities/rome2000/D1.html; and Jonathan Boardman, *Rome: A Cultural and Literary Companion* (New York: Interlink Books, 2001), pp. 47–48.

46 *"with St. Peter's preserving"*: Boardman, *Rome*, pp. 45–46.

47 *By the middle of the fifteenth century:* Ibid., p. 46.

52 *Though the dome was considered finished:* Magnuson, *Rome in the Age of Bernini*, vol. 1, p. 131.

53 *"He made it very different"*: Giorgio Vasari is quoted in David Watkin, *A History of Western Architecture* (London: Thames and Hudson, 1986), p. 197.

54 *New burial places:* Magnuson, *Rome in the Age of Bernini,* vol. 1, p. 126.

56 *The church needed a nave:* Ibid., p. 127.

 "according to ecclesiastical rule": See Paolo Portoghesi, *Roma Barocca: The History of an Architectonic Culture,* trans. Barbara Luigia la Penta (Cambridge, MA: MIT Press, 1970), p. 59.

 The pope and the Congregazione: Magnuson, *Rome in the Age of Bernini,* vol. 1, p. 127, and Hibbard, *Carlo Maderno,* p. 66.

 "One sees that in the present building": Portoghesi, *Roma Barocca,* p. 59.

57 *A number of architects were called upon:* Ibid., p. 58, and Magnuson, *Rome in the Age of Bernini,* vol. 1, p. 128.

58 *At one point, 866 laborers:* Magnuson, *Rome in the Age of Bernini,* vol. 1, p. 128.

 "have risen as a single mass": Le Corbusier's comments are quoted in Christian Norberg-Schulz, *Baroque Architecture* (Milan: Electa; New York: Rizzoli, 1979), pp. 64–68.

59 *After a brief two-year reign:* Magnuson, *Rome in the Age of Bernini,* vol. 1, p. 215. Magnuson's description of the conclave that elected Urban VIII makes it sound particularly grueling. It appears to have been a contest of physical as well as political survival, with the French and Spanish factions vying for ascendancy, a secret ballot used for the first time, and cardinals battling malaria and other illnesses during the Roman summer.

60 *"It is your great fortune":* Baldinucci, *The Life of Bernini,* p. 15.

 "Whoever becomes pope will find": Scribner, *Gianlorenzo Bernini,* p. 15. Here Domenico Bernini is quoted.

 Bernini was allowed unlimited access: Marder, *Bernini and the Art of Architecture,* p. 19, and Hibbard, *Bernini,* p. 68.

 "informed Bernini that it was his wish": Baldinucci, *Life of Bernini,* p. 15.

61 *"Pope Paul objected":* Portoghesi, *Roma Barocca,* p. 59.

62 *"he would have to resign himself":* Marder, *Bernini and the Art of Architecture,* p. 31.

FOUR: *A Collaboration in Bronze*

64 *"what appears to the viewer"*: See Avery, *Bernini*, p. 95; a slightly different translation is available in Baldinucci, *Life of Bernini*, p. 16.

"turned something provisory": See Victor-L. Tapié, *The Age of Grandeur: Baroque Art and Architecture* (Paris: Librairie Plon, 1957; New York: Frederick A. Praeger, 1961), p. 46.

"There are days when the vast nave": See Henry James, *Henry James on Italy* (New York: Weidenfeld & Nicholson, 1988), p. 101.

"huge uncouth structure": Scribner, *Gianlorenzo Bernini*, p. 17.

67 to found a *società di arte*: Connors, "Francesco Borromini."

69 *Though the exact design of the new ciborium*: Marder, *Bernini and the Art of Architecture*, p. 29.

70 *"a wooden armature"*: See W. Chandler Kirwin, *Powers Matchless: The Pontificate of Urban VIII, the Baldachin, and Gian Lorenzo Bernini* (New York: Peter Lang, 1997), p. 15.

"It happened one day": Baldinucci, *Life of Bernini*, pp. 10–11.

71 *"the four columns"*: Kirwin, *Powers Matchless*, p. 94. Kirwin is quoting minutes of the meeting of the Congregazione.

72 *"From the day of Urban's election ceremony"*: Ibid., p. 79.

"a wise conjunction": Ibid., p. 28. He is quoting Count Virgilio Malvezzi from Pietro Redondi's *Galileo Heretic*.

"wanted not only to emulate them": Ibid., p. 86.

74 *"the four columns made to hold up the baldachin"*: Ibid., p. 95.

"Maderno no doubt": Ibid., p. 33.

75 *"a proclamation in which it is made"*: Ibid., p. 96.

76 *"in its size, proportion"*: Ibid., p. 95.

77 *A contemporary guidebook to Rome*: Marder, *Bernini and the Art of Architecture*, p. 47.

his first major religious statue: Scribner, *Gianlorenzo Bernini*, p. 16.

78 *"to cover the high altar"*: Kirwin, *Powers Matchless*, p. 106.

79 *"touched neither the columns"*: Marder, *Bernini and the Art of Architecture*, p. 31.

80 *Within less than eighteen months*: Kirwin, *Powers Matchless*, p. 106.

81 *"are not supported by columns"*: Marder, *Bernini and the Art of Architecture*, p. 32, is quoting Hibbard, *Carlo Maderno*, p. 128.

"if the Baldachin tells us anything": Kirwin, *Powers Matchless*, p. 106.

82 *By the next spring*: Ibid., p. 130.

carved by Borromini and Agostino Radi: Magnuson, *Rome in the Age of Bernini*, vol. 1, p. 261.

83 *cast in massive sections*: Ibid., p. 250.

"one of the largest items in the accounts": Ibid., p. 261.

the recently installed bronze ribs: Ibid., p. 260; Marder, *Bernini and the Art of Architecture*, p. 37.

84 *a task that Borromini was in charge of*: Connors, "Virtuoso Architecture in Cassiano's Rome."

"operated at the beginning": Kirwin, *Powers Matchless*, p. 128. He is quoting Oskar Pollak, a historian who wrote a survey of the art world during Urban's papacy.

86 *"had no intention of promoting"*: Connors, "Francesco Borromini."

Bernini replaced the large statue: Marder, *Bernini and the Art of Architecture*, p. 34.

87 *strengthened by a metal bar*: Avery, *Bernini*, p. 99.

much like the finished Baldacchino: Portoghesi, *The Rome of Borromini*, p. 30.

"contributed decisively": Ibid.

89 *"the figures dart"*: Norberg-Schulz, *Baroque Architecture*, p. 147, is quoting Argan.

90 *"the entire fabric was the work of his mind"*: Marder, *Bernini and the Art of Architecture*, p. 61. He is referring to Patricia Waddy on Taddeo Barberini.

"was in great part the design of Borromini": Joseph Connors, "Virgilio Spada's Defence of Borromini," *Burlington Magazine* 131 (1989),

pp. 75–90. I am quoting from the online version of this essay which is available at http://www.columbia.edu/~jc65/cvlinks/virgilio.html.

the oval staircase in the south wing: Blunt, *Borromini,* p. 24.

91 *"in later years [Borromini] used to say":* Connors, "Virgilio Spada's Defence of Borromini."

"Knowing what Borromini had accomplished": Portoghesi, *Roma Barocca,* p. 165.

92 *"Urban . . . appointed him":* Ibid., p. 166.

93 "Lo procurò suo adherente": Connors, "Francesco Borromini."

"the exceptional talent of his assistant": Portoghesi, *Roma Barocca,* p. 166.

"like the dragon": Avery, *Bernini,* p. 274, is quoting Passeri.

"To Francesco Castelli": Portoghesi, *The Rome of Borromini,* p. 31.

95 *It was the seventeenth-century version:* Connors refers here to an account in Giovanni Battista Passeri's biography of Borromini, published in 1772.

"abandoned every [sculptural] impresa": Connors, "Francesco Borromini." Connors quotes from Jacob Hess, ed., *Die Künstlerbiographien von Giovanni Battista Passeri,* Römische Forschungen der Bibliotheca Hertziana XI (1934; repr., Worms am Rhine, 1995), p. 361.

"Despite the fact that": Connors, "Francesco Borromini."

FIVE: *The Circle and the Triangle*

98 *"He saw the Majesty of God":* Joseph Connors, "Un Teorema Sacro: San Carlo alle Quattro Fontane," in Manuela Kahn-Rossi and Marco Franciolli, eds., *Il giovane Borromini: dagli esordi a San Carlino* (Lugano: Museo Cantonale d'Arte, September–November 1999), pp. 459–95. The material here is quoted from the online version of this essay, which is available at http://www.columbia.edu/~jc65/cvlinks/teorema.htm.

Anthony Blunt notes that the cardinal: Blunt, *Borromini,* p. 53.

99　*When rumors circulated:* This and the following details concerning Fra Juan de la Anunciación come from Connors, "Francesco Borromini."

"as rich as Solomon's temple": Ibid.

101　*"the corner is the enemy":* Magnuson, *Rome in the Age of Bernini,* vol. 1, p. 290.

At the flat center: Blunt, *Borromini,* p. 55.

102　*"among all the figures in architecture":* Addison is quoted in Charles Saumarez Smith, *The Building of Castle Howard* (Chicago: University of Chicago Press, 1990), p. 45.

Standing to the right of the church: Blunt, *Borromini,* p. 55.

104　*"in one the bulge comes at the top":* Ibid., p. 57.

"flickering movement": Magnuson, *Rome in the Age of Bernini,* vol. 1, p. 291.

105　*He is said to have explained later:* Ibid.

Borromini began work on San Carlo: Portoghesi, *The Rome of Borromini,* p. 41.

by June 1636: Ibid., and Magnuson, *Rome in the Age of Bernini,* vol. 1, p. 291.

109　*"Borromini was the first architect":* Blunt, *Borromini,* p. 70.

111　*"subtly aristocratic":* Portoghesi, *The Rome of Borromini,* p. 61.

"completely out of character": Blunt, *Borromini,* p. 108.

112　*"the altar fits the transept":* Ibid., p. 108.

he died suddenly in 1643: Connors, "Francesco Borromini."

113　*"judged by all to be of an art so rare":* Portoghesi, *Rome Barocca,* p. 169.

"those of different countries": Ibid.

"is continually harassed": Ibid.

"worked on his buildings": Ibid., p. 169.

114　*"beautiful little church":* Connors, "Un Teorema Sacro."

"well founded on the antique": Portoghesi, *Roma Barocca,* p. 169.

"set apart by instinct": Sacheverell Sitwell, *Baroque and Rococo* (New York: G. P. Putnam's Sons, 1967), pp. 96–97.

117 *"a milestone in the history of sculpture"*: Hibbard, *Bernini*, p. 89.

"was almost completed when a mishap occurred": The details of this anecdote come from Baldinucci, *Life of Bernini*, pp. 11–12.

118 *"If of an evening"*: Fagiolo and Cipriani, *Bernini*, p. 14.

SIX: *"Ignorant Persons and Copyists"*

121 *"spread among all classes of society"*: Blunt, *Borromini*, p. 85.

In 1575 Pope Gregory XIII gave Neri: Ibid., p. 86.

But by then they had also outgrown: Joseph Connors, in his introduction to Francesco Borromini, *Opus architectonicum* (Milan: Il Polifilo, Trattati di architectura, 1998). The material quoted here is from the online version of this essay, which is available at http://www.columbia.edu/~jc65/opus/opus.int.htm.

122 *"where religious gatherings"*: Magnuson, *Rome in the Age of Bernini*, vol. 1, p. 300.

123 *"throughout Rome"*: Portoghesi, *Roma Barocca*, p. 170.

124 *Maruscelli was simply trying to conceal*: Blunt, *Borromini*, p. 86.

"had diverse designs drawn up": Portoghesi, *The Rome of Borromini*, p. 49.

125 *"In this situation"*: Ibid.

"The Prior said": Ibid., p. 50.

126 *"Partly through his brilliance"*: Connors, introduction to *Opus architectonicum*.

Even though Borromini's initial duties: Connors, "Virgilio Spada's Defence of Borromini."

"With [Maruscelli's] advice": Connors, introduction to *Opus architectonicum*.

127 *"Maruscelli's oratory"*: Ibid.

128 *"a prismatic hall"*: Portoghesi, *Roma Barocca*, p. 170.

129 *"smoothing the transition"*: Magnuson, *Rome in the Age of Bernini*, vol. 1, p. 303.

130 *"One thinks that with a bit of perspective"*: Connors, *Opus architectonicum.*

The new Oratory was completed by 1640: Magnuson, *Rome in the Age of Bernini*, vol. 1, p. 301.

"insisted on approving": Ibid., p. 303.

131 *which the order found insulting*: Connors, "Virgilio Spada's Defence of Borromini."

"I beg whoever should read these sayings": Ibid.

"in place of Borromini": Ibid.

"Ingannare la vista": Joseph Connors, "Virtuoso Architecture in Cassiano's Rome," in *Cassiano Dal Pozzo's Paper Museum*, vol. 2, ed. Jennifer Montagu (London: Quaderni Puteani 3, 1992), pp. 23–40.

that it be as unadorned as possible: Magnuson, *Rome in the Age of Bernini*, vol. 1, p. 303.

132 *"How wonderful it would be"*: Blunt, *Borromini*, p. 92.

"In giving form to said façade": Connors, introdution to *Opus architectonicum.*

"the springiness of a sheet of metal": Blunt, *Borromini*, p. 93.

133 *"one of Borromini's most remarkable façades"*: Magnuson, *Rome in the Age of Bernini*, vol. 1, p. 303.

134 *"a great inclination to pleasure"*: Scribner, *Gianlorenzo Bernini*, p. 82.

his brother's soprastante: See Sarah McPhee, *Bernini and the Bell Towers: Architecture and Politics at the Vatican* (New Haven, CT: Yale University Press, 2002), p. 62.

135 *"rich pension that went with it"*: Baldinucci, *Life of Bernini*, p. 11.

"was then inflamed with desire": Bernini, *Life of the Cavalier Gian Lorenzo Bernini*, p. 29.

"To succeed with a portrait": Fagiolo and Cipriani, *Bernini*, p. 14.

136 "fieramente inamorato": Scribner, *Gianlorenzo Bernini*, p. 82.

Pietro had bought next to the church: Marder, *Bernini and the Art of Architecture,* p. 21.

"accompanied him amorously": Avery, *Bernini,* p. 274.

137 *"notorious for his ruthless ambition":* Ibid.

There, he carried out his master's orders: Ibid.

138 *"with kicking at the door":* Ibid., p. 275.

"mitigate the penalties": Ibid.

"The Pope, apprised of the deed": Bernini, *Life of the Cavalier Gian Lorenzo Bernini,* p. 29.

139 *He cut her out of a joint portrait:* Avery, *Bernini,* p. 275.

This "strange illness": Bernini, *Life of the Cavalier Gian Lorenzo Bernini,* p. 30.

"desired to make [Bernini]": Baldinucci, *Life of Bernini,* p. 20.

On May 15, 1639: For more details on Bernini's marriage, see Marder, *Bernini and the Art of Architecture,* p. 21, and Hibbard, *Bernini,* pp. 114–15.

"faultlessly docile": Avery, *Bernini,* p. 275.

140 *"harmony is the most beautiful thing in the world":* Fagiolo and Cipriani, *Bernini,* p. 32. The complete quote is "Harmony is the most beautiful thing in the world, and grandeur does not depend on the amount of money invested but on the grandeur of the architect's style and the nobility of his idea."

SEVEN: *An Ox and a Deer*

141 *The beginning of Bernini's problems:* McPhee, *Bernini and the Bell Towers,* p. 50.

142 *one at each end of the façade:* Ibid., p. 14.

the façade would appear larger: Ibid., p. 19.

"that were dangerously destabilizing": Ibid., p. 22.

"The ground was so sandy": Ibid., p. 23.

143 *He even had a foundation:* Ibid., p. 24.

"where a torrent of water": Ibid., p. 28.

144 *"Bernini's competence"*: Ibid., p. 44.

"[I]t is believed . . . that Bernini will retreat": Ibid.

"Bernini not only made the design": Baldinucci, *Life of Bernini*, p. 30.

145 *"it was the Pope's custom"*: Ibid.

"Borromini, who knew Maderno's façade": Connors, "Francesco Borromini."

"The prudent artist": Baldinucci, *Life of Bernini*, p. 30.

146 *"formed of two orders of columns and pilasters"*: Ibid., p. 31.

"no less than twenty-four columns": Magnuson, *Rome in the Age of Bernini*, vol. 1, p. 271.

"only if his brother approved": McPhee, *Bernini and the Bell Towers*, p. 61.

147 *"cloath'd with white marble"*: Avery, *Bernini*, pp. 104–5.

"festoons and dolphins": Marder, *Bernini and the Art of Architecture*, p. 73.

148 *Marc Antonio Valena recorded*: McPhee, *Bernini and the Bell Towers*, p. 63.

Urban ordered it torn down: Ibid., p. 175.

"grows in such a manner": Ibid., p. 69; and Marder, *Bernini and the Art of Architecture*, p. 73. This and the following quotes in the paragraph are from this source. McPhee uses the term "intervene" in *Bernini and the Bell Towers*, p. 69.

"The Cavaliere Bernini": McPhee, *Bernini and the Bell Towers*, p. 75.

150 *"the upper part of the campanile"*: Avery, *Bernini*, p. 105.

Another Englishman: McPhee, *Bernini and the Bell Towers*, p. 81.

151 *Bernini wrote to the powerful cardinal Jules Mazarin*: Avery, *Bernini*, p. 234.

153 *almost immediately after Innocent was elected*: McPhee, *Bernini and the Bell Towers*, p. 311, n. 42.

"fissures"—in the façade: Ibid., p. 95.

multitudes who collect in St. Peter's Square: Ibid.; and Baldinucci, *Life of Bernini*, p. 30.

154 *"Bernini suggested that soundings be made"*: McPhee, *Bernini and the Bell Towers*, p. 91.

"*straight back to through the mass of Maderno's foundation*": Ibid., p. 99.

155 "*The ruin of the campanile*": Ibid., pp. 101–2.

"*The prudent architect*": Ibid., p. 103.

156 *including both Bernini and Borromini*: Ibid., p. 104.

"*When an ox and a deer run*": Ibid., p. 111.

157 *it would take either a fool or a zealot*: Ibid., p. 114.

158 *the tower would devastate it*: Ibid., p. 117.

Domenico Bernini, as expected: Ibid., p. 96.

"*quickly took up arms*": Baldinucci, *Life of Bernini*, p. 31.

"*People whom Pope Innocent X trusted*": Ibid., pp. 31–32.

159 "*If it were me*": McPhee, *Bernini and the Bell Towers*, p. 317, n. 118.

"*to do him the favor of intervening*": Ibid., p. 119.

"*told him that Borromini*": Ibid., p. 120.

"*the pope did not wish to abandon the tower project*": Ibid.

160 *Four months later*: Ibid., p. 137.

His proposed towers were lighter: Ibid., p. 136.

161 "*situate in falso*": Ibid., p. 141.

"*but then thought better of it*": Ibid., p. 146.

"*given the right not to approve*": Ibid., p. 139.

Longhi also wanted the foundations reinforced: Ibid., p. 142.

162 "*most proportionate to the whole*": Ibid., p. 162; see also fig. 128 on p. 153.

"*It seemed a good idea*": Baldinucci, *Life of Bernini*, p. 33.

"*A campanile that has recently been constructed*": McPhee, *Bernini and the Bell Towers*, p. 165.

163 *some evidence suggests that Bernini's investments*: Marder, *Bernini and the Art of Architecture*, p. 78.

"*for the claims of damages*": Ibid., p. 169.

"*enemies of Bernini*": Baldinucci, *Life of Bernini*, p. 34.

"*knew how to use such opportunities*": Ibid.

"It was the opinion of many": Ibid.

"since from the unexpected novelty": Bernini, *Life of the Cavalier Gian Lorenzo Bernini*, p. 33.

164 *"came forward as Bernini's most dangerous critic"*: Rudolf Wittkower, *Art and Architecture in Italy, 1600–1750*, vol. 2, *The High Baroque* (New Haven, CT: Yale University Press, 1999), p. 39.

his agent Francesco Mantovani: McPhee, *Bernini and the Bell Towers*, pp. 167–68.

EIGHT: *Ecstasy and Wisdom*

165 *"When a man loses"*: Baldinucci, *Life of Bernini*, p. 34.

166 *"Even the great have been touched"*: McPhee, *Bernini and the Bell Towers*, pp. 169–70.

"tacit approval": Ibid.

167 *"It is a miracle"*: Ibid., p. 170.

Several of them, including Cardinal Antonio Barberini: Avery, *Bernini*, p. 236.

But a year later: Ibid.

168 *"a hoary old man"*: Ibid., p. 234.

Bernini completed only the figure of Truth: Scribner, *Gianlorenzo Bernini*, p. 86.

"the rotten old tub": Avery, *Bernini*, p. 182.

169 *"Whether dissuaded from the work"*: Scribner, *Gianlorenzo Bernini*, p. 86, quotes Domenico Bernini.

"the most beautiful virtue": Avery, *Bernini*, p. 234.

He was appointed secretary to the papal legate: Magnuson, *Rome in the Age of Bernini*, vol. 2, p. 1. Magnuson spells Mazarin's name "Mazzarino."

170 *Rather than sculpting from life*: Avery, *Bernini*, p. 233.

Mazarin quietly agreed: Ibid.

171 *"The figure of Time"*: Ibid., p. 234; Fagiolo and Cipriani, *Bernini*, p. 17.

"if Bernini were to decide": Avery, *Bernini*, p. 235.

172 *"I saw beside me"*: Ibid., p. 76.

173 *the first time since the Baldacchino:* Portoghesi, *Roma Barocca*, p. 94.

 "it is the gentlemen carved out of white marble": Avery, *Bernini*, p. 148.

174 *"In the opinion of all"*: Bernini, *Life of the Cavalier Gian Lorenzo Bernini*, p. 34.

 "In that group the Cavalier has surpassed himself": Ibid.

 "This is the least bad work": Magnuson, *Rome in the Age of Bernini*, vol. 2, p. 80.

 "So fair a swoon": Baldinucci, *Life of Bernini*, p. 35.

175 *"If this is Divine Love"*: From John Varriano, *Italian Baroque and Rococo Architecture* (New York: Oxford University Press, 1986), p. 175.

 one of the two public posts: Blunt, *Borromini*, p. 111.

 "Cavalier Bernini has made known": Portoghesi, *The Rome of Borromini*, p. 149.

 work at the site had been halted: Blunt, *Borromini*, p. 111.

176 *"because of the liveliness of his talent"*: Connors, introduction to *Opus architectonicum.*

 the dome was covered with lead: Blunt, *Borromini*, p. 111.

177 *"Never perhaps did the Baroque ideal"*: Ibid., p. 114.

 consecrated by Cardinal Antonio Barberini: Magnuson, *Rome in the Age of Bernini*, vol. 2, p. 205.

 It is both the symbol of Charity and Prudence: Portoghesi, *Roma Barocca*, p. 173.

 Monsignor Carlo Cartari seconds this conclusion: Portoghesi, *The Rome of Borromini*, p. 158.

 "must also have had in mind": Blunt, *Borromini*, p. 116.

178 *Borromini considered placing a semicircle:* Magnuson, *Rome in the Age of Bernini*, vol. 2, p. 205.

180 *tempietto, as it was then called:* Portoghesi, *The Rome of Borromini*, p. 149.

182 *"the twisting spire"*: Sitwell, *Baroque and Rococo*, p. 98.

"a brilliant and free interpretation": See Livia Velani, *Rome: Where to Find Michelangelo, Raphael, Caravaggio, Bernini, Borromini* (Florence: Scala, 2000), p. 120.

"mounted on a pedestal": Connors, "Francesco Borromini."

NINE: *A Pope's Renovations*

184 *Built on the spot*: Avery, *Bernini*, p. 95.

Lago di Piazza Navona: Magnuson, *Rome in the Age of Bernini*, vol. 2, p. 288.

185 *This determined, formidable woman*: Ibid., p. 4.

she was known for being di nauseante ingordigia: Ibid., p. 6.

"latter-day Agrippina": Ibid., p. 7.

187 *taken from St. Peter's*: See Caroline Vincenti Montanaro and Andrea Fasolo, *Palazzi and Villas of Rome* (Venice: Arsenale Editrice, 2001), p. 132.

called in Borromini: Magnuson, *Rome in the Age of Bernini*, vol. 2, p. 53.

Borromini designed several versions: Blunt, *Borromini*, p. 173.

"a long court with apsed ends": Ibid.

188 *Innocent let him design*: Magnuson, *Rome in the Age of Bernini*, vol. 2, p. 54.

189 *"quelling the tumult"*: From Rudolf Preimesberger, "Images of the Papacy Before and After 1648" (Forschungsstelle/Research Center "Westfälischer Friede," 2000–2003), p. 8, http://www.lwl.org/west faelischer-friede/wfe-t/wfe-txt2-67.htm (accessed August 2004).

"a study in practical mathematics": Portoghesi, *The Rome of Borromini*, p. 179.

190 *"closed in his favor"*: Ibid., p. 159.

191 *The official seat of the pope*: Magnuson, *Rome in the Age of Bernini*, vol. 2, p. 34.

192 *a deeply coffered wooden ceiling*: Ibid., p. 35.

193 *the pope appointed Spada*: Ibid.; see also Blunt, *Borromini*, p. 134.

194 *In a letter dated March 16, 1647:* Magnuson, *Rome in the Age of Bernini,* vol. 2, p. 39.

"gave great satisfaction to the Pope": Portoghesi, *The Rome of Borromini,* pp. 159–61.

before he was given the post: Blunt, *Borromini,* p. 134.

195 *twelve rectangular statuary niches, called tabernacles:* Magnuson, *Rome in the Age of Bernini,* vol. 2, p. 37.

196 *laurels and palm fronds:* Blunt, *Borromini,* p. 142.

he would not allow them to proceed with the vaulting: Ibid., p. 141; see also Portoghesi, *The Rome of Borromini,* p. 159.

197 *"the teachings of Baronius":* Connors, "Francesco Borromini."

windows between the aisles: Blunt, *Borromini,* p. 141.

198 *"look in personally to see":* Magnuson, *Rome in the Age of Bernini,* vol. 2, p. 39.

199 *the body was discovered elsewhere:* Connors, "Francesco Borromini"; and Portoghesi, *The Rome of Borromini,* p. 182.

"He was remanded to temporary banishment": Connors, "Francesco Borromini."

200 *Innocent awarded Borromini a knighthood:* Ibid.

TEN: *Water and Disappointment*

202 *he placed a rectangular stone trough:* Magnuson, *Rome in the Age of Bernini,* vol. 2, p. 80.

203 *rediscovered lying in several salvageable pieces:* Baldinucci, *Life of Bernini,* p. 36; Bernini, *Life of the Cavalier Gian Lorenzo Bernini,* p. 35; Blunt, *Borromini,* p. 133; and Magnuson, *Rome in the Age of Bernini,* vol. 2, p. 80.

Innocent inspected the obelisk: Avery, *Bernini,* p. 194.

"an apotheosis of water": Hibbard, *Bernini,* p. 110.

"He lifts his hollow shell": Marder, *Bernini and the Art of Architecture,* p. 90.

204 *"Every artist worth the name":* Hibbard, *Bernini,* p. 120.

"features an allegorical figure": Marder, *Bernini and the Art of Architecture*, p. 95.

205 *"Attributing the aversion of the Pope"*: Bernini, *Life of the Cavalier Gian Lorenzo Bernini*, p. 35.

"knowledge of the tenacious": Ibid.

"Making up in ingenuity": Ibid.

"could not deny to so praiseworthy": Ibid.

206 *"received it with . . . much pleasure"*: Ibid.

"would at least demand": Ibid., p. 36.

"deliberately placed the model": Ibid.

"Upon seeing such a noble creation": Baldinucci, *Life of Bernini*, p. 36.

"This design cannot be by any other": Bernini, *Life of the Cavalier Gian Lorenzo Bernini*, p. 36.

"with a thousand signs of esteem": Baldinucci, *The Life of Bernini*, p. 36.

207 *"Borromini stormed through"*: Connors, "Virgilio Spada's Defence of Borromini."

208 *"allowed work to continue"*: Connors, "Francesco Borromini."

"Borromini called a general walkout": Ibid.

209 *Work on the fountain began soon after*: Magnuson, *Rome in the Age of Bernini*, vol. 2, p. 81.

210 *a sum so high*: Ibid., p. 83.

"Noi volemo altro": This famous couplet has been translated over the years in numerous ways; this version is my translation. It may be others' as well.

using Bernini's successful and long-established practice: Ibid., p. 87; see also Hibbard, *Bernini*, p. 121.

an impressive achievement: Hibbard, *Bernini*, p. 121.

211 *"is almost as dirty as West Smithfield"*: This quote appears in John Varriano, *A Literary Companion to Rome* (New York: St. Martin's, 1991), p. 166.

Innocent was inordinately pleased: Baldinucci, *Life of Bernini*, pp. 38–39.

212 *He received 3,000 scudi:* Magnuson, *Rome in the Age of Bernini,* vol. 2, p. 87.

213 *To counter such criticism:* Ibid., p. 88. Magnuson recounts a story Domenico included in his biography of his father.

"O come mi vergogno": Ibid.

214 *"the saddest in the whole of Borromini's career":* Blunt, *Borromini,* p. 156.

215 *the princess of Romano:* Magnuson, *Rome in the Age of Bernini,* vol. 2, p. 56.

216 *at the suggestion of Virgilio Spada:* Ibid., p. 60.

"a certain staircase": Portoghesi, *The Rome of Borromini,* p. 168.

217 *"absurd and unjustifiable":* Ibid.

218 *"Even though the pope was fed up with him":* Connors, "Virgilio Spada's Defence of Borromini."

220 *A set of low, curved steps:* Magnuson, *Rome in the Age of Bernini,* vol. 2, p. 61; and Portoghesi, *The Rome of Borromini,* p. 168.

"generous enough to make his façade": Portoghesi, *The Rome of Borromini,* p. 168.

Borromini insisted that only the best brick would do: Magnuson, *Rome in the Age of Bernini,* vol. 2, p. 62.

"a collapse": Ibid., p. 61.

222 *"The senile decay":* Ibid., p. 118.

capricci inutili: Ibid., p. 208.

223 *"She still continued to hover":* Ibid., p. 119.

ELEVEN: *Affection and Caprices*

225 *the* squadrone volante: Magnuson, *Rome in the Age of Bernini,* vol. 2, p. 124.

226 *Only Chigi cast his vote for another cardinal:* Ibid.

"the defender of the papal dignity": See Richard Krautheimer, *The Rome of Alexander VII: 1655–1667* (Princeton, NJ: Princeton University Press, 1985), p. 157.

"Architecture . . . on a large scale": Ibid., p. 14.

227 *"like a child"*: Ibid., p. 10.

he wore a hair shirt: Magnuson, *Rome in the Age of Bernini*, vol. 2, p. 126.

"The sun had not yet set": Bernini, *Life of the Cavalier Gian Lorenzo Bernini*, p. 36.

"encouraged Bernini to embark upon great things": Baldinucci, *Life of Bernini*, p. 42.

228 *"a monthly provision"*: Ibid., p. 43.

"the sequence of envy": See Francesca Bottari, "Francesco Borromini," in *Francesco Borromini and Rome*, ed. Francesca Bottari (Rome: Artemide Edizioni, 1999), p. 26.

229 *But it wasn't all conflict*: Connors, "Virgilio Spada's Defence of Borromini."

"When I returned": Ibid.

230 *"the result of uneven settling"*: Ibid.

before Innocent X allowed construction: Portoghesi, *The Rome of Borromini*, p. 50; see also Connors, "Francesco Borromini."

"I the undersigned": Ibid.

232 *to commemorate the university's official opening*: Magnuson, *Rome in the Age of Bernini*, vol. 2, p. 206.

"by the top of his head": Hibbard, *Bernini*, p. 187; and Scribner, *Gianlorenzo Bernini*, p. 96.

233 *Rainaldi proposed four different shapes*: Magnuson, *Rome in the Age of Bernini*, vol. 2, p. 164.

234 *"covered loggias"*: See Timothy K. Kitao, *Circle and Oval in the Square of Saint Peter's* (New York: New York University Press, 1974), p. 7.

"Bernini's trapezoidal piazza": Ibid., p. 8.

"it seems likely that the pope": Magnuson, *Rome in the Age of Bernini*, vol. 2, p. 169.

235 *"immediately . . . saw the drawbacks"*: Kitao, *Circle and Oval*, p. 10.

the pope proposed an oval piazza: Magnuson, *Rome in the Age of Bernini*, vol. 2, p. 165.

237 *"a forest of gigantic stone trunks"*: Varriano, *A Literary Companion to Rome,* p. 220.

 "The image of the piazza": Hibbard, *Bernini*, p. 155.

 "architecture consisted in proportions": Chantelou, *Diary of the Cavaliere Bernini's Visit to France*, p. 48.

 "where all small and shabby things": Ibid.

 "with its clusters": Ibid.

238 *"with the exacting preparations"*: Magnuson, *Rome in the Age of Bernini*, vol. 2, p. 169.

 By the next summer: Ibid., p. 171.

239 *Urban VIII founded the Collegium Urbanum:* Blunt, *Borromini*, p. 183.

 "Very likely it was at this time": Portoghesi, *The Rome of Borromini*, p. 281.

243 *essentially complete by 1662:* Magnuson, *Rome in the Age of Bernini*, vol. 2, p. 206.

TWELVE: *Training the Eye to See*

244 *a brilliant piece of theater:* Sitwell, *Baroque and Rococo*, p. 51.

245 *"Son, I feel a special satisfaction"*: Hibbard, *Bernini*, p. 148.

 every Friday for four decades: Magnuson, *Rome in the Age of Bernini*, vol. 2, p. 340.

246 *"a large and sumptuous church"*: Ibid., p. 197.

 growing number of courtiers: Krautheimer, *The Rome of Alexander VII*, p. 59.

 to finance the interior decoration: Marder, *Bernini and the Art of Architecture*, p. 196.

247 *"making it less visible"*: Magnuson, *Rome in the Age of Bernini*, vol. 2, p. 197.

 "rings of water": Sitwell, *Baroque and Rococo*, p. 52.

251 *describes the stairs as "rickety"*: Hibbard, *Bernini*, p. 163.

254 *"was the most daring operation"*: Fagiolo and Cipriani, *Bernini*, p. 32.

THIRTEEN: *No Greater Favor, No Sadder End*

258 *Alexander met with Borromini:* Connors, "Francesco Borromini."

259 *"could only be satisfied":* Baldinucci, *Life of Bernini,* p. 45.

"I have a great desire": Ibid., p. 47.

260 *"[I] entreat you then":* Ibid.

"as though he were a traveling elephant": Chantelou, *Diary,* p. 24.

261 *"a man of medium height":* Ibid., pp. 14–15.

"a big little thing": Ibid., p. xxii.

"a little cap had been placed on a very large head": Ibid., p. 33.

"Paris seemed nothing but a mass of chimneys": Ibid., p. 98.

"art should be disguised": Ibid., p. 99.

"Let no one speak to me": Andrew Zega and Bernd H. Dams, *Palaces of the Sun King: Versailles, Trianon, Marly: The Chateau of Louis XIV* (London: Laurence King Publishing, 2002), p. 41.

the madrigal that Abbé Buti wrote: Ibid, p. 39.

262 *"The Cavaliere never went into detail":* See Cecil Gould, *Bernini in France* (Princeton, NJ: Princeton University Press, 1982), p. 13.

"in admiration and loudly exclaimed": Baldinucci, *Life of Bernini,* p. 53.

"gently parted the locks of hair": Ibid.

263 *"My king will last longer":* Hibbard, *Bernini,* p. 177.

"I must return to Rome": Fagiolo and Cipriani, *Bernini,* p. 30; and Chantelou, *Diary,* p. 75.

Though the foundation stone: Chantelou, *Diary,* p. 306.

264 *"in return for a generous recompense":* Connors, "Francesco Borromini."

266 *"a slow fever":* Bernini, *Life of the Cavalier Gian Lorenzo Bernini,* p. 39.

"It is only right": Ibid., p. 40.

267 *"Father, I must render account to a Lord":* Baldinucci, *The Life of Bernini,* p. 70.

"It astonished everyone": Bernini, *Life of the Cavalier Gian Lorenzo Bernini,* p. 40.

"so numerous . . . that it was necessary to postpone": Baldinucci, *Life of Bernini,* p. 71.

"to a lucky star": Fagiolo and Cipriani, *Bernini,* p. 38.

FOURTEEN: *A Legacy in Stone*

270　*"You are made for Rome"*: Avery, *Bernini,* p. 273.

"He is by nature of such a temperament": Connors, "Virgilio Spada's Defence of Borromini."

"He [Bernini] could not bear to be laughed at": Magnuson, *Rome in the Age of Bernini,* vol. 1, p. 250.

"It's got all the moves in it that I've made": These comments by Gehry are from a transcript of a *60 Minutes II* piece about him that aired originally on January 23, 2002.

SELECTED BIBLIOGRAPHY

Ackerman, James S. *The Villa: Form and Ideology of Country Houses.* Princeton, NJ: Princeton University Press, 1990.

Andersen, Liselotte. *Baroque and Rococo Art.* New York: Harry N. Abrams, 1969.

Avery, Charles. *Bernini: Genius of the Baroque.* New York: Bulfinch Press, 1997.

Baglione, Giovanni. *Le vite de' pittori, scultori, architetti, ed intagliatori, dal pontificato di Gregorio XIII. del 1572. fino a' tempi di papa Urbano VIII. nel 1642.* Bologna: A. Forni, 1986.

Baldinucci, Filippo. *The Life of Bernini.* Translated by Catherine Enggass. University Park: Pennsylvania State University Press, 1966.

Blaser, Werner, ed. *Drawings of Great Buildings.* Basel, Switzerland: Birkhäuser Verlag, 1983.

Boardman, Jonathan. *Rome: A Cultural and Literary Companion.* New York: Interlink Books, 2001.

Boorsch, Suzanne. "The Building of the Vatican: The Papacy and Architecture." *Metropolitan Museum of Art Bulletin,* Winter 1982–83.

Borromini, Francesco. *Opus architectonicum.* Edited by Joseph Connors. Milan: Il Polifilo, Trattati di architettura, 1998.

Borsi, Franco. *Bernini Architetto.* New York: Rizzoli, 1984.

Borsi, Stephano. *Borromini.* Florence: Giunti Gruppo Editoriale, 2000.

Bottari, Francesca, ed. *Francesco Borromini and Rome.* Rome: Artemide Edizioni, 1999.

Burchard, John. *Bernini Is Dead? Architecture and the Social Purpose.* New York: McGraw-Hill, 1976.

Cannon-Brookes, P. and C. *Baroque Churches.* London: Paul Hamlyn, 1969.

Chantelou, Paul Fréart de. *Diary of the Cavaliere Bernini's Visit to France.* Translated by Margery Corbett. Princeton, NJ: Princeton University Press, 1985.

Connors, Joseph. "A Copy of Borromini's S. Carlo alle Quattro Fontane in Gubbio." *Burlington Magazine* 137 (1995).

————. "Francesco Borromini: La vita 1599–1667." In *Borromini e l'universo barocco* (catalog for exhibition held at the Palazzo delle Esposizioni in Rome), edited by Richard Bösel and Christoph Frommel. Milan: Electa 2000.

————. "Poussin detrattore di Borromini." In *Atti del Convegno Internazionale su Borromini,* proceedings of conference held in January 2000 at the Bibliotheca Hertziana and Palazzo Barberini.

————. "Virgilio Spada's Defence of Borromini." *Burlington Magazine* 131 (1989): 75–90.

————. "Virtuoso Architecture in Cassiano's Rome." In *Cassiano Dal Pozzo's Paper Museum,* vol. 2, edited by Jennifer Montagu. London: Quaderni Puteani 3, 1992, pp. 23–40.

Fagiolo, Maurizio, and Angela Cipriani. *Bernini.* Rome: Scala, 1981.

Fiore, Kristina Herrmann, ed. *Guide to the Borghese Gallery.* Rome: Ministero per i Beni Culturali e Ambientali, Soprintendenza per i Beni Artistici e Storici di Roma, 1997.

Gallico, Sonia. *Vatican.* Rome: Edizioni Musei Vaticani Ars Italia Editrice, 1999.

Gould, Cecil. *Bernini in France: An Episode in Seventeenth-Century History.* Princeton, NJ: Princeton University Press, 1982.

Harris, Ann Sutherland, ed. *Selected Drawings of Gian Lorenzo Bernini.* New York: Dover Publications, 1977.

Hempel, Eberhard. *Francesco Borromini.* Vienna: A. Schroll & Co., 1924.

Hersey, George L. *Architecture and Geometry in the Age of the Baroque.* Chicago: University of Chicago Press, 2000.

Herz, Alexandra. "Borromini, S. Ivo, and Prudentius." *Journal of the Society of Architectural Historians* 48, no. 2 (June 1989): 150–57.

Hibbard, Howard. *Bernini.* New York: Penguin Books, 1965.

―――. *Carlo Maderno and Roman Architecture 1580–1630.* University Park: Pennsylvania State University Press, 1971.

Holmes, George, ed. *The Oxford Illustrated History of Italy.* New York: Oxford University Press, 2001.

Hopkins, Andrew. *Italian Architecture from Michelangelo to Borromini.* New York: Thames & Hudson, 2002.

James, Henry. *Henry James on Italy.* New York: Weidenfeld & Nicholson, 1988.

Kirwin, W. Chandler. *Powers Matchless: The Pontificate of Urban VIII, the Baldachin, and Gian Lorenzo Bernini.* New York: Peter Lang, 1997.

Kitao, Timothy K. *Circle and Oval in the Square of St. Peter's.* New York: New York University Press, 1974.

Korn, Frank J. *A Catholic's Guide to Rome: Discovering the Soul of the Eternal City.* New York: Paulist Press, 2000.

Krautheimer, Richard. *The Rome of Alexander VII: 1655–1667.* Princeton, NJ: Princeton University Press, 1985.

Lavin, Irving, ed. *Gianlorenzo Bernini: New Aspects of His Art and Thought.* University Park: Pennsylvania State University Press, 1985.

McPhee, Sarah. *Bernini and the Bell Towers: Architecture and Politics at the Vatican.* New Haven, CT: Yale University Press, 2002.

Magnuson, Torgil. *Rome in the Age of Bernini.* 2 vols. Translated by Nancy Adler. Stockholm: Almqvist & Wiksell International, 1986.

Marder, Tod A. *Bernini and the Art of Architecture.* New York: Abbeville Publishing Group, 1998.

Menen, Aubrey. *Art & Money: An Irreverent History.* New York: McGraw-Hill, 1980.

Millon, Henry A. *Baroque and Rococo Architecture.* New York: George Braziller, 1961.

————. *The Triumph of the Baroque: Architecture in Europe, 1600–1750.* New York: Rizzoli, 1999.

Norberg-Schulz, Christian. *Baroque Architecture.* Milan: Electa; New York: Rizzoli, 1979.

Norton, Richard. *Bernini and Other Studies in the History of Art.* New York: Macmillan, 1914.

Norwich, John Julius, ed. *Great Architecture of the World.* New York: Random House, 1975.

Passeri, Giovanni Battista. *Vite de' pittori, scultori ed architetti, che anno lavorato in Roma, morti dal 1641 fino al 1673.* Bologna: A. Forni, 2000.

Pevsner, Nikolaus. *An Outline of European Architecture.* New York: Penguin Books, 1997.

Portoghesi, Paolo. *Roma Barocca: The History of an Architectonic Culture.* Translated by Barbara Luigia la Penta. Cambridge, MA: MIT Press, 1970.

————. *The Rome of Borromini: Architecture as Language.* Translated by Barbara Luigia la Penta. New York: George Braziller, 1968.

Raffaëlli-Fournel, Laure, ed. *The Knopf Guide: Rome.* Translated by Louis Marcelin-Rice and Kate Newton. New York: Alfred A. Knopf, 1994.

Raspe, Martin. "The Final Problem: Borromini's Failed Publication Project and His Suicide" *Annali di Architettura: Rivista del Centro Internazionale di Studi di Architettura Andrea Palladio* (Vicenza, Italy), 2001.

Scribner, Charles, III. *Gianlorenzo Bernini.* New York: Harry N. Abrams, 1991.

Smith, Charles Saumarez. *The Building of Castle Howard.* Chicago: University of Chicago Press, 1990.

Tapié, Victor-L. *The Age of Grandeur: Baroque Art and Architecture.* New York: Frederick A. Praeger, 1961.

Thelen, Heinrich. *Francesco Borromini: Die Handzeichnungen.* Graz, Austria: Akademische Druck und Verlagsanstalt, 1967.

————. *Zur Entstehungsgeschichte der Hochaltar-Architektur von St. Peter in Rom.* Berlin: Gebr. Mann, 1967.

Varriano, John. *Italian Baroque and Rococo Architecture.* New York: Oxford University Press, 1986.

———. *A Literary Companion to Rome.* New York: St. Martin's, 1995.

Vicini, Maria Lucrezia, ed. *Guide to the Spada Gallery.* Rome: Ministero per i Beni e le Attività Culturali, Soprintendenza Speciale per il Polo Museale Romano, 2002.

Wallace, Robert, and the editors of Time-Life Books. *The World of Bernini: 1598–1680.* Alexandria, VA: Time-Life Books, 1970.

Wittkower, Rudolf. *Art and Architecture in Italy, 1600–1750.* Vol. 2, *The High Baroque.* Revised by Joseph Connors and Jennifer Montagu. New Haven, CT: Yale University Press, 1999.

———. *Gian Lorenzo Bernini: The Sculptor of the Roman Baroque.* New York: Phaidon Press, 1955.

———. *Gothic vs. Classic: Architectural Projects in Seventeenth-Century Italy.* New York: George Braziller, 1974.

Worsley, Giles. *Classical Architecture in Britain: The Heroic Age.* New Haven, CT: Yale University Press, 1995.

Zanella, Andrea, ed. *Bernini: All His Works from All Over the World.* Translated by Isobel Butters Caleffi. Rome: Fratelli Palombi, 1993.

Zega, Andrew, and Dams, Bernd H. *Palaces of the Sun King: Versailles, Trianon, Marly: The Chateaux of the Sun King.* London: Laurence King Publishers, 2002.

Zevi, Bruno. *The Modern Language of Architecture.* Vancouver, BC: Douglas & McIntyre Ltd., 1978.

ACKNOWLEDGMENTS

This book, like architecture itself, is both an individual and a collective endeavor. Without the help of the people listed below, it would still be a collection of notes scribbled on pieces of scrap paper.

Writing a book whose protagonists are two Italian artists presents considerable challenges, and I am enormously grateful to Portia Prebys, Ingrid Rowland, and Charles Scribner III for making them less onerous than they could have been. Their role in helping me to navigate the Rome of today and the Rome of the seventeenth century was extraordinary, and their insights and corrections have made this a better book (though any errors are solely mine). I am also grateful to the historians, experts, and scholars whom I quote, and to Sister Catherine Anne Clark at the Vatican Library and Denise Gavio at the Library of the American Academy in Rome for their help.

Suzanne Gluck, in her omniscience, convinced me that this was a book I could write, and I am very pleased that Henry Ferris at William Morrow agreed with her. His intelligent, thoughtful editing and his enthusiasm for the book—as well as the enthusiasm of Michael Morrison, Lisa Gallagher, Sharyn Rosenblum, Juliette Shapland, and everyone at Morrow—have been gratifying. I also am indebted to Maureen Clark for her careful work on the manuscript.

Sara Nelson, Jane Rosenman, Adriana Trigiani, Lisa Wilson, Marianne Goldstein, Neil Gladstone, Mary Anne Grimes, Matt Herman, Ned Ehrbar, Alex George, and Alex Wellen were especially helpful during the writing of this book. Their patience and understanding were very much appreciated.

And I am enormously grateful to my family. They'll never know how much they helped me.

INDEX

Page numbers in *boldface italics* refer to illustrations.

Bernini, Luigi (brother):
 and Costanza, 134, 136–38
 family honor besmirched by, 266
 and St. Peter's, 146–47, 149
Bernini, Paolo (son), 260
Bernini, Msgr. Pier Filippo (son), 174
Bernini, Pietro (father), 17–18, 19, 26
 Assumption of the Virgin, 21–22, 32
 Carthusian Monastery, San Martino, 18
 and his son's talents, 22, 27–28
 Santa Maria Maggiore, 20–21
 and St. Peter's, 84
 Virgin and Child with the Infant St. John, 20
Biffi (sculptor), 39
Bissone, Italy, Borromini born in, 36–37
Bitonto, Fra Giovanni Maria da, 254
Blake, William, 14
Blunt, Anthony, 90, 98, 109, 111, 121, 132, 177, 187, 214
Boardman, Jonathan, 46
Bolgi, Andrea, 160
Bonarelli, Costanza, 134–39, 168
Bonarelli, Matteo, 134
Borghese, Cardinal Camillo, *see* Paul V, Pope
Borghese, Cardinal Scipione, 24–25, 33, 116–19, 212
Borghese family:
 Cappella Paolina as chapel of, 21
 and Villa/Galleria Borghese, 24, 35, 118, 169
Borghese Warrior (Greek sculpture), 34
Borromeo, San Carlo, 98
Borromini, Bernardo, 9
Borromini, Francesco:
 and Alexander VII, 6, 8, 82, 179, 183, 231–32, 238, 246, 258
 as architect, *see* Borromini, Francesco, architecture
 attack on himself, 11, 265
 biographies of, 8, 39, 92, 93, 163
 birth of, 36
 death of, 1–2, 4, 264–65

as decorative sculptor, 39, 40, 82
drawings destroyed by, 9
early years of, 37
education of, 38–39
estate of, 264–65
final phase of career, 4–6, 8, 214, 224, 228, 232, 258–59
graphite used by, 10
health problems of, 8–10
income of, 92, 93–94, 96, 97, 113, 264
and Innocent X, 183, 187–91, 193–200, 202–4, 207–8, 217–18, 222, 228, 239, 265
knighthood awarded to, 200
legacy of, 268–71
in Milan, 37–39, 182
and murder in San Giovanni, 199–200, 218
Opus architectonicum, 124, 126–27, 131–32
and Oratorians, 6, 130–31, 133, 229–30
and Pamphili family, 187–91, 218, 224
personal traits of, 2, 7, 16–17, 85–86, 111, 113–14, 126, 200, 228, 270
professional traits of, 5–6, 7, 8, 14, 16, 40, 54, 67, 87, 96, 97, 100, 111, 126, 127, 130, 131, 176, 178–79, 213–14, 222, 230, 243, 270–71
public statements about St. Peter's, 78–79, 81
quarrels with clients, 5, 7, 224, 228–29
and Radi, 82, 94–95, 97
reputation of, 6, 7–8, 111, 113–14, 230
rivalry of Bernini and, 2, 7, 14, 17, 46, 63, 81, 85–86, 92–95, 96–97, 114, 141, 145, 155–61, 163–64, 165, 167, 190, 207–8, 240
and Rome, 13, 268–71
and Spada, 122, 124–26, 200, 208, 218, 229–30, 258, 265, 270
and St. Peter's bell towers, 153–61, 193
technical skills of, 66, 68
tomb of, 2–4, 264–65
will written by, 9, 10, 264

Fréart de Chantelou, Paul, 8, 25, 227, 237,
 260–61, 263, 267

Gaius, Emperor, 156
Galileo, 18, 27
Garovo, Anastasia, 36
Garovo, Leone, 39–40, 67
Gehry, Frank, 270
Genius:
 distrust of, 13–14
 and power, 207
 sources of, 17
Gigli, Giacinto, 148, 209, 216, 222, 224
Giustiniani, Giovanni, 185
*Goat Amalthea Suckling the Infant Jupiter and a
 Satyr, The* (Bernini), 23
Gothic forms, 7–8, 38, 39, 51, 68, 101, 106,
 182, 192
Gregory II, Pope, 45
Gregory XI, Pope, 192
Gregory XIII, Pope, 121, 202
Gregory XV, Pope, 6, 59, 71, 72, 80, 122,
 134, 238
Grimaldi, Giacomo, 156
Guzmán, Enrico de, 20

Habbakuk (Bernini), 232–33
Hadrian, mausoleum of, 44
Hadrian's Villa, 146
Head of St. John (Bernini), 25–26
Helena, Saint, 49
Henry IV, king of France, 26–27
Herrera, Monsignor, 61
Hibbard, Howard, 27, 60, 117, 203, 204,
 237

Ignatius, Saint, 245
Innocent X, Pope, 5, 131
 and Bernini, 166–67, 171, 205–8
 and Borromini, 183, 187–91, 193–200,
 202–4, 207–8, 217–18, 222, 228, 239,
 265
 crest of, 189

election of, 152
and Fountain of the Four Rivers, 202–8,
 210–12
illness and death of, 222–23, 228, 229
and Mazarin, 226
and Palazzo Pamphili, 185–89, 201
personal traits of, 159, 223
and Piazza Navona, 201–8
and St. Peter's, 152–54, 156, 157, 158,
 159–60, 161–63, 165, 233
and San Giovanni, 191–200
and Sant'Agnese, 201, 214–18, 220,
 222–24, 228, 229
and Sant'Andrea, 245–46
and Sant'Ivo, 230
sister of, 185–86
Innocent XI, Pope, 267

James, Henry, 21, 64, 196
Jerusalem, Temple of Solomon in, 69
Jesuits, 6, 26, 59
 motto of, 251
 and Propaganda Fide College, 242
 and Sant'Andrea, 245, 246–47, 250, 251
 symbol of, 242
John Chrysostom, Saint, 250
John the Baptist, Saint, 4
Juan de la Anunciación, Fra, 99
Juan de San Bonaventura, Fra, 113, 123, 194
Julius II, Pope, 4, 48, 49, 50, 82, 193

Kirwin, W. Chandler, 70, 71, 72, 74, 81
Kitao, Timothy, 234
Krautheimer, Richard, 226

Lante, Cardinal Marcello, 154, 160
Laocoön, 9
Lassels, Richard, 150
Lateran, *see* San Giovanni in Laterano
Le Corbusier, 58
Le Duc, Gabriel, 261
Leo IV, Pope, 192
Leo X, Pope, 3, 51

Naples:
 as artistic backwater, 20
 Bernini family in, 18, 20
 history of, 18–19
 Santissimi Apostoli in, 111–12
Nash, John, 89
Neri, San Filippo, 5, 120–21, 122, 129
Nero, Emperor, 44, 156
Newton, Sir Isaac, 18, 242
Nicholas V, Pope, 47
Nicoletti, Andrea, 72
Norton, Richard, 34

Oliva, Father Gian Paolo, 223
Opus architectonicum (Spada and Borromini),
 124, 126–27, 131–32
Oratorians of Saint Filippo Neri,
 152
 art collection of, 121
 Borromini dismissed by, 5, 130–31, 133,
 229–30
 on early Christian antiquity, 197
 founding of, 120–21
 importance of music to, 122
 Santa Maria as church of, 5, 120, 121
Oratorio di San Filippo Neri, 6, 112,
 120–33
 Borromini as architect of, 5, 123–27,
 130–31, 219
 completion of, 130
 designs for, 122–23, 124–30, *128*
 façade of, 127–28, 131–33
 Maruscelli's work on, 122–27
 sacristy of, 126–27
 windows of, 124, 125, 129–30
Ovid, *Metamorphosis*, 203

Palazzo Spada, 254, *255*, 256
Palladian windows, 188–89
Palladio, Andrea, 178, 188
Pallavicino, Sforza, 226
Pallotta, Cardinal Giambattista, 155–56,
 234

Pamphili, Cardinal Camillo, 206
 and Bernini, 164, 166
 and Borromini, 5, 189, 218, 219, 222, 224,
 228, 229
 coat of arms of, 247
 as head of family, 224
 and Innocent X, 217, 222–23
 and Piazza Navona, 5, 185
 and Rainaldis, 215, 217, 219
 and Sant'Agnese, 5, 218, 219, 222, 228,
 229
 and Sant'Andrea, 246–48, 251
 villa of, 189–90
Pamphili, Donna Costanza, 205
Pamphili, Cardinal Giambattista, 152, 185; *see
 also* Innocent X, Pope
Pamphili, Donna Olimpia Maidalchini,
 164, 166, 185–87, 206, 207, 217, 218,
 223, 224
Pamphili family:
 ambitions of, 183–84
 Bernini's play about, 166–67
 Borromini's quarrels with, 5, 224, 228–29
 Doria-Pamphili collection, 185
 dove as symbol of, 208, 210
 and Fountain of the Four Rivers, 202
 and Innocent X's death, 223–24, 228
 Palazzo Pamphili, 185–89, 196, 200, 201,
 209, 212, 216, 219
 and Piazza Navona, 5, 183–84, 185,
 187–88, 200, 201–14
 power of, 190
 property holdings of, 184–85, 215
 and Sant'Agnese, 5, 188, 201, 215–19,
 228–29
 and Urban's death, 167
Pannini, Giovanni Paolo, 268–70
Pantheon, 52, 84, 85, 180
Panziroli, Cardinal Giovanni Giacomo, 166,
 211
Pascoli, Lione, 8–9
Passeri, Giovanni Battista, 93, 94, 95, 114
Paul III, Pope, 51